Expressionism reassessed

Expressionism reassessed

Shulamith Behr
David Fanning
Douglas Jarman *editors*

MANCHESTER UNIVERSITY PRESS
Manchester and New York

distributed exclusively in the USA and Canada by St. Martin's Press

Copyright © Manchester University Press 1993

Whilst copyright in the volume as a whole is vested in Manchester University Press, copyright in individual chapters belongs to their respective authors, and no chapter may be reproduced wholly or in part without the express permission in writing of both author and publisher.

Published by Manchester University Press
Oxford Road, Manchester M13 9PL, UK
and Room 400, 175 Fifth Avenue, New York, NY 10010, USA

Distributed exclusively in the USA and Canada
by St Martin's Press, Inc.,
175 Fifth Avenue, New York, NY 10010, USA

British Library Cataloguing-in-Publication Data
A catalogue record for this book is available from the British Library.

Library of Congress Cataloging-in-Publication Data
Expressionism reassessed / edited by Shulamith Behr, David Fanning,
 and Douglas Jarman
 p. c.m.
 Includes bibliographical references and index.
 ISBN 0-7190-3843-X (cloth). — ISBN 0-7190-3844-8 (paper)
 1. Expressionism (Art) 2. Arts. Modern—20th century. I. Behr, Shulamith,
 II. Fanning, David. III. Jarman, Douglas
 NX456.5.E9E86 1993
 700—dc.20 93-2709

ISBN 0 7190 3843 X *hardback*
ISBN 0 7190 3844 8 *paperback*

Typeset in Monotype Apollo
by Koinonia Ltd, Manchester
Printed in Great Britain,
by Bell & Bain Limited, Glasgow

CONTENTS

LIST OF ILLUSTRATIONS

Oil on canvas and size in centimetres, if not otherwise specified

FOREWORD

Expressionism: bonfire and jellyfish

John Willett

Expressionism, as the rich programme of events at the Manchester International Festival made clear, is a difficult phenomenon to define. Sometimes it is a bonfire, sometimes a jellyfish; how can one articulate either, let alone a mixture of the two? I thought we might make a start by setting out some of the many different uses of the term. Here, then, are seven applications and a short final comment.

In the discussions about the 1911 *Sezession* 'Expressionism' was treated as a German offshoot of the Fauves: bright colours, wildness, primitivism, *joie de vivre* à la Matisse, freedom à la Nietzsche. Above all, an element of expressive distortion. Visible passion. This school, developing around the *Brücke*, as its centre shifted from Dresden to Berlin, was receptive to other European '-isms' of the period 1908-1912: Cubism, Futurism, Orphism. For many the word came to stand for the modern movement *schlechthin*. Hence 'Expressionist' might be used for any German adherent of that wider movement.

Almost simultaneously the same label came to be applied to the modernists in Vienna and Munich. In the first case this was thanks largely to Kokoschka's involvement with Walden and *Der Sturm* – though Kokoschka didn't like being so labelled. In the second case it was because Kandinsky was a modernist pioneer with some of the primitivism and force of expression of the Dresden-Berlin school, even though his roots lay in Symbolism rather than in Cézanne or the Fauves. Of his closest colleagues Marc shared the expressionist openness to the main European '-isms', though there is a soft centre to him which only Otto Müller of the other group could match. But what is expressionist about Klee?

In music there are clear links and analogies between Kandinsky and Schoenberg but there is not much community of *feeling* and *method* between the Second Viennese School and the *Brücke*. The savagery and jaggedness of the great expressionist graphics, for instance, which are anyway not so evident in the *Blaue Reiter*, are scarcely there in Schoenberg – scarcely in the music, that is, or in the mainly symbolist texts which he chose to set and not at all in his paintings. Those who

are listening out for those particular qualities will find them not in the Viennese but in the work of Stravinsky and Bartók.

In drama too there is, in the classic expressionist theatre of Kaiser and Hasenclever, a strong sense of structure – even if that structure is articulated in a disjointed, episodic, unconventional way. There is humour, however gallows-ish, and social criticism in key with some of the crucial preoccupations immediately before, during and after the First World War. Of all this, however, there seems to be nothing in the more abstract dramatic writing of Kandinsky and Kokoschka nor, with a handful of exceptions like Kurt Jooss and Jean Weidt, in the 'modern dance' associated with Wigman and Laban.

So it was the Expressionism of what Karl Ludwig Schneider called 'zerbrochene Formen' that persisted throughout the First War, as experienced in central and Eastern Europe, and pervaded the so-called 'Second Expressionism' of the early Weimar Republic. This fuelled the Activism of the years 1916-18, then the art of the new Socialist establishment and finally the left-wing reaction against it which culminated in the militancy of German Communist art before Socialist Realism anaesthetised it. It is hard, on the other hand, to see any political implications in the work of the *Blaue Reiter* or in the music of Schoenberg, whose philosophy owed more to Rudolf Steiner than to Friedrich Nietzsche and practically nothing to that of Karl Marx. Admittedly the picture became complicated by other factors, such as Kokoschka's identification with Czechoslovakia in the mid-30s and the Nazi idea of *Kunstbolschewismus* around the same time by which Jews, Slavs and the entire modern movement became a single super-demon devoted to undermining Germany's naturally lofty view of the arts. But broadly speaking, the Berlin wing of Expressionism can still be seen as 'political', the Austro-Bavarian branches not.

This is the main division in our concepts of Expressionism, and it runs across the many different discussions of the subject. But, of course, there are other variations. These become evident in the whole run-up to the German movement, when great expressive artists like Munch and Modersohn-Becker, to say nothing of Goya and El Greco, became retrospectively grouped under that label. So did Hodler; but then if Hodler why not Gauguin? I think this is because the power and the originality of Symbolism as a great international movement has become rather overlooked. And perhaps this in turn is why Kandinsky and Schoenberg are now identified with the new mid-European '-ism' which remained unnamed until both men were middle-aged. There were artists, writers and musicians in other countries – notably France,

Italy and England — who would today be known as Expressionists had they been German: Soutine, Rouault, Sironi and Bomberg for a start. And probably the same would apply to the Cubist Picasso, the Orphist Delaunay. The fact is that it served as much more comprehensive a term in mid-Europe than elsewhere. Germany and Austria became isolated by the war, other -isms were cut off from their roots abroad, and by the fall of the two Empires Expressionism had grown into the all-purpose modern movement.

What of today? Ever since the movement's rehabilitation following its garrotting by the Nazis, works — and particularly the graphic works — by the main expressionist artists have spoken not just to dealers and collectors but above all to young artists, students and dissidents of one kind or another. Most of us know this but it still remains a striking experience to come across exhibits — in an art school end-of-year show, let's say, or as illustrations in a poetry magazine — which clearly echo Nolde or Kirchner or maybe Beckmann. Is this the plagiarism that we encounter in other fields? Are these mere second-hand versions of a manner that has become fashionable among examiners and art historians? Is it the overblown rhetoric of today's successful Berlin artists who try to push Expressionism further and on to a bigger scale? I don't feel that this is so: much rather that the young are digging beneath the surface and finding a passion, a discomfort and sometimes a fury that they also feel in themselves and the societies they live in. This is no imitation: it is a use of similar means to express feelings that they share. We find the same thing in black communities as well as white — among peasants and pop stars alike. '*Vive l'Expression*' said a slogan in the University of Paris in 1968, and this remains the ideal in many parts of the world.

Part of the fascination of twentieth-century German and Austrian culture is that it bears the marks of its time; it is scarred. Its history has been one of ups and downs, loves and hatreds, prosperity and crisis, wars and peace. And much the same is true of its reception in other countries. When I first encountered the originality and violence of Expressionism, back in the days of Hitler's Degenerate Art Exhibition and the opening of his House of German Art (an antithesis I have not forgotten, with the glowing image of Klee's *Goldfish* still swimming above it all), it was not much considered, shown or reproduced in Western Europe and America. Everything good and beautiful, we were told, came from France. Fifty years later received opinion has swung the other way. Germany is at present the fashion, France is not. So let us please remember that this is a world where everything is open.

Progress in the arts (if that means anything at all) is certainly not linear. One great achievement does not exclude or devalue another. Opening our eyes and ears to Expressionism must not make us shut them to anything else.

ACKNOWLEDGEMENTS

The editors wish to thank all the contributors to the present book and, in addition, David Fisk, Christopher Yates, Heide Harwood and her assistants, Sue Kitchen, Rhys Williams, the Goethe Institute Manchester, the Austrian Institute, the University of Manchester, the Visiting Arts Office of Great Britain and Northern Ireland, the Arts Council International Initiative Fund and Bull Information Systems (Cheshire) for their support.

INTRODUCTION

Expressionism reassessed

Shulamith Behr
David Fanning
Douglas Jarman

Expressionist art is instantly recognisable. The unreal colours, the distorted shapes and the often primitive-seeming techniques of the paintings of Kirchner, Schmidt-Rottluff and Pechstein; the bizarre camera angles, menacing chiaroscuro and grotesquely distorted sets of a film such as Wiene's *The Cabinet of Dr Caligari*; the extreme dramatic situations and the tortured mental states of the protagonists of Schoenberg's *Erwartung* and Berg's *Wozzeck* – all have a raw emotional intensity that immediately identifies these works as 'expressionist'.

But if the peculiar qualities that make art 'expressionist' are instantly recognisable they are also, as a number of contributors to this book point out, curiously difficult to define.

The expressive distortions of reality, the extent to which the external objective world is filtered through the internal subjective world of the artist's emotions in an attempt to express an inner reality – the psychological reality behind appearances – are easy enough to discern in paintings and graphic works or in the theatre and cinema. But how are such qualities to be recognised in, for example, architecture, dance, poetry or abstract instrumental music? How can reality be distorted in those art forms that make no reference to a reality outside themselves?

Music poses these questions in their most acute forms and, inevitably perhaps, such concerns dominate the three music con- tributions by Christopher Hailey, Peter Franklin and Stephen Hinton. What do we mean if we describe the angular, fragmented melodic lines and dissonant atonal harmony of Schoenberg's textless Orchestral Pieces Op.16 as 'expressionist'? Similarly in architecture what is implied when we so designate Erich Mendelsohn's Einstein tower?

Was Expressionism, unlike the other more easily definable '-isms' of twentieth-century art, anything more than an attitude and the word itself any more than a vague portmanteau term indicating, at the most,

a set of superficial similarities. Will, indeed – as the 'revisionist history' proposed by David Elliott suggests – future historians question whether Expressionism as an identifiable style ever existed?

To attempt to define Expressionism chronologically is as problematic as doing so in terms of style. The expressionist period can most conveniently be taken as covering the two decades from the founding of *Die Brücke* by four young students in Dresden in 1905 to the holding of the first *Neue Sachlichkeit* exhibition in Mannheim 1925. The adoption of such a time span, however, while appropriate for some art forms works less well for others. In music, for example, the twenty years from 1905 to 1925 encompass all the free atonal music of Schoenberg (the Piano Suite Op.25, the first completely twelve-note work, was written in 1921-23) and are neatly marked off by the première of Strauss's *Salome* at one end and that of Berg's *Wozzeck* at the other. In painting and cinema, on the other hand, the restriction of the period to these two decades omits many works that we now regard as quintessentially expressionist. Munch's *The Scream*, for instance, was painted in 1893, over a decade before the founding of *Die Brücke*, while many of the most important works of the expressionist cinema appeared only in the decade after the *Neue Sachlichkeit* exhibition. Perhaps, as John Willett has suggested, the wide chronological differences between the various manifestations of Expressionism were the result of nothing more than the fact that the greater the number of people involved in the production of a work the longer it took for the influence of the new movement to be felt. In any event, *The Cabinet of Dr Caligari* (1919) was not made until after the First War, while Lang's *Metropolis* (1927), Von Sternberg's *The Blue Angel* (1930) and Pabst's *Pandora's Box* (1937) appeared only after Expressionism was dead.

But to speak of Expressionism as being 'dead', or to attempt to limit its chronological span, is, in any case, to misrepresent the power and the influence which this amorphous, theoretically ill-defined movement has had. Not only was it the single most important artistic movement in northern Europe during the first decades of the century, dominating all the arts in Germany, Austria and (as Marit Werenskiold demonstrates) Scandinavia but, through its influence on painting, stage design, music and cinema, it has permanently affected the whole of twentieth-century art and culture.

That Britain, almost alone amongst the countries of northern Europe, remained relatively unaffected by Expressionism during the 1920s-1940s (a subject discussed by Professor J. M. Ritchie) was due less to British artists themselves being unaware of the movement – both

Michael Powell and Alfred Hitchcock, for example, worked in Berlin in the 1920s – than to many of the most important émigré artists regarding the UK as little more than a stopping-off point en route to America. Of all art forms it was, as Werner Sudendorf shows, the pre-Hitler German cinema that embraced the modernist aspects of Expressionism most enthusiastically, forging, in a film such as *The Cabinet of Dr Caligari*, a link between the style of 'high culture' and a popular narrative framework that appealed to a mass audience. With its emigration from the Old to the New World, Expressionism, which had had only a peripheral influence on Britain, entered the mainstream of American art and, thanks to Hollywood, would have a lasting influence on the most important popular art form of the twentieth century.

One of the difficulties in defining 'Expressionism' lies in the fact that those involved in the movement had no very clear idea of precisely what it was they were involved in. Unlike the Italian Futurists, the Expressionists produced few manifestos and had no formal programme; brought up, for the most part, within the confines of the stifling, complacent and philistine culture of Wilhelminian Germany they were, in the words of Peter Gay, 'Rebels with a cause but with no clear definitions or concrete aims'.

The too-often-misused term 'Zeitgeist' is perhaps for once appropriate as a description of what it was that united the members of a movement that John Willett describes as appearing sometimes like a bonfire and sometimes like a jellyfish. Coming to the movement from different angles and with different ideas, the Expressionists were united only in their German and North European origins, their rejection of the classical ideals of beauty, their youthful passion and their belief in an art that would break the bounds of aestheticism in its pursuit of emotional and psychological intensity.

It was this pursuit of raw truth, regardless of the inhibitions imposed by tradition, that led Franz Marc to apply the name 'Die jungen Wilden' to the early expressionists. Yet, as a number of the following essays make clear, it is difficult to regard even the 'wildness' which is (and was at the time) generally regarded as typically expressionist as being a defining characteristic. If Expressionism was a movement of rebellion – an 'uprising of the spirit against reality' – it was as much a rebellion against prevailing cultural and social institutions as against prevailing stylistic issues; and yet the artists whom we commonly regard as expressionist displayed a notably ambivalent attitude both to the existing artistic rules which they wished to overturn ('All

knowledge and education and skill is irrelevant for the creation of the work of art ... poetry cannot take account of grammar', declared Lothar Schreyer) and to the cultural institutions that maintained these rules.

The belief in the possibility of a 'Utopia' – that a perfect emotional expression, aided by a return to the natural and the 'primitive', could generate a passionate communality which would lead to some kind of ideal society – is a constant thread in expressionist thought. Dennis Sharp feels that it was thanks to this belief that architecture, the most directly social of the arts, assumed such a dominance in the radical post-First World War dream of reconstruction and, while playing a peripheral role in the expressionist movement as a whole, became 'a blueprint activity ... capable of creative speculation on a vast scale'. Werner Sudendorf points to the influence of architects such as Poelzig, Reimann, Warm and Röhrig on the stylistic qualities of 'cinematic architecture', while Erich Ranfft's discussion of expressionist sculpture is similarly focused on its architectural and ideological context, illustrating the way in which utopian aspirations informed the aesthetic criteria of uncommissioned works as well as those resulting from public, religious and commercial patronage.

Yet the rural colonies (such as the Worpswede circle, discussed by Gill Perry) which many of the expressionist artists formed were the product of a strange mixture of utopian aspirations and practical considerations, such as the cheaper cost of living in the country and the accessibility of good train services. The members of *Die Brücke*, who celebrated their freedom from conventions and restrictions in both their art and in their private lives, were also serious businessmen who paid their subscriptions to belong to the group and had a highly organised exhibitions policy; they were both against the existing academic and artistic institutions and, at the same time, eager to carve themselves a niche in bourgeois society.

From being ignored in the years before the *Sonderbund* exhibition of 1912, the expressionist painters soon established themselves as the official avant-garde and by 1918 had become 'old masters'. By 1933 the museums were full of expressionist works and Expressionism was generally accepted as representing modern German art. That the German expressionists were able to found over 250 journals and periodicals is itself evidence of their success in finding a niche in society and creating a market for their work: that many of these periodicals were small affairs, with few of them lasting for more than a year, is less important than the fact that there were clearly enough writers and enough interested readers to make the founding of such

periodicals worthwhile. When the Nazis eventually turned their face against Expressionism it was largely because of its various associations with Bolshevism and the Weimar Republic – and in spite of the fact (as David Elliott, following Georg Lukács, points out in his chapter) that certain characteristics of the movement anticipated the excesses of National Socialism itself. These and other aspects of the sociology of Expressionism inevitably invite reassessment, not only in the present book but no doubt in future studies also.

But perhaps the Expressionists' ambivalent attitude to both social and artistic rules should not surprise us since, as Professor Alexander Goehr has suggested, Expressionism can only exist when there is a rule structure: when, that is, there first exists a generally accepted and understood set of conventions that can be stretched and distorted in the interest of expressing a variety of things that the artist feels cannot be expressed in a more conventional way – in the interest, for example, of erotic expression or the articulation of political, religious, mystical or theosophical beliefs.

Certainly, for all the manifest expressionist credentials of Schoenberg's *Erwartung* and of a select few pieces by his colleagues Berg and Webern, one can hardly describe the attitude of the composers of the Second Viennese School even as 'ambivalent', let alone as an iconoclastic desire to overturn the existing artistic rules. Berg's *Wozzeck*, with its deliberate dialectical synthesis of traditional musical forms and eruptive expressionist gestures, is but one illustration of the deep awareness of a tradition stretching back through Mahler, Wagner and Brahms to Beethoven, Mozart, Haydn and Bach that permeated the thought of the whole Schoenberg school. Expressionism in music lasted for only a short period and the subsequent development of all three composers demonstrates the extent to which they were concerned, above all, to operate within an orderly and rule-abiding system.

Writings on the Second Viennese School have tended to be analytical pieces concerned with examining the technical innovations of the expressionist 'free atonal' music in terms of a self-contained crisis in the musical language itself. The three music chapters in this book seek to place the music in a wider context: Christopher Hailey by tackling the question of what historical and aesthetic impulses lay behind the movement; Peter Franklin by discussing the 'oppositional modernism' of Franz Schreker and considering Schoenberg's music in the light of Georg Lukács's famous social critique of Expressionism, and Stephen Hinton by focusing on the intersection between Expressionism and the

New Objectivity in the early music of Hindemith and Weill. By discussing musical Expressionism in a larger historical and social context, rather than in isolation, the three chapters together not only give music a more extensive treatment than it has received in any comparable symposium to date but also offer a new perspective to the musician and non-musician alike.

Many of the contributors to this book have taken the opportunity – and, indeed, were positively encouraged to take the opportunity – to deal with topics that involve a number of different artistic disciplines.

Such a breaking down of artistic boundaries was, of course, characteristic of the expressionist period itself, when many artists moved freely between the different art forms. Wassily Kandinsky (whose stage-composition *Violet* is discussed by Shulamith Behr), Oskar Kokoschka and Ludwig Meidner, for example, wrote as well as painted, while during his expressionist period Schoenberg spent almost as much time painting as he did composing.

An exploration of the extent to which ideas from one discipline were assimilated into another is a consistent theme of the following chapters. Thus Manfred Kuxdorf, noting the lack of a systematic investigation into the links between dance and German literature, sets out the various philosophical and literary conceptions of the dance, outlines the various kinds of innovative dance during the period (such as the *Ausdruckstanz* of Mary Wigman) and investigates the influence of dance on the works of Wedekind, Kaiser and the young poets who published in *Der Sturm* and *Die Aktion*; Colin Rhodes considers the influence of the New German dance movement of Laban and Wigman on the later paintings of Ernst Ludwig Kirchner (an influence that gradually led him, in the late 1920s and early 30s, towards an abstracted form of Expressionism) while Erich Ranfft traces the significance which the gestures and movements of interpretative dance had for expressionist sculpture.

Doubtless the expressionists' belief in the relative unimportance of technical expertise encouraged such movement between the artistic disciplines, but there was also one notable precedent for this drawing together of the art forms into an aesthetic totality. That precedent was, of course, the music-dramas of Richard Wagner and the attendant Wagnerian concept of the *Gesamtkunstwerk* – the 'total work of art', the legacy of which is explored by Peter Vergo who demonstrates the extent to which some of the underlying concepts of Expressionism were determined by the 'creative misunderstanding' of Wagner's ideas.

It is difficult to overestimate the influence of Wagner – as an aesthetic model to be followed or consciously rejected – on the art of the late nineteenth and early twentieth centuries. In theory abstract music might, following Schopenhauer's conviction, be regarded as the medium which most lent itself to the statement of metaphysical truths: in practice it was the union of the arts into a theatrical whole that most excited the artists' interest.

Yet the true *Gesamtkunstwerk* – myth, mobilised by the aural and visual art of the stage – could, it was felt, do more than simply create a previously undreamed-of aesthetic totality. Nietzsche's promotion of the 'Dionysian' elements of Wagner's music in *The Birth of Tragedy* (1872) reinforced the belief not only in the values of instinctual expression but also in the capability of the individual to attain salvation through creative activity. The artist assumed the role of prophet in initiating an epochal rebirth, the theatre became a temple, and (as both Kandinsky's essay 'On Stage Composition', and Keith-Smith's study of Lothar Schreyer's unpublished theoretical work 'The Liberation of Stage Art' demonstrate) the stage director became a priest, whose function it was to interpret and explicate the text.

The importance of the underlying religious element in Expressionism is touched on by Erich Ranfft in his analysis of expressionist sculpture, while its political implications are highlighted in Rhys Williams's examination of the socialism of Gustav Landauer and its impact on the theatrical works of Georg Kaiser, Ernst Toller and Carl Sternheim. Such preoccupations also form the basis of Ray Furness's wide-ranging survey of expressionist theatre which suggests that what has tended to be regarded as a subsidiary aspect is in fact crucial not only to Expressionism itself but to the appreciation of the broader chronological perspective that stretches from the Wagnerian music-drama to the *Thingspiel* of Nazi Germany.

Of all the -isms of the modern period, discussions of Expressionism have most frequently obscured its genesis and development. To question the often assumed 'wildness' or 'revolutionary' status of its practitioners is at the same time to offer a salutary reminder of the paradoxes of expressionist culture. From the disputed origins and chronological and aesthetic demarcations of the term, to the lack of cohesiveness of the movement, the complexities of Expressionism invite, and no doubt will continue to invite, reassessment.

Background:
concepts, definitions and geographical centres

1

The origins of Expressionism and the notion of the *Gesamtkunstwerk*

Peter Vergo

Over the past several decades, a number of writers – among them Carl Schorske, Donald Gordon, and Reinhold Heller[1] – have underlined the importance of the Idealist tradition in nineteenth-century German philosophy for any understanding of the genesis of Expressionism, pointing especially to the works of philosophers such as Schopenhauer and Nietzsche. It is also invariably the case that somewhere along the line, in any discussion of the philosophical antecedents of Expressionism, another major influence is mentioned – that of Wagner; but these seemingly obligatory allusions are usually unaccompanied by any more detailed discussion. For while it is true that a very great deal has been written about 'Wagnerism' and its influence on the Symbolist generation, as well as its wider cultural and political influence,[2] Wagner's significance for the 1900s and after, especially in the domain of the visual arts, has by comparison gone largely unexamined. I therefore propose to consider in this paper the influence exerted by Wagnerian theory and practice, in particular the Wagnerian notion of the *Gesamtkunstwerk* (total work of art), on the artists of the expressionist generation.

In discussing Wagnerian theory, it should perhaps be observed at the outset that the composer's ideas would, at least in the opinion of the present writer, have had relatively little impact had it not been for the power of his music. Even Wagner himself, in the preface to the second edition of his treatise *Opera and Drama*, referred to what he called the 'obduracy' of his ideas; and since then author after author has pointed to the composer's convoluted language and the turgidity of his rhetoric. Michael Tanner, for example, in his contribution to that well-known anthology, *The Wagner Companion*, describes Wagner's writings as 'full of special pleading and, except when he is being practical or hits the odd inspired phrase, lacking in the astonishing energy and resource of both the man and his art'.[3] Rather, what happened – and this can be clearly demonstrated in the case of the French Symbolists, for example

– was that artists working in other media (writers, poets, painters) from the 1870s onwards were simply bowled over by the musical and dramatic effect of Wagner's operas; and then, having picked themselves up, they turned to his theoretical writings, which are of course voluminous, in search of a key which might unlock the mystery of the Wagnerian magic.

Unfortunately, Wagner's writings do not in themselves provide a very good key. His meaning is sometimes obscure and his arguments are often rambling and inconsistent, which is perhaps why so many subsequent admirers picked on the one notion that seemed relatively easy to comprehend: that of the *Gesamtkunstwerk*. Not only did they pick on it; they distorted it in ways scarcely credible, given that, in this instance at least, Wagner's own intentions were quite unambiguous. It is none the less the case that during the years around 1900, the term *Gesamtkunstwerk* was hurled around like a kind of verbal projectile, being applied to things that Wagner himself would never have conceived of, and certainly would never have sanctioned: book design and typography, interior decor and furnishing, architecture and design. The first editor of the Viennese periodical *Ver Sacrum*, Wilhelm Schölermann, described the relationship between typography and illustration, the layout of graphic material on the printed page, as creating a 'kind of *Gesamtkunstwerk*', while other writers found the same term equally appropriate in discussing, for example, the architecture and interiors of the Scottish art nouveau architect Charles Rennie Mackintosh – improbable though such a usage might seem.

Ironically, Wagner himself does not actually put that much stress on the *term Gesamtkunstwerk*, preferring, typically, more convoluted formulations such as 'Gesamtvolkskunst' or 'das Kunstwerk des Gesamtvolkes' – the 'work of art of an entire people'. He also refers repeatedly to 'das gemeinsame Kunstwerk', another term difficult to translate and which might perhaps best be rendered as 'communal art', or even 'the common artistic endeavour', the purpose of which was the expression of what Wagner calls 'der künstlerische Mensch' – artistic man:

> Artistic man can be wholly satisfied only by the unification of all forms of art in the service of the common artistic endeavour; any fragmentation of his artistic sensibilities limits his freedom, prevents him from being fully that which he is capable of being. The highest form of communal art is drama; it can exist in its full entirety only if it embraces every variety of art ... only when eye and ear mutually reinforce the impressions each receives, only then is artistic man present in all his completeness.[4]

As so often, the language used in this particular passage is somewhat opaque, but the thrust of Wagner's argument generally is quite clear. What he means by 'das gemeinsame Kunstwerk' is a new kind of art which will express the identity, the character, the cultural and mythic aspirations of an entire people, while uniting them in a common ritualistic and – in Wagner's eyes at least – religious experience. At the same time, the 'gemeinsame Kunstwerk' was to unite the different *forms* of art – the arts with a small 'a' – in the service of a higher idea, subordinating them to the overall *dramatic* purpose which, in his early writings at least, Wagner believed ruled supreme, taking precedence even over the purely musical element (hence his subsequent elaboration of the notion of 'music drama'). Fortunately, his reading of Schopenhauer at the critical moment, between his completion of the text for his tetralogy *The Ring of the Nibelung* and the composition of the music, convinced him – we might say 'just in time' – of the intrinsic supremacy of music over all other forms of art as vehicle of pure expression.

Wagner, of course, was notorious for not always practising what he preached – or rather, he rarely practised what he preached. In the case of his own operas he never actually applied the principle of the *Gesamtkunstwerk* in the kind of additive or accretive way he himself described – the piling of one art form upon another, as if the more varied the different kinds of art combined at the same time on the operatic stage, the greater would be the impact. Moreover, though he minutely specified the scenic effects he wished to achieve on the stage, he found himself obliged to leave their actual realisation in the hands of others, so that, even at Bayreuth, the scenic aspect of the staging of his operas continued as before to be left to professional stage designers. Wagner himself, in any case, had little real sensitivity to the visual arts, which perhaps goes some way towards explaining the coarse naturalism of the early Bayreuth productions – grandiose visions that were long on imagination and short on practicality and which were the frequent butt of critics and satirists.[5] Even Wagner's admirers are frequently led to confess that they perceive a strain of vulgarity, not in his music, but in his dramatic conceptions. For whatever reason, the naturalist tradition continued to dominate the Wagnerian stage throughout the remainder of the nineteenth century, and it not until well after 1900 that we encounter anywhere in Europe anything which, as regards its visual aspect, deviates in any significant way from the early Munich and Bayreuth productions.

An article such as this hardly permits further exploration of the

history of the Wagnerian stage, fascinating though that subject is. What I do want to examine is the way in which the Wagnerian notion of the *Gesamtkunstwerk* was creatively *mis*interpreted by the generation of artists who came to maturity during the years after 1900 – how it was subjected, as it were, to a series of fruitful misunderstandings. Of these misunderstandings two, in particular, were to be of profound consequence for the theory and practice of Expressionism.

First, during the early years of this century, Wagner's authority was frequently invoked in support of the idea that the various arts were growing ever closer together, that they even sprang from the same common root, and that the distinctions between them were becoming more and more irrelevant, of merely 'external' significance – a quintessentially expressionist view. In reality, Wagner had believed almost exactly the opposite: that both the character and purpose of the various forms of art were quite different. That did not bother the expressionist artists. They believed – and here once again the influence of Schopenhauerian philosophy is clearly seen – that the task of art was to give voice to an *inner* world, and that the inner experience of the artist and the inner nature of the world itself were in essence the same. Hence their disdain for everything external since it was the internal, not the external aspect of art that was important. The material differences between the different art forms were merely external; it was the inner message that was of crucial significance, and all that mattered was to choose the external form most appropriate to the inner message which it was the task of art to convey. And since 'skill' in the manipulation of a given medium was likewise a merely external attribute, the artist was at liberty to range freely from painting to poetry to musical composition – or all at the same time – no matter in which (if any) of these fields his or her formal training might have been.

In practice, what is striking is just how many expressionist artists in fact 'crossed the boundaries' which had previously divided one art form from another. Kokoschka, in addition to his pictorial work, wrote poems, plays and essays; Barlach was active both as sculptor and playwright; Kandinsky made paintings, graphics, poems, plays. His stage works afford a particularly interesting example, not least for their point of contact with the exactly contemporary experiments of Schoenberg. Kandinsky, admittedly, having little musical competence, turned to a professional composer, his compatriot Thomas von Hartmann, for the music for his play *The Yellow Sound* – just as Wagner, having no competence in the visual arts, had relied on professional stage designers. But for *The Yellow Sound* and his other

dramatic experiments – 'stage compositions', he called them – Kandinsky wrote his own texts, visualised both sets and costumes, and wrote down meticulous directions not only for the visual aspect of the staging, but also gesture, movement, expression etc. Indeed, in some dozen pages of the text of *The Yellow Sound* there are to be found no more than fifteen lines of spoken or sung dialogue. In this we may detect another obvious point of resemblance with Wagner's operas, where the obsessively detailed stage directions often rival in length the actual lines given to the dramatis personae.

There are, however, not only striking similarities between these early expressionist stage works and their Wagnerian antecedents, but also a number of important differences – differences that spring, at least in part, from a second misunderstanding of Wagner's ideas. Wagner, as we have seen, had been content to leave at least some aspects of the staging of his music-dramas in the hands of others. Regarding music-drama generally, he even stated quite specifically that the composer and the librettist, for example, need not be one and the same person (though in reality he invariably wrote the libretto for his own operas, evidently attaching great importance to every detail of the poetic and verse forms which he, in many cases, more or less invented – another instance of the frequent discrepancies between what he said and his actual practice). By contrast, if we look at the dramatic experiments created by a number of expressionist artists during the early years of the twentieth century, we find the author or composer frequently assuming a kind of tyrannical role, almost a cross between artistic dictator and master of ceremonies. The fact that such artists sought to apply what they considered to be Wagnerian ideas in a way that is actually far more literal than Wagner himself intended or practised – taking, for example, every detail of costume and decor and choreography, as well as music and libretto, into their own hands – constitutes the second of those 'fruitful misunderstandings' referred to earlier.

To focus briefly on two particular examples, the early stage works of Schoenberg – his monodrama *Erwartung*, and the opera *Die glückliche Hand* – are a case in point. For *Erwartung*, while Schoenberg himself provided a whole succession of very detailed sketches for the staging, he in fact drew on a text by an amateur writer called Marie Pappenheim, whose portrait he also painted. But in the case of *Die glückliche Hand*, usually translated as *The Lucky Hand*, Schoenberg followed what he must have regarded as Wagnerian precedent with almost slavish loyalty,[6] creating not merely the music but also the text and the set and costume designs with his own hands. Without doubt,

The Lucky Hand is, in any case, by far the most Wagnerian of all Schoenberg's stage works and contains a number of quite specific Wagnerian borrowings, most notably the moment at which the sword-brandishing hero (or anti-hero), observing workers forging diadems, seizes a hammer which he brings down with a mighty blow on an anvil which then splits in two – an undisguised allusion to the forging scene in Act I of *Siegfried*, mixed with a dash of the enslaved Nibelungen from *Rheingold* for good measure. Schoenberg's use of the chorus in *Die glückliche Hand*, six men and six women who comment mordantly on the drama, also echoes Wagner's notions concerning the role of the chorus in Greek tragedy – however misguided those may have been.

There is, however, one major point of divergence compared with Wagner's operas – a divergence which has to do with the apparent lack of stage action and virtual anonymity of the characters in Schoenberg's operatic works. *Erwartung*, in particular, is strikingly devoid of action – or does it, indeed, all happen in the mind? All we know, or are told, is that an unnamed woman is found wandering alone in a forest at night. Approximately one third of the way through this drama – if 'drama' it can be called – she stumbles across the dead body of her lover. The remaining two thirds of the work pass in a kind of waking nightmare, in which the woman reproaches the corpse for its alleged infidelities – though whether these grievances are real or imagined it is impossible to tell. And that is all: nothing else happens, merely the unbridled expression of naked emotion of the most sinister kind by an anonymous female figure, alone, somewhere in a forest, in the middle of the night.

Die glückliche Hand has, it is true, somewhat more in the way of narrative than *Erwartung*, centering as it does around a triangular relationship between a woman and two men, but their roles are no further defined than simply by their sex, and we are told nothing about their identity nor indeed about their relationship to each other, save in terms of their mutual attraction, jealousy and desire. And in both these early Schoenberg stage works, external actions and events pale into insignificance by comparison with that which they in a sense symbolise: states of mind, fears and aspirations, love, jealousy, hatred – in other words, psychological states. It is by no means coincidental that *Erwartung* has often been seen as the archetype, as well as one of the earliest examples, of pure psycho-drama. Nor is it any coincidence that in other expressionist stage works, too (Kandinsky's *The Yellow Sound*, Kokoschka's *Murderer, Hope of Women*) we find the same lack of specificity, the same disdain for merely external narrative – characters

identified merely as 'giants' or 'people in flowing garb', 'warriors' or 'maidens', without any indication of the relationship between them or indeed where or when the action might be taking place; all these 'external' details are stripped away in order to allow the inner message of the drama to sound forth more powerfully, more clearly, more unequivocally.

All this contrasts dramatically – or at least appears to do so – with Wagner's stage works, which are not only rich in both musical and visual symbolism but are also heavily dependent on narrative, in the sense that at almost every moment something quite specific is happening on the stage. We are also told in almost excessive detail about the relationship between characters, about their identities and respective roles, even their subterfuges – Wotan in the guise of the Wanderer, Freia the bringer of eternal youth, Hagen being Alberich's son and so on. This, indeed, was the burden of the criticisms levelled at Wagner by the expressionist generation, no matter how much they owed him: that his operas, with their convoluted plot and intricate symbolism, tended to remain on the level of 'merely external narrative'. Kandinsky, in his essay 'On Stage Composition' published in the epoch-making *Blaue Reiter Almanach* of 1912,[7] alludes specifically to Wagner in a not very flattering way, complaining at some length about what he sees as the composer's excessively materialistic manner of identifying the principal characters, as well as individual symbols such as sword, ring and so on, by means of the famous Wagnerian device of the *Leitmotiv*. He also caricatures what he calls the 'crude parallelism' which he sees as the dominant characteristic of Wagner's operas (heightened emotion, for example, being invariably accompanied by a crescendo in the orchestral writing) contrasting this with his own practice whereby, in order to highlight what he calls events of an *inner* character, a particular climactic moment may be 'externally' at odds with the musical or scenic material, a 'crescendo' of stage lighting being accompanied by a diminuendo in the orchestra, and so forth.

But in reality, has not Kandinsky here failed to grasp something absolutely crucial in Wagner – the disjunction between verbal and musical content? Despite the vagueness of many of Wagner's more general utterances about art, in describing his own operatic practice he made it perfectly clear that he envisaged a fundamental difference, a difference in kind between the verbal messages carried by the singing voice and the more abstract emotive content embodied in the purely orchestral writing. 'The particular genius of the human voice', wrote Wagner, 'is that it is circumscribed in character, but also specific and

clear ... it represents the human heart in all its delimitable, individual emotion.' 'In the instruments,' on the other hand, 'the primal organs of creation and nature are represented. What they articulate can never be clearly determined or stipulated because they render primal feeling itself, emergent from the chaos of the first creation when there might even have been no human beings to take it into their hearts.'[8] In other words (to paraphrase Wagner's somewhat lurid prose) while the characters are singing their hearts out on stage, the orchestra is actually carrying on its own extremely complex, convoluted and in many ways independent musical argument, unseen in the darkness of the orchestra pit.

We ourselves might add, of course, that the orchestra deals neither in concepts nor in images, but works upon our deeper emotions by means of the resources peculiar to music itself. The Wagnerian invention of the *Leitmotiv*, which Kandinsky disdainfully likened to the 'all-too-familar label on the accustomed wine bottle',[9] in fact put into the composer's hands an extraordinarily subtle and flexible means of conveying *thought* – not conscious, rational thought, but the most secret purposes and repressed emotions of which the characters themselves are at times partly unaware. Indeed, it is striking that, more than half a century before the expressionist artists launched their battle cry, their call for a new art, Wagner in his writings of the early 1850s had already clearly articulated this crucial distinction between the external and internal meanings inherent in the work of dramatic art, between conceptual reasoning and the communication of emotional states, between the rational and deductive on the one hand and the irrational, the inspirational on the other. In so doing he foreshadowed, however unwittingly, a dichotomy central to expressionist thinking as to the nature and purpose of art.

Notes

1 See Schorske, *Fin-de-Siècle Vienna*; Gordon, *Expressionism: Art and Idea;* R. Heller, *Brücke: German Expressionist Prints from the Granvil and Marcia Specks Collection*, Evanston, 1988, and the same author's *Art in Germany, 1909-1936*.
2 See D. Large and W. Weber (eds), *Wagnerism in European Culture and Politics*, London, 1984.
3 'The Total Work of Art', in P. Burbidge and R. Sutton (eds), *The Wagner Companion*, Boston and London 1979, p. 148.
4 'Das Kunstwerk der Zukunft', in W. Golther (ed.), *Richard Wagner: Gesammelte Schriften und Dichtungen in zehn Bänden*, Berlin and Leipzig, III, p. 105 (author's translation).
5 See E. Kreowski and E. Fuchs, *Richard Wagner in der Karikatur*, Berlin, 1907.
6 For an English translation of *The Lucky Hand* see Kandinsky and Schoenberg, *Letters, Pictures and Documents*, pp. 91-8.

7 Translated in Kandinsky, *Complete Writings on Art*, pp. 257-65. See also, Kandinsky and Schoenberg, *Letters, Pictures and Documents*, pp. 111-17.
8 Cited after Bryan Magee, *Aspects of Wagner*, London, 1972, p. 56.
9 Kandinsky, *Complete Writings on Art*, p. 261.

Concepts of Expressionism in Scandinavia

Marit Werenskiold

Many people today think of Edvard Munch as the great and solitary genius of Expressionism in Scandinavia. They consider him the father of German Expressionism and regard his picture *The Scream* (1893) as the very prototype of an expressionist painting (plate I). This, however, springs from a later concept.[1] In the years 1910-20, the period when Expressionism flourished, Munch was a relatively peripheral figure in the Scandinavian and German debate on Expressionism.

The first 'Expressionists' in Scandinavia were Henri Matisse and the Norwegian and Swedish pupils who attended Matisse's academy in Paris in 1908-11. From 1912 the Russian Wassily Kandinsky and his circle *Der Blaue Reiter* became known in Scandinavia as the leading expressionists on German soil. This corresponds to the pre-war concept of Expressionism in Germany where Kandinsky was regarded as the expressionist *par excellence* and as a follower of Matisse.

The term 'Expressionism' came to Scandinavia from England in early 1911 as a synonym for 'post-Impressionism' before the word appeared in Germany. Originally it meant just 'modern art', the new movement emanating from Cézanne, Van Gogh and Gauguin of which Matisse, *le roi des Fauves*, was the international leader and ideologist.[2]

Expressionism was considered an anarchistic movement, with Matisse's essay 'Notes of a Painter' of December 1908 as a declaration of its basic programme.[3] The word itself referred to Matisse's dictum: 'What I try to achieve above all is expression' and indicated the opposition of the new painters to Impressionism which was now branded as a superficial illusionist art as opposed to the deeper spiritual intuition which the new painters sought to express. The anarchistic attitude was evident in Matisse's other dictum: 'No rules exist outside the individual', a sentence which is mirrored in the multitude of 'wild' and individual styles characteristic of expressionist – or 'modern' – art.

The term 'Expressionism' was launched in the Scandinavian press by

the young art historian Carl David Moselius in the spring of 1911, in the liberal Stockholm newspaper *Dagens Nyheter*.[4] On 20 March 1911 Moselius published his article 'Expressionism and Impressionism' in which he referred to the British art critic Arthur Clutton-Brock in his proposal to replace the 'misleading' term 'post-Impressionism' with 'Expressionism' as the best name for the new, Parisian anti-impressionist movement spearheaded by Matisse.

Quoting from Matisse's 'Notes of a Painter' Moselius declared that: 'It is expression understood in its full breadth, not just the psychological, which the Expressionists substitute for the Impressionists' "impression".' Expressionism, said Moselius, is subjective, recollective art; Impressionism is objective 'perceptual art'. Like the impressionist the expressionist can also feel a spontaneous 'joy of reality' but

> for him the image of reality possesses its own inherent corrective, it sustains an inner, truer, more tranquil, more characterful, primitively simplified picture, a picture of concentrated expressiveness, and it is this that the painter must toil to achieve. It is this that has to be brought up from the unconscious in his own soul, but for this purpose more than ... a reporter's interest in it is needed.[5]

Moselius's reference to Arthur Clutton-Brock related to an article on 'The Post-Impressionists' in *The Burlington Magazine* of January 1911, in which the word 'expressionist' was introduced to the journal's international readership.[6] The article was a review of the *Burlington* editor Roger Fry's epoch-making exhibition 'Manet and the Post-Impressionists' in the Grafton Galleries in London from November 1910 to January 1911 – the first ambitious attempt at an historical survey of the new Parisian art movement that had followed and formed a reaction against Impressionism.[7]

The word 'post-Impressionism' had been coined by Fry for this occasion, as a compromise with a stubborn journalist who did not like Fry's idea of calling the exhibition 'The Expressionists'. This term had already been used in print, probably by Fry, in *The Times* of 11 July 1910 in a review called 'Modern French Pictures at Brighton'.[8] This is the earliest documented use of the word in its modern meaning, apart from a similar occurrence in a Czech text of February 1910 which probably also reflects Matisse's use of the concept 'expressionism' in 'Notes of a Painter'.[9]

The occasion for Moselius's article in *Dagens Nyheter* of 20 March 1911 was partly a sensational exhibition by Matisse's Norwegian pupil Henrik Sorensen in Stockholm in February 1911[10] and partly the third

exhibition of the Swedish group *De unga* (The Young Ones), also consisting of Matisse's pupils, that was due to be presented in the same city. Moselius regarded Sorensen as 'if not the first then, at any rate, the most advanced exponent in the Nordic countries' of the new trend, whereas he portrayed Henri Matisse as 'the most abused representative of Expressionism' in contemporary France.

In the press review of *De unga*'s third exhibition, 'Expressionism' has slipped into the critics' vocabulary as a synonym for 'post-Impressionism' in accordance with Moselius's use of the term. The exhibition was opened on 9 April 1911 in Hallin's art gallery, that is to say about the same time as the opening of the twenty-second exhibition of the Berliner *Sezession* where the term 'Expressionisten', also referring to the youngest of the radical Parisian artists, was introduced to the German public.[11]

At least thirteen of the eighteen exhibitors of *De unga*, including Isaac Grünewald, Leander Engström, Gösta Sandels and Birger Simonsson, the leader of the group, had been pupils of Matisse in Paris in the previous three years. The first exhibition had taken place in the spring of 1909 and the second in the spring of 1910, when the group had made its first breakthrough as the vanguard of the radical, French-influenced painting in Sweden.

In 1912 a new elite group, *De atta* (The Eight) or 'The Expressionists', made themselves conspicuous in Stockholm under the leadership of Grünewald and his gifted wife Sigrid Hjertén.[12] The couple soon became the 'King and Queen of the Wild' in Sweden, provoking harsh attacks from both left and right.

In Norway Matisse's pupils had been prominent at the National Autumn Exhibition in Christiania (Oslo) since 1909, when Henrik Sorensen had had a *succes de scandale* with the painting *Svartbekken* named after a notorious murderer. In November 1911 six of the Norwegians, led by Sorensen and Jean Heiberg, exhibited under the group name 'The Expressionists' in the Copenhagen Society of Art. This occurred four months before the Berlin editor and promoter of Expressionism Herwarth Walden arranged his first exhibition of 'Expressionists' in the *Sturm* gallery in Berlin in March 1912.[13]

If one disregards the German *Brücke* group's exhibition in Copenhagen in 1908,[14] which had attracted little attention, the Norwegian 'Expressionist' exhibition constituted the Danish public's first, disturbing encounter with the new French-inspired painting. The art critic in *Illustreret Tidende* gave a lively description of the exhibition:

Never before have we seen a collection of anything so utterly radical
What will primarily catch the eye of the Danish art viewer is this enormous
brightness, which rebels against one's old and grey ideas of what colour is
... then again one can be startled by the monstrous that is seemingly present
in the drawing ... if one looks around one finds that the basis for all that is
frisky, daring, presumptuous in these young paintings is an artistic serenity
which is primarily due to a great painterly mastery of composition.[15]

In January-February 1912 Matisse's Norwegian pupils were
presented to a non-Scandinavian public for the first time at the
Norwegian exhibition in the Viennese *Hagenbund*, where they and
Edvard Munch were accorded a separate room. The exhibition caused a
great stir and some scandal in the Vienna press and among the public.
Particularly negative was the reviewer of the *Neue Freie Presse* who
found the young Paris-inspired 'Expressionists' Sorensen, Heiberg and
others more rabidly radical than 'our Kokoschka and Schiele' and
possibly suffering from a mental infection.[16]

Less attention was accorded to the young Norwegian artists at the
international *Sonderbund* exhibition in Cologne in the summer of 1912
which, inspired by Roger Fry's survey of the French post-Impressionists in
London in 1910-11, constituted the first broad presentation of the
'Expressionismus' movement in Europe. Here Norway was the only
Scandinavian country invited to participate. Munch was given a large
room to himself in the German section as one of the fathers of the new
painting on a par with Cézanne, Gauguin and Van Gogh.[17]

The only living artist, apart from Munch, who shared the honour of
a separate room in Cologne in 1912 was Pablo Picasso whose brand-new
cubist works were on show in the French section. His rival Matisse was
accorded a surprisingly modest role at the exhibition, with only a
handful of paintings in one of the French rooms. Matisse's influence on
the host of international artists exhibiting was, however, strongly felt
by many of the visitors, including Munch who wrote to a friend:

Here there is naturally a great deal of Matissism and Cézanneism just as at
home Here there is a collection of the wildest that is painted in Europe –
I am quite classic and pale Cologne cathedral is shaken to its
foundations.[18]

That the forty-eight year old Munch now appeared as a 'pale classic'
and as a father figure of German Expressionism gave him a final
breakthrough with the German public, which had known and
discussed him as a genius or a sham for twenty years.

Presumably the generous representation of Munch in the German
section of the Cologne exhibition of 1912, as well as the slighting of

Matisse, was a deliberate act of art policy on the part of the organisers – an attempt to conceal, because of German nationalistic opinion, the enormous significance of the Frenchman for the flourishing of the new painting in Germany.[19]

The Cologne exhibition was in itself an important manifestation of art policy and an important contribution to the German cultural debate at the time. On the part of the organisers the exhibition must have been meant as an answer to the forceful attack made in 1911 on the supporters of the new French painting in Germany through *A Protest of German Artists* edited by Carl Vinnen. An important goal of the exhibition must have been to demonstrate that the young German painting had strong roots in the 'Germanic' artists Van Gogh and Munch as well as in the French masters and that Expressionism was an international, not just a French, art movement.

The picture the Cologne exhibition gave of Munch's relationship to the expressionist movement was, by and large, uncritically accepted by both the German and Scandinavian reviewers – a picture that could in part be justified by the fact that the *Brücke* group in Dresden in 1906-9 had shown a strong interest in Munch and had invited him to several of their exhibitions.[20] However, it was Matisse and the other French *fauves*, the 'wild men' of Paris, who had inspired Kandinsky and Franz Marc to adopt the name 'Die Wilden' for the members of the new art movement presented in the *Blaue Reiter Almanach* of 1912 – an almanac that was on sale at the Cologne exhibition and that was eagerly read as representing the new programme of Expressionism.[21]

While Kandinsky did not like Munch's pictures at Cologne, August Macke visited Munch's room 'forty times' and Ernst Ludwig Kirchner also expressed deep sympathy with Munch, whom he met at the exhibition.[22] Word of Munch's success in Cologne soon reached Scandinavia and finally led Christiania University to accept his designs for the decoration of the Festival Hall there.

In December 1913 Munch was hailed at home and abroad on the occasion of his fiftieth birthday. Writing in the Copenhagen *Politiken*, Jens Thiis, the director of the National Gallery in Christiania, commented ironically on the prevailing view of Munch in Germany:

> Now he is acclaimed and worshipped as ... the great painterly genius of the Germanic race, as the artist of line and colour above all others, as the true father of Expressionism, the visionary who once and for all has parted the mists of our time and seen the goal.[23]

Munch, however, was soon put aside in the Scandinavian and

German debate on Expressionism, obviously because his art now seemed formally conservative compared with the new trends. In Germany interest was focused on *Die Brücke* and particularly *Der Blaue Reiter* who had a touring exhibition in Scandinavia in the spring of 1914 organised by Herwarth Walden's *Der Sturm* gallery. The tour started in Christiania and continued to Helsingfors, Trondheim and Gothenburg in January–June 1914. Kandinsky took part with several abstract paintings, among them *Composition 5*, which caused a great sensation with the press and the public.[24]

In May 1914 the great Baltic Exhibition opened in Malmö, at which Sweden, Denmark, Germany, Finland and Russia presented their art and industry to each other and the world at large. In the catalogue the 'Expressionists' were consigned to a minor room in the Swedish section. The group consisted of Isaac Grünewald, Sigrid Hjertén, Leander Engström, Einar Jolin and Nils von Dardel, all of whom had taken part in *De atta*'s exhibition in 1912. The five regarded themselves as rivals to the foreign expressionists at the exhibition.[25]

Among the latter the Munich group of Russians caused the greatest stir. Here Kandinsky and Jawlensky proved to be the exhibition's main attraction. Among Kandinsky's paintings was the huge *Composition 6* which is today in the Hermitage Museum in St Petersburg, a symbolic representation of the imminent revolution.[26]

On the outbreak of war in August 1914 the festivities connected with the Baltic Exhibition came to an abrupt end. Art in neutral Scandinavia entered a new phase, cut off from its former close contact with France. At the same time, while there was a slump on the continent, the Scandinavian art market started to boom. Scandinavia therefore became an important field of interest for both French and German art-dealing, a development reflected not least in *Der Sturm*'s activities during the war.[27]

In April 1915 Herwarth Walden organised an exhibition of 'Swedish Expressionists' in the *Sturm* gallery in Berlin. Those invited to participate were Hjertén, Grünewald, Edvard Hald and Jolin, all former pupils of Matisse (see fig. 1), together with the Scandinavian artist Gösta Adrian-Nilsson. The exhibition was reviewed by several critics, among them R. L. Orchelle in the Berlin edition of the *Continental Times*:

> Those Americans who have the good fortune to be in Berlin at the present time … may now … have the pleasure, or at least the sensation, of becoming acquainted with the latest phase of the latest art. This is called Expressionism, the name under which the German and Scandinavian new school designate their works.[28]

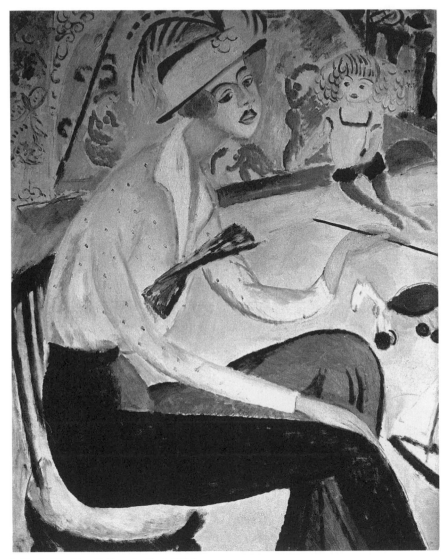

1 Sigrid Hjertén, *Self-portrait, c.* 1914

One of the great events in Swedish art during the war years was *Der Sturm*'s Kandinsky exhibition in Gummeson's art gallery in Stockholm in February 1916. Kandinsky himself paid the city a visit of about two month's duration, accompanied by Gabriele Münter who remained in Scandinavia until 1920 and became a close friend of Sigrid Hjertén and Isaac Grünewald.[29]

The climax of Expressionism in Scandinavia was reached in 1918 when Grünewald, together with Hjertén and Engström, staged a big

'Expressionist Exhibition' in Liljevalchs Konsthall in Stockholm. The exhibition catalogue contained no fewer than 526 items from the period 1908-18 and was widely discussed in the press.[30]

Much attention was also attracted by Grünewald's manifesto *The New Renaissance in Art* which was on sale at the exhibition. In the manifesto Grünewald presented himself in the third person as 'the expressionist'. He opened with Matisse's motto 'Je vais vers mon sentiment vers l'extase' and summarised his views of Expressionism in these words: 'Simplification, greatness, expressiveness, clarity – see there the watchwords of the new art'.[31]

In September 1918 Grünewald held another expressionist exhibition in Copenhagen where, together with his Norwegian friend Per Krohg, he had been particularly active during the war years as a leader and inspirer of young Danish art. It was in connection with the notorious Artists' Autumn Exhibition of 1918 that 'Expressionism' first became the great catchword in the Danish art debate. Among the most conspicuous works at the exhibition were Vilhelm Lundstrom's blasphemous cubist *Commandments* made of bits of packing cases, Jais Nielsen's *Departure!*, and William Scharff's Kandinsky-inspired compositions. The exhibitors were accused of bluff and madness by the public.[32]

On 15 January 1919, shortly after the armistice, a bombshell struck the Danish art world. The highly esteemed medical professor Carl Julius Salomonsen launched an attack on the new art in his lecture 'Infectious mental disorders before and now, with particular regard to the latest trends' which he delivered to the Danish Medical-Historical Society. The lecture on 'Dysmorphism' was soon published as a pamphlet and gave rise to a violent debate in the Danish press throughout the spring and summer of 1919. The word 'Expressionism' was now on everybody's lips as a designation for the new international movement in all branches of art.[33]

In 1920 the debate about the new art in Denmark subsided. In the spring there were rumours in the Swedish press of Isaac Grünewald's 'conversion' from Expressionism. The rumours were soon connected with German art critics' proclamation of 'the bankruptcy of Expressionism'.[34] In the following year, on the occasion of a Munch exhibition in Berlin, the collector Gustav Schiefler made a vain attempt to launch Edvard Munch as the real and genuine expressionist, in contrast to the prevailing 'Expressionismus' movement in Germany:

Here is true Expressionism, if this word should be used at all: not a frantic messing about with arbitrary forms but a capturing of spiritual sensations

in the guise of the natural appearance which, through the context it is given, is ennobled and lifted to a higher sphere.[35]

With these words Schiefler presaged the new trends of classicism and 'new sobriety' which succeeded Expressionism in both Germany and Scandinavia.

Notes

1 Werenskiold, *The Concept of Expressionism*, p. 89. In the present paper the word 'Scandinavia' is used in the strict sense of Norway, Sweden and Denmark.
2 The history of the Scandinavian concepts of Expressionism is not discussed systematically in the catalogue *Scandinavian Modernism: Painting in Denmark, Finland, Iceland, Norway and Sweden 1910-20* published by the Nordic Council of Ministers, Copenhagen, 1989.
3 H. Matisse, 'Notes d'un peintre', *La Grande Revue*, 25 December 1908, pp. 731-45.
4 C. Moselius, 'Impressionism och expressionism', *Dagens Nyheter*, 20 March 1911, p. 6.
5 Werenskiold, *The Concept of Expressionism*, p. 96.
6 A. Clutton-Brock, 'The Post-Impressionists', *The Burlington Magazine*, 18 January 1911, pp. 216-19.
7 Werenskiold, *The Concept of Expressionism*, pp. 13-14.
8 *Ibid.*, pp. 14-15, 215-19.
9 Gordon, *Expressionism: Art and Idea*, p. 175.
10 M. Werenskiold, *De norske Matisse-elevene: Laeretid og gjennombrudd 1908-14*, Oslo 1972, pp. 85-9.
11 Werenskiold, *The Concept of Expressionism*, pp. 5-6, 96. On the Berlin exhibition see R. Mannheim, 'Expressionismus – Zur Entstehung eines kunsthistorischen Stil- und Periodenbegriffes', *Zeitschrift für Kunstgeschichte*, XLIX, 1986, pp. 78ff.
12 *De atta* consisted of seven artists: Grünewald, Hjertén, Leander Engström, Einar Jolin, Gösta Sandels, Nils von Dardel and Tor Bjurström. Werenskiold, *The Concept of Expressionism*, p. 101.
13 Werenskiold, *De norske Matisse-elevene*, pp. 77-82, 98-9; Werenskiold, *The Concept of Expressionism*, p. 37-8, 97-8.
14 M. Werenskiold, 'Die Brücke in Skandinavien: Zwei Austellungen in Kopenhagen und Christiania 1908', *Brücke-Archiv* VII, Berlin 1974, pp. 3-21; M. Werenskiold, 'Fra Kirchner til Kandinsky. Die Brücke og Der Blaue Reiter i Kristiania 1908-16', *Kunst og Kultur*, LXXII, 1989. pp. 137-55.
15 U. C., 'Ung norsk Kunst', *Illustreret Tidende*, 12 November 1911.
16 Werenskiold, *De norske Matisse-elevene*, pp. 103-4.
17 Werenskiold, *The Concept of Expressionism*, pp. 6, 38-9, 94-8, 100, 136-8.
18 Letter from Edvard Munch to Jappe Nilssen, *ibid.*, p. 138.
19 *Ibid.*, pp. 39-40.
20 M. Werenskiold, 'Die Brücke und Edvard Munch', *Zeitschrift des deutschen Vereins für Kunstwissenschaft*, XXVIII, 1974, pp. 140-52.
21 Werenskiold, *The Concept of Expressionism*, pp. 45, 100.
22 *Ibid.*, p. 138. Werenskiold, 'Die Brücke in Skandinavien'. p. 152, note 47.
23 J. Thiis, 'Edvard Munch', *Politikens Kronik*, 13 December 1913.
24 Werenskiold, 'Fra Kirchner til Kandinsky', pp. 139-45.
25 Werenskiold, *The Concept of Expressionism*, pp. 107-9.
26 *Ibid.*, pp. 108-9. On this interpretation of *Composition 6*, 1913, see M.

Werenskiold, 'Kandinsky's Moscow', *Art in America*, March 1989, pp. 96-111.

27 M. Werenskiold, 'Herwarth Walden: Ekspresjonismens apostel i Skandinavia 1912-1923', *Kunst og Kultur*, LXIII, 1980, pp. 143-58.

28 Werenskiold, *The Concept of Expressionism*, p. 112.

29 *Ibid.*, p. 115. Kandinsky and Münter also exhibited in Christiania in May-June 1916.

30 Werenskiold, *The Concept of Expressionism*, p. 120.

31 *Ibid.*, pp. 120-7.

32 *Ibid.*, pp. 156-9.

33 *Ibid.*, p. 160.

34 *Ibid.*, p. 129.

35 G. Schiefler, 'Edvard Munchs neuere Graphik', *Das Kunstblatt*, V/3, 1921, p. 74.

Expressionism in exile in Great Britain

J. M. Ritchie

It would be easy to show that Expressionism was an exotic movement which, however widespread in German-speaking countries, had little or no effect on insular, conservative Great Britain. Attempts have been made to demonstrate that, in fact, this is not true and that, for example, in the theatre, there were some interesting experiments, which as Robert Graves put it, 'did temporarily raise the mental age of the average theatre-goer from 14 to 17.'[1] There was no cabaret in England and cabaret had been one of the theatrical preoccupations of the German Expressionists. The single attempt to open one after the First World War was banned in accordance with the Defence of the Realm Act. Fortunately Ireland came to the rescue of the British theatre, for example, with Sean O'Casey, whose early melodramatic plays seemed strangely expressionistic when compared with the genteel repertoire of the contemporary British theatre. Fortunately too, some English intellectuals did at this time make their way to Berlin instead of Paris (e.g. Auden and Isherwood), and from there brought back their awareness of German Expressionism and exposed the British public to it in plays like *The Dog beneath the Skin* which followed the new revue-type structure and even attempted to reproduce the essence of avant-garde expressionistic cabaret with songs like 'Rhondda Moon' followed by an anti-Art sketch in which Destructive Desmond destroys a Rembrandt before the eyes of a delighted audience.

Of course, even without Auden and Isherwood there were also other intellectuals and theatre aficionados who were fascinated by German theatre and who also knew enough German to translate the new works and introduce them into the English repertoire. I am thinking particularly of Ashley Dukes.[2] If Expressionism did reach the English stage then it was largely thanks to him. He translated Georg Kaiser's play *From Morning till Midnight* and made it into the success of the little theatre movement. In 1922 he was in Germany again and saw the great Karl Heinz Martin production of Toller's *Machine Wreckers* and was overwhelmed by the play and the staging. He visited Toller in prison and received permission to translate not only the *Machine Wreckers* but

also that author's prison diary *The Swallow Book*.

Expressionism in Germany was no tiny avant-garde coterie of which the general public could remain blissfully unaware – it was a vast movement involving the most famous names and as far as the theatre was concerned, the most famous actors and the most elaborate and expensive productions. This could never be the case in the English theatre, and Ashley Dukes's successes with Kaiser and Toller were small-scale compared with exposure first-hand to the excitement of the real thing. Nevertheless Expressionism did come to Britain in translation.

The same applies to the expressionist poets and writers. Here again as with the little theatre movement, one has to turn to the little magazine movement and remarkably it emerges that Expressionism did come to Britain especially through the agency of one man, Eugene Jolas, and one little magazine *transition*.[3] Looking through this journal for the late 1920s one discovers translations of many of the leading expressionist poets, including René Schickele, the poet of pacifism, Else Lasker-Schüler, the bohemian poetess, Georg Trakl, and August Stramm, the inventor of the extreme expressionistic telegram-style. Even more remarkable is the fact that Jolas also published translations of experimental expressionistic prose, not only of Gottfried Benn but also Carl Einstein, an extremely difficult experimenter whom only the most strong-minded of university teachers of Expressionism in this country will even attempt to understand. It goes without saying that expressionist drama is also represented, this time by the mannered Expressionism of Carl Sternheim, whose play *The Knickers* serialised in *transition* is still a hit wherever it is performed. These are names the British public may still not be too familiar with, but what about Kurt Schwitters, or Kafka, who are also included in *transition*? All this may have been known to a small public, but that small public was reading James Joyce's *Finnegans Wake* as it was published in *transition* as 'Work in Progress', and was also reading Joyce alongside explanatory essays about Expressionism and these translations of Gottfried Benn, Carl Einstein, Kafka, Sternheim and others.

So far the focus has been on the limited extent to which Expressionism made its way across the channel by way of translation, the little theatre movement, and little magazines like *transition*. All this was very small-scale. With the rise of National Socialism this was to change dramatically and drastically. After a short honeymoon period, in which it seemed that Expressionism would prove as acceptable to the new leaders as Futurism did to the Italian fascists, Expressionism was denounced and a new creed of Blood and Soil proclaimed. Very few

writers, artists and intellectuals became Nazis and remained Nazis. Hanns Johst, the Expressionist who was the originator of the phrase 'Every time I hear the word culture, I make my revolver ready' in his Nazi play *Schlageter*, rose to the highest office in the land.[4] Gottfried Benn who welcomed the National Socialist uprising, emigrated into the Army. Hundreds and thousands of others were forced into real emigration and exile, some to die there like Kurt Schwitters who had been among the Expressionists and Dadaists in *transition*. Kurt Schwitters died not far from Manchester in the Lake District.[5]

But who else took Expressionism with them into exile in this country? Georg Kaiser went into exile and died in Switzerland. Toller, an anti-fascist and anti-Nazi from the very beginning, also went into exile and spent a considerable amount of time in Britain, where his plays were performed and his presence and fiery rhetoric acclaimed. He was very much a high-visibility exile.

Carl Sternheim was not so well known, though his play *The Knickers*, as has been mentioned, was translated. And Ashley Dukes had had great success with another of Sternheim's plays, *Die Marquise von Arcis*, in which Vivien Leigh made her startling debut. Heartened by this, Sternheim decided to settle in England, but the move was not a success and he returned to Belgium. But Toller and Sternheim were by no means the only dramatists from the expressionist generation to seek asylum on these shores.[6]

Walter Hasenclever had made his name as one of the fieriest of the new-wave dramatists with his drama of father-son conflict *Der Sohn*. He knew England well, had studied in Oxford, and was keen to see his plays performed in this country. Coming across to London regularly from France, Hasenclever saw three productions of his plays, one of them indeed in the professional hands of John Gielgud, but he failed to make the breakthrough in Britain and he died in exile in France.

Far more successful, especially in the field of comedy, was Bruno Frank, but the greatest success of all was to fall to the most successful of the survivors of the expressionist generation in exile, Franz Werfel, whose *Jacobowsky and the Colonel* was to be the greatest of all exile theatrical successes both in this country and in America.[7]

What is truly remarkable about the theatre history of this period is that there seems to have been no anti-German feeling. Hasenclever, Toller, Zuckmayer (who was working on films for Korda) were all able to come to Britain and have their plays performed. This also applied to the producers like Reinhardt himself, Jessner, Erich Stern, Rudolf Bernauer, Caspar Neher, some of whom had been associated with the

most successful of expressionistic theatrical experiments. All seem to have been accepted and to have been able to bring their art to the British theatre. Needless to say the same seems to have applied to expressionist actors and actresses. The only thing capable of stopping a successful career on the British stage or in British films seems to have been a German accent, though some actors like Conrad Veidt and Peter Lorre turned even this into a springboard to success. Fritz Kortner, who has been described as 'the incarnation of the German expressionist actor' was in England for nearly four years. 'My reputation as an actor was sufficient', he wrote in his memoirs, 'to bring me my first film part, but between my profession and me stood the English language. ... I, always striving to achieve the utmost expressiveness, was expected to renounce it.'[8]

From a starting-point which indicated that Expressionism was a remote movement in a foreign country which could have little impact or influence on an island culture like that of the British Isles, it begins therefore to look as if, first by means of translations, and then by means of actual physical transfer, Expressionism *did* come to this country. And yet, of course, one has to admit that the cultural transfer is patchy and uneven. Not all the poets were known, not all the dramatists were translated and certainly not all of them came to this country. And not all the arts are equally distributed. Opera, for example, had been one of the arts exposed to the most radical of modernisation processes in Weimar Germany. Yet, although radical works like Stramm's *Sancta Susanna* had early been translated into English, the operatic version was not something the British public of the time was exposed to. Opera in Britain became German through the German take-over and development of Glyndebourne, but opera there was that of Mozart and not of Schoenberg.

Perhaps the most successful of all the cultural transfers of this period was in the sphere not of music and opera, but of dance.[10] Expressive, expressionist dance had been one of the greatest of all the developments associated with Expressionism. Breaking with the conventions of classical ballet a whole new art form had developed, which was lost to Germany when leading figures like Rudolf Laban and Kurt Joos were forced to abandon the great theatres of Germany and Austria for an uncertain future in England. For Laban, it must have meant a great wrench to move from orchestrating the mass dance figures of the German Olympics to holding dance classes in a small college in rural England at Dartington. Yet he and Sigurd Leeder and Kurt Jooss were to transform the whole of dance culture in this country.

What of the other arts? What of the painters? Immediately after the Nazi take-over on 30 January 1933 action was taken against those not well disposed to the new regime. Those employed as teachers at schools and academies were removed, like Oskar Kokoschka in Dresden. 'Horror chambers' denouncing modern art movements like Expressionism were set up in public art galleries. Not surprisingly artists fled – Kurt Schwitters first to Norway, and then to England, Oskar Kokoschka to Czechoslovakia, where an Oskar Kokoschka Association was founded in his name, but without his membership. Kokoschka replied to the Nazi exhibition of 'Decadent Art', focusing on himself and fellow-expressionists, with a self-portrait of himself as a decadent artist. This picture he exhibited in July 1938 in London at the Twentieth Century German Art Exhibition.[11] It was the first of many such explicitly political anti-fascist pictures he, the expressionist artist, was to paint. Like Heinrich Mann and Thomas Mann, Kokoschka had been given a Czech passport, a passport being in times of exile the most precious possession one could have. So Kokoschka, followed by the members of the Czech Oskar Kokoschka Association and 350 Communists, made his way to England and helped found the influential Free German League of Culture.[12]

The most famous of the visionary expressionists to come to England outside this group was Ludwig Meidner, but he who came later – like those who came earlier – was to discover that expressionist art of their kind was unknown in England.[13] Their work was not appreciated, indeed it was often rejected, as the reception of the above-mentioned Exhibition of Twentieth Century German Art in some quarters demonstrated. Kokoschka himself, however, remained a prominent figure through proclamations, publications, pictures and speeches. He also attracted pupils like Georg Eisler.

The architects who came over enjoyed greater acceptance than the artists. Marcel Breuer and Walter Gropius were in England from 1934 to 1937, a comparatively short time, before they moved on to America, where Gropius founded the New Bauhaus in Chicago in 1937, but while they were in London Gropius and Breuer, in association with the English architect Jack Pritchard, built the Lawn Road Flats, and designed furniture for Isokon Furniture, including Marcel Breuer's now famous standard chair. Moholy-Nagy was also in England at this time and is now remembered most for the light sculptures in the film *The Shape of Things to Come*; in fact it could be argued that the greatest public impact of Expressionism in exile came about through the new art of photography and with it the medium of film. Indeed, as John

Willett has pointed out, one of the most prominent figures of the Expressionist movement, the man who introduced the expressionist poet Georg Heym to *Der Neue Club* namely Simon Ghuttmann, ended his days in exile in London, where for many years he ran a photo agency.[14] In fact he was still alive until very recently, demonstrating not only that Expressionism was alive and well in London but also remarkably effective. Even more remarkably, Simon Ghuttmann was not the only member of *Der Neue Club* to find safety in exile in this country. Rudolf Majut came to England and lived in Leicester, where he was associated with the University's German Department; indeed Leicester, with its special collections, was to become a mini-centre for expressionist art.[15] Kurt Hiller, who had been one of the first of his generation of artists and writers to be arrested by the Gestapo, lived in London for fifteen years. The expressionist writer with the curious name Koffka (not to be confused with Kafka), another member of *Der Neue Club*, also ended up in exile in London and used the power of his words not for the banned and banished expressionist journals, but for the exile London newspaper *Die Zeitung* and for the BBC.

Strangely enough, if one looks for the hidden influence of Expressionism in exile in this country, one comes again and again to the BBC which was to provide a home, employment and the opportunity of directing their linguistic and other skills against the Germany which had denounced Expressionism as degenerate and decadent and forced these artists into exile. Not only Friedrich Koffka worked for the BBC, but also the Expressionist Hans Flesch-Brunningen, who came to London in 1934; he was the spokesman and commentator for the Austrian section of the BBC, and also President of the PEN centre for German writers abroad. Even more significant was Karl Otten, who came to England via Spain in 1933 and went blind in London in 1944. Karl Otten wrote 120 radio broadcasts for the BBC. He is famous, not only as an Expressionist himself, but as the man who through his anthologies of expressionist poetry and drama made Expressionism available to a German public which had been forcibly deprived of it by years of Nazi censorship and banning.

Perhaps the most remarkable aspect of Expressionism in exile in this country is not the fact that so many Expressionists were actually here and for so long, but that there should be so much poetic activity. The poets after all included Max Herrmann-Neisse who emigrated to England via Switzerland and Holland in 1933. He was not happy here but two volumes of his poetry were first published in Britain during the war, in German, in 1941 and 1942. Sylvia von Harden, whose portrait

by Otto Dix has recently been admired by thousands of visitors to the Tate Gallery, came to this country in 1933 and died near London in 1964. Elisabeth Janstein died here in 1944. One poetess from the Expressionist generation, Henriette Hardenberg, is still alive, still writing poetry in London. She has been rediscovered, reprinted and feted as the remarkable survivor from a lost generation. German Expressionism in exile is not dead. It is still alive and living in London.

The question remains, however, as to how much influence or impact all these figures had. John Willett argues that they had little or none, that England was not ready for Expressionism and of course he is right. Modern Art came from France, not from Germany. Paris was the place, not Berlin or Vienna. English people had learned French at school, not German, and so on. But at the same time he is wrong. For one thing, for Germans to come to England was not new, Germans had been coming to England for a long time – there was a German Colony in London in the nineteenth century – so, to a certain extent, Germans, Austrians and Czechs arriving in London as a result of Nazi oppression were not a new phenomenon.[16] There was a German-speaking community to receive them and new organisations were quickly set up where necessary. The Free German League of Culture, of which Oskar Kokoschka became a President, was not an insignificant little club. It had an artists section, an actors section, its own theatre, restaurant etc, and a wide-ranging spectrum of activities. There had been an Oskar Kokoschka Association in Prague, and when its members arrived in London they became the new heart of the artists section.

Apart from the Free German League of Culture (which was admittedly a Communist Front Organisation), there was also an Austrian Centre. It was even bigger, had by the end around 7,000 members, its own theatre and an even better restaurant. Then there were the Sudeten Germans, who of course had their own organisation centred on the Rudolf Fuchs House. Rudolf Fuchs, himself an Expressionist, emigrated to London in 1939 and died there three years later. Two volumes of his poetry were published in German at the time, the first *Gedichte aus Reigate* (London 1941), the second posthumously *Ein wissender Soldat* (London 1943). John Willett makes the point that there were no German publishers in England as there had been for example in the Netherlands. Nevertheless, books were published in German in London, in wartime, including books by Expressionists. They may not have had an immediate impact, but who expects difficult, avant-garde work always to have an immediate impact? Besides – it is not true to say that there were no German publishers in

this country. Of course there were − not necessarily publishing only expressionist works, but certainly publishing. Kurt Eulenburg was a music publisher taken over by Schott & Co.; Ludwig Goldscheider the art publisher was with Phaidon, which was originally German; Otto Haas was a music publisher and antiquarian. Jakob Hegner, the famous Dresden publisher, was in London; K.-L. Maschler founded the Lincolns Prager Publishing Company. Walter Neurath founded Thames and Hudson, whose influence was to extend from the Thames to the Hudson River. Publishing in fact became a German take-over zone. *Picture Post* and *Lilliput* were essentially German thanks to Stefan Lorant and Kurt Hutton. John Heartfield worked for Hamish Hamilton, Hans Peter Schmoller designed books for Penguin; Peter Szolnay worked for Heinemanns; Jan Tschichold was typographer and art director for Penguin.

And where would all this be without Vicky (alias Viktor Weisz), Richard Ziegler and Walter Trier doing their anti-Nazi cartoons and drawings?[17] They were not all expressionists or anything like it, but they did come from the German, Austrian, Czech literary and aesthetic ambience of Expressionism. And there were plenty of books about Expressionism by exiles and others − Richard Samuel on German life, literature and the theatre, Bihalji-Merin's Pelican Special on *Modern German Art* and Pevsner's *Pioneers of the Modern Movement* tracing the development of modern architecture and design from William Morris to the Bauhaus.[18]

Where does that leave us with the question of Expressionism in exile in this country? First of all we are talking about exile, not voluntary emigration; we are talking about writers and artists who were being forced to leave their own country and settle elsewhere. Exile was difficult and distressing for everybody and it was not to be expected that they would all be happy and successful. Max Herrmann-Neisse was very unhappy, Ludwig Meidner was far from successful.

We are, however, also talking about a mass exodus of culture, not about an isolated or individual experience. Hence even for Great Britain, which was not the exile land of first choice for many (the danger of invasion and capture was still too great) the numbers are large. In his bibliography of German Expressionism in the United Kingdom and Ireland Brian Keith-Smith lists over fifty names,[19] Paul Raabe, in his bibliography of authors and books of literary Expressionism, lists those who died here.[20] But Henriette Hardenberg is alive at the time of writing; Expressionism is not a thing of the past. And despite what John Willett and others have written, Expressionism did settle here and put down roots.

The United Kingdom is rightly recognised as a traditional home for exiles, and those who chose to remain here and not move on did find a home here. They were welcomed by the settlers from previous generations. The clubs they set up to look after their interests became the largest and most effective in the world. The Free German League of Culture, of which Oskar Kokoschka was an effective President, had an influence far beyond the narrow range of exile politics into art, literature, theatre, music and publishing. The Artist Section alone had over 100 members. The exhibitions which were mounted through the Artists International Association travelled to the major cities of Great Britain. During the war London had three German-language theatres. New York had none. German books were published, including the works of German and Austrian poets. German plays were performed both in English and in German.

In this connection it is perhaps permissible to conclude by complimenting Manchester on the part it had to play in helping to promote the work of expressionists in exile like Ernst Toller. Toller was exceptionally popular in this country in the 1920s and 1930s with left-wing drama groups. He was the outstanding dramatist of the expressionist generation, had been an active politician imprisoned for his revolutionary beliefs, and expressed these beliefs in a new dramatic form and a new dramatic language, which perhaps had a particular appeal in this country because a play like *Machine Wreckers* was based so closely on English history. In exile in England Toller became in addition the most powerful of speakers against National Socialism on platforms around the country. As a speaker and as a dramatist he had some of his greatest successes in Manchester. His *Draw the Fires* was performed at the Manchester Repertory Theatre 11-23 February 1934; *The Blind Goddess* at the same theatre 3-8 June 1935; his anti-Nazi play *Pastor Hall* again in this theatre 20 November-2 December 1939. Toller's fame had reached its height in England with the publication in 1935 of his collected plays, including his play on *Mary Baker Eddy*, which to this day exists only in the English version. *Draw the Fires* was published separately and provided with music by Hanns Eisler for the production by the Manchester Repertory Theatre. For the first and only time Toller himself acted as producer in England. This was no little play with a limited cast, but one which demanded mass scenes. The press, including the *Manchester Guardian*, *The Times* and other national newspapers were enthusiastic, and the run of the play had to be extended. The first night of Toller's historical play was indeed so successful that the *Manchester Guardian* was able to report a larger

audience to the Manchester Repertory Theatre than ever before on a Monday – not forgetting *Love on the Dole*.[21] That a play by a notorious Expressionist could attract a bigger audience in Manchester than a notoriously non-expressionistic play like *Love on the Dole* surely says a great deal about Expressionism in exile in this country.

Notes

1 J. M. Ritchie, 'German theatre between the wars and the genteel tradition', *Modern Drama*, Kansas, 1965, pp. 363-74.

2 J. M. Ritchie, 'Ashley Dukes and the German theatre between the wars' in *Affinities: Essays in Memory of O. Wolff*, R. Last (ed.), London, 1971, pp. 97-109.

3 J. M. Ritchie, 'Translations of the German Expressionists in Eugene Jolas's Journal *transition'*, *Oxford German Studies*, VIII, 1973-74, pp. 149-58.

4 J. M. Ritchie, 'Johst's *Schlageter* and the end of the Weimar Republic', in *Weimar Germany – Writers and Politics*, G. Bartram and A. Waine (eds), London, 1982, pp. 160-74.

5 *Kurt Schwitters in exile: the late work, 1937-1948,* exhibition catalogue, Marlborough Fine Art, London, 1981.

6 J. M. Ritchie, 'Theater in Exil im Grossbritannien', *Exil – Sonderband* II, 1991, pp. 63-79.

7 J. M. Ritchie, 'The many faces of Jacobowsky', in *Franz Werfel: An Austrian Writer Reassessed*, L. Huber (ed.), Oxford, 1989, pp. 193-210.

8 J. Spalek and J. Strelka, *Deutschsprachige Exilliteratur seit 1933: New York*, parts 1 and 2, Berne and Munich, 1989, p. 1149.

9 E. Levi, 'Carl Ebert, Glyndebourne and the Regeneration of British Opera', in *Theatre and Film in Exile*, G. Berghaus (ed.), London, 1989, pp. 179-88.

10 V. Preston-Dunlop, 'Rudolf Laban and Kurt Joos in Exile. Their Relationship and Diverse Influence on Dance in Great Britain', in *Theatre and Film in Exile*, pp. 167-78.

11 C. Frowein, 'The Exhibition of 20th Century German Art in London 1938. Eine Antwort auf die Ausstellung "Entartete Kunst" in München 1937', *Exilforschung*, II, 1984, pp. 212-37.

12 'Oskar Kokoschka im Exil in der Tschechoslowakei und in Grossbritannien', in W. Haftmann, *Verfemte Kunst*, Cologne, 1986.

13 T. Grochowiak, *Ludwig Meidner*, Recklinghausen, 1966.

14 J. Willett, in *Exile in Great Britain: Refugees from Hitler's Germany*, Leamington Spa and New Jersey, 1984.

15 *The Expressionist Revolution in German Art 1871-1933*, catalogue to the permanent collection of Leicestershire Museums and Art Gallery, 1978.

16 R. Ashton, *Little Germany: Exile and Asylum in Victorian England*, Oxford, 1986.

17 R. Davies and L. Ottaway, *Vicky*, London, 1987, p. 197.

18 R. Samuel and R. Hinton Thomas, *Expressionism in German Life, Literature and the Theatre 1910-1942*, Cambridge, 1939 (new edn Philadelphia 1971); P. Thoene (alias Bihalji-Merin), *Modern German Art*, London, 1938; N. Pevsner, *Pioneers of the Modern Movement from William Morris to Walter Gropius*, London, 1936.

19 B. Keith-Smith, *German Expressionism in the United Kingdom and Ireland*, Bristol, 1986.

20 P. Raabe, *Die Autoren und Bücher des Expressionismus: Ein bibliographisches Handbuch*, Stuttgart, 1985.

21 *Manchester Guardian*, Wednesday 13 February 1935.

Expressionism: a health warning

David Elliott

What does Expressionism mean to you?

Considering the dismal historical events with which it has been associated, is it really worthy of celebration or should it, rather, be issued with a health warning to be taken only by adolescent males in darkened rooms, and then in extremely small doses? We should also remember that Expressionism does not end with the aftermath of the First World War: how should its reappearance in both the German Democratic and Federal Republics during the 1960s be regarded? Was it a picturesque, and possibly threatening, reversion to national traditions which were previously out of bounds? Or, conversely, could it be viewed as a unique and positive contribution to the mainstream of modern European culture?

There are, of course, no simple answers to these questions and the reader should be warned that my response is articulated by a revision-ist view of the cultural history of the twentieth century rather than by 'objective' codifications of the aesthetic qualities of individual works of art.

But firstly, there is the problem of defining Expressionism itself; in what sense could it be said even to have existed? Never a homogeneous style, Expressionism was the result of a compendium of influences and ideas, which achieved coherence out of a common cultural experience and state of mind. It was, in brief, a conflation, some may say a confusion, of art and life. In the visual arts in particular, the formal grammar by which it is typified is uniformly derived from other sources: from the work of recognised precursors.such as Van Gogh, Gauguin, Munch and Ensor, from African and Polynesian sculpture, from the art and architecture of the Middle Ages, from the wild colours of the Fauves, from the faceted planes of the Cubists; from the dynamic force lines of the Futurists. Wassily Kandinsky, a Russian working in Munich, was one of the few real innovators.

Unlike other Modernist art movements, in which it was axiomatic that invention was a fundamental part of their meaning and signifi-cance, Expressionism had no formal programme. In spite of its name it is distinguished by content. When an archaeologist or historian begins,

in some imaginary future, to sift through the charred artefacts and cultures of long dead European civilisations, he or she may question whether it even existed.[1] Expressionism was primarily a specific grouping of ideas and attitudes; both are by their nature immaterial and may find many different forms of artistic expression.

In what must be, in the space available, an inevitably superficial analysis of complex relationships, two concepts, those of *Zeitgeist* and *Kultur*, which do not have direct equivalents in the English language, have first to be understood. The English term 'spirit of the time' does not capture the optimistic charge of cultural predestination which contributed to the meaning of *Zeitgeist* when the term was first coined in Germany, Switzerland and Austria during the 1860s. The German state had only recently been unified under the force of arms of the Prussian monarchy. The industrial, scientific and economic revolutions which were then taking place were regarded by positivist historians as part of the immutable march of progress which unification and development had brought in its path. The old Empires of Austria, France and Russia had seen their day; a new Europe was being born.

The concept of *Kultur* was developed to fit in with this new reality; the word had none of the bolt-on, take it or leave it connotations of the English word 'culture', but described a fundamental sense of being shared by German-speaking peoples. In the late nineteenth century this word too began to be associated with the historical destiny of groups who had previously been isolated but who could now see that they were bound together in a common state, soil and blood. In this sense the idea of *Kultur* could prove to be more of a liability than an asset in the newly unified Germany of the 1990s.[2]

The social revolutionaries of Marx, the tragic Superheroes of Nietzsche, and the alienated neurotics whose creative impulses were articulated by Freud, were three identifiably Germanic elements which flowed together in the broad stream of cultural opposition, which as the nineteenth century approachèd its end, spread throughout Europe in the new phenomenon of the cultural avant-garde.

The generation which reached maturity at the beginning of the twentieth century believed that their fathers had worshipped the Golden Calf of materialist progress; that the old cultures of Europe were either dying or dead and that a social and scientific dawn lay just below the horizon. Karl Ernst Osthaus, art collector and patron, saw art as a social palliative and force for improvement; he regarded

> the nineteenth century [as] the century of specialisation. Through speciali-
> sation a void has come about in the world. Each person sits on his own

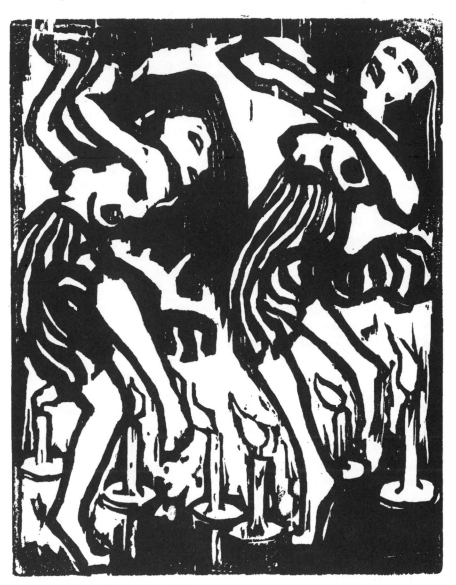

2 Emil Nolde, *Candle Dancers*, 1917

branch and has no idea of the whole tree. Here is where art must come in and act as an intermediary, uniting and unleashing productive forces, and it must saturate every aspect of work.[3]

Some artists like Ludwig Meidner, Franz Marc and Max Beckmann, or writers such as Jakob van Hoddis, Georg Trakl and August Stramm, felt that the time for gradualism had passed. Projecting their individual anxieties on to society as a whole, they thought that the forest was

already ablaze and the apocalypse at hand. Other artists (and this reaction was not confined only to Germany) cheerfully welcomed the outbreak of the First World War in the optimistic belief that destruction would cut away dead wood to provide light and space for the new.

Messianic and utopian tendencies had, from the 1890s, been fashionable throughout European society. In Germany in particular these combined nationalism with the spiritual need to return to basics in the notion of *Geist*, or spirit, which held within its cultural portfolio the sense of a mystical identification with the racial destiny of the German or Northern races. Art without *Geist* was almost a contradiction in terms.[4] The ornaments of civilisation had to be stripped away to expose the hidden substance of *Geist* beneath.

At a more popular level the growth of Naturism, youth organisations and the cult of the body beautiful were, from the 1890s at a time of expanding population and burgeoning industry, also part of a widespread and deeply felt need for essential values, coherent identity and authentic feeling. The dichotomy and pathetic distance between the untrammelled freedom of nature and the seductive alienation of the city – the ethics-free-zone between what Nietzsche would have described as the 'dreams and illusions' of the Apollonian creative impulse and the 'intoxication' and orgiastic excess of the Dionysian – lies at the heart of Expressionism (fig. 2).

Such a contrast may be seen in the life cycle of *Die Brücke*, the first group of young expressionist artists in Germany: from 1905, in Dresden and at the Moritzburg lakes nearby, these artists collided art with cosmic reality by painting with all the uncorrupted and amoral nobility of 'savages' (plate II). Gauguin's exotic and primitivist dream had been transposed to Saxony: the warrior, the amazon, the gipsy, the nomad, the mask, the god, the maker were its new Apollonian expression.

The idyll was not to last. By 1911 most of the group had moved north to Berlin and hardened cynicism was added to their earlier naivety. Still struggling to make a living, they experienced as well as depicted the alienation of the great Metropolis, exaggerating and empathising with its vertiginous perspectives. The bar, the café, the brothel, the tart, the madman, the firm but forgiving father, the prodigal but repentant son, the artist and the victim became the Dionysian archetypes of Expressionism.

At the beginning of the war in 1914, the social philosophy of Expressionism, rooted as it was in German Idealist philosophy, was relatively untrammelled by concrete political theory. Artistic communes such as *Die Brücke* in Dresden or *Barkenhof* in Worpswede

aspired to the condition not of revolutionary cells but of medieval craft guilds. This kind of Socialism, if it can be called that, paid its dues to William Morris rather than to Marx, and looked back, rather than forward, to an imagined pre-capitalist Golden Age of rude truths and social harmony.

By the end of the war such fantasies could no longer be sustained. Unconditional surrender, the demoralising effect of the war itself, the Revolution in Russia, the collapse of the German and Austrian Empires and ensuing hyper-inflation had radicalised *Kultur*. The Dadaists and *Novembergruppe* in Berlin, the short-lived Soviets in Munich and elsewhere – all imagined their own revolutionary utopias. But this period of euphoria did not last; within two years the hard realities of survival in the unstable and politically compromised Republic had made an irreversible impact. The old expressionist icons of the wounded hero or the suicidal poet followed the logic of their own significance and died. A new laconic realism – no less alienated than that of Expressionism, but less inclined to contemplate its cosmic navel – became the dominant cultural trend.

The utopias and apocalypses – real and imagined – of pre-war Expressionism were, during the 1920s, subsumed in the dramatic polarisation of German society and politics. Popularist and authoritarian visions of society were held by both Right and Left. At one extreme was the racially pure vision of the historic destiny of the German *Volk*; at the other was the collectivist dream of Communist World Government under the Third International. Artists now had to decide where they stood in this battle of ideologies and to what extent their art could be enlisted in the service of any one cause. It was not long before the force of this conflict made any case for independent artistic integrity seem utopian and irrelevant to the *Zeitgeist* – the greater community of historically determined attitudes and ideas.

Not surprisingly, the historiography of Expressionism has been as confused as the phenomenon itself and in the schism of Germany into East and West after the war became polarised between left and right. Marxist critic Georg Lukács in his essay 'The Rise and Fall of Expressionism' was one of the first to identify the anti-intellectual, *volkisch*, and God-building characteristics of Expressionism with the excesses of National Socialism. This was written in 1934, at the very time when the National Socialists themselves had decided that Expressionism's Modernist stance effectively debarred it from being a widely intelligible, and therefore authentic, expression of the German *Geist*.

After the war, in the GDR, the phenomenon of Expressionism was

reanalysed by Lukács's successors and an activist left-wing history was constructed which allowed for the rehabilitation of the movement as a form of critical realism. Early examples of this genre can be seen in the symbolical paintings of concentration camp atrocities by Hans Grundig or Horst Strempel.[5]

During the early 1950s such works were superseded by the more optimistic Soviet-inspired Socialist Realism which became the official Party line, but towards the end of the decade this was in turn overthrown by a younger generation of official artists. Initially adopting the leftist Modernism of Picasso and Léger, they began to reappropriate the specifically German styles of Expressionism and Magic Realism in paintings which commented, sometimes ironically, on the artistic, social and political peculiarities of the GDR.[6]

Other artists, such as A. R. Penck, worked outside the official system as part of a 'dissident' avant-garde and had to support themselves by other means. Penck's child-like images consciously echo, in both their subjects and technique, the infantile ambitions of a State which believed that all life could be planned and regulated; they also amplify the anxieties of living in such a world.[7] Penck's work, however, has a closer relationship to that of artists working in the Federal Republic who were employing similar strategies of displacement. There was a market for his work in the West, and in 1980 he was able to purchase the freedom to live where he wished.

In the Federal Republic, art and *Kultur* developed along a radically different path. Seminal works by émigré psychoanalysts and cultural historians such as Erich Fromm in *Escape from Freedom* (1941) or Siegfried Kracauer in *From Caligari to Hitler* (1946) had effectively issued Expressionism and the attitudes it represented with a political health warning. These works suggested that the attitudes which Expressionism typified had helped create the ethical and intellectual wasteland in which National Socialism had taken root.[8] And, as a result, the resurrection of specifically German traditions in the arts was taboo. In the late 1940s through to the mid-50s, acceptable forms of expression in the visual arts included the not always entirely plausible concept of 'inner emigration', in which individual artists were said to have cultivated their own gardens during the years of National Socialism, or the 'new internationalism' orchestrated from Paris or New York; the abstract paintings of Bernard Schultze or Fred Thiele are typical examples.

Although the mechanisms were different, and in the West censorship of the self undoubtedly played a greater part than that of the State,

Kultur throughout Germany was effectively sterilised until the beginning of the 1960s. The problem of constructing an artistic language that could represent, without censorship, the realities of the new Germany faced the generation of artists who, studying in the late 1950s, did not feel responsibility for the past. A large number had been born in the East and had migrated westwards. At the height of the Economic Miracle the avant-garde made critical reference to the consumerism of the new German *Kultur*. In this vacuum these artists entered into an ironical dialogue with the largest and nearest cultural mass: the neo-Stalinist Socialist Realism which lay on its Eastern borders. Gerhard Richter, Sigmar Polke and Konrad Fischer (the first two had left the East as young children) developed a style they described as Capitalist Realism. As had been the case before the First World War, the subject of art became not so much a single motif but a whole system of values and belief. Indeed art was again being transformed, true to Nietzschean principles, into an alternative structure – a virtual ideology in itself. This was a path which, during the sixties and seventies, Joseph Beuys and his pupils followed, initially at the Düsseldorf Academy of Arts and subsequently at the Freie Internationale Hochschule für Kreativität und interdiziplinäre Forschung, which Beuys founded in 1973.

> I am in Pandemonium undergoing hygienic solace ... PASSIONATE FEELINGS OF THE CROWD, CORROBORATING CLICHES, VISITING RELIGIOUS, soul brothels with rhythm and click of backgammon, smiling inanely at the one thing that is painful. What is victorious about this? Do you want to see me cry? Pandemoniac shots in the back along the roadbed – umbilical rails

This typical extract from one of the Pandemonium Manifestos, which Georg Baselitz wrote with Eugen Schoenbeck in Berlin in the early 1960s, could almost have been taken from one of the early expressionist magazines. But the imagery was unmistakably new: an apotheosis of meat, of disgust for the flesh, for the fall-out of the body. It was a new primitivism which claimed to deny all knowledge of what had gone before: 'When I make my paintings I begin to do things as if I were the first, the only one, as if none of these examples existed.' That said, there were obvious precursors; in Mannerism, in German Romantic painting, in the style and subjects of Edvard Munch, in the masks and epic ambitions of Emil Nolde and Axel Gallen-Kallela, both members of *Die Brücke*. But it was Baselitz's and Schoenbeck's ironical hero paintings of the mid-1960s, based on Socialist Realist and expressionist archetypes which rooted these artists in their tradition and from which Baselitz embarked on the series of modernist strategies which culminated in the creative method by which his work is still recognised (plate III).

Also in the mid-sixties Markus Lüpertz, working in Berlin, adopted the persona of a dandy and invented the neo-Nietzschean conceit of the dithyramb – a rhythmic, poetic and iconic form in which 'the grace of the twentieth century will be made visible'. This underlying concept has been the constant and unifying element in an oeuvre which is characterised by its abrupt changes of style. Subsequently in Düsseldorf in the late 1960s and early 1970s, Jörg Immendorff and Anselm Kiefer, under the initial tutelage of Beuys, constructed their own neo-romantic and poetic versions of modern German *Kultur*. For Immendorff, history was reduced to a forest of stereotypical signs and emblems: a Café – the Café Deutschland; a classical sculpture – the Brandenburg Gate; an iceberg – a cold war; an eagle and some compasses – two national symbols; a seam – the edge which joins and divides. These elements dwarfed the characters who passed in their vicinity and created an overwhelming impression of stasis and impassive force. With their overt references to popular art and political posters they gave a poetic, yet down-to-earth representation of cultural legacy and institutional power.

No less ironical, Kiefer gravitated, on the other hand, towards the depiction of archetypical cultural symbols in heavily worked paintings which bore physical evidence of destruction – an echo of that which Germany had both caused and experienced. Initially misunderstood and criticised as neo-fascist, such works examine the pretension and impotence of art in the face of evil. As in the work of other artists, the redolent symbols of culture – order, religion, knowledge, land, and national identity – are framed by an unselfpitying neo-pathos. Armed with the virtue of self-knowledge such strategies are intended to deflate the image and its associations in order to appropriate and revalidate it.

A criticism of the status quo was fundamental to the German avant-garde during the 1960s and 1970s. The sincerities and cynicisms of pre-war German culture had shown themselves to be misguided and impotent; the past was a liability, yet it could not be ignored. If one believes in the existence of post-modernism in the eighties then one of its most important features is the death of sincerity in art. Avant-garde art in Germany in the 1960s anticipated this demise because the previous sterilisation of its languages by National Socialism had meant that no statement could be innocent. Every cultural act became an exorcism of the past and a testimony of national transformation.

However, as Ernst Gombrich once remarked, paintings, unlike words, cannot be placed within quotation marks; levels of visual irony are not easily perceived or simply deciphered. This is the danger of

such an approach. The meanings and cultural significance of work by such artists as Baselitz, Lüpertz, Kiefer or Immendorff are reflexive and, like series of Chinese boxes, have to be unpacked. Yet without knowledge of this process of displacement this work could seem at best retardataire, at worst, fascistic. It may be argued that only complex and multifaceted forms of art can reflect the realities of a complicated and many-cultured world, yet when these forms are dependent on irony for their effect (and once they have entered the public domain they are inevitably divorced from the intention of the artist) they may become either ambiguous or unintelligible. If it is art alone that suffers from this, the price may not be too high to pay and times may change. But in a world of many *Kulturen*, one man's irony can too easily become another man, or woman's, oppression. In culture in which the barriers between art, life and political action are easily confused, ambiguity of this kind could, in the new Germany of the twenty-first century, easily become a luxury that we can no longer afford.

Notes

1 This realisation strikes at the heart of the problem of understanding Expressionism. Its arts are recognised not by any superficial similarity but by the specific confluence of ideas and subject matter which gave them meaning. 'Expressionism' in this context describes a kind of art in which social, historical, political, philosophical, even scientific and medical ideas, crystallised into a series of widely held attitudes and beliefs.

2 From the 1860s the rigidly hierarchical social classes of Wilhelmine Germany were unified by a belief in the ideals of national self-determination, progress and historical destiny. By the turn of the century the *Zeitgeist* had begun to change; the Establishment were unaffected by this, but it was the younger generation who felt stifled by the oppressive and materialistic determinism of their forebears. If the earlier nineteenth century had romanticised, realised and invested in the governments of new nation states, the cultural pendulum had, by the end of the century, begun to swing back towards the spiritual and material needs of the individual. An abrasive relationship between the individual and the collective will has characterised German politics in the twentieth century. Since the reunification of Germany, the spectre of extreme nationalism has begun to rematerialise.

3 S. Müller, 'Support and opposition in Wilhelminian Culture', in I. Rogoff (ed.), *The Divided Heritage*, Cambridge, 1990, p. 188.

4 Working out of this idea the Swiss art historian and critic, Heinrich Wölfflin, developed a form of aesthetic criticism based on the idea of 'equivalents', in which visual and ideal values were seen as interchangeable. The German art historian Wilhelm Worringer focused in his seminal book *Abstraction and Empathy* on the innate spirituality and formal predestination of Northern as opposed to classical Mediterranean art. In aesthetics the Viennese professor Alois Riegl described the collective creative impulse as *Kunstwollen*, a will to art, using not so different a terminology from Nietzsche's in describing the 'will to power' of his Superheroes. The will to art, it was suggested, was already an integral part of the *Kultur*.

5　See D. Elliott, 'Absent Guests: Art in the GDR', in I. Rogoff (ed.), *The Divided Heritage*, Cambridge, 1990.

6　*Ibid.*

7　Penck has spoken about Expressionism as follows: 'I have a very strange attitude to Expressionism. When I began working creatively in a more aware way at the age of 14 or 15, people who once knew about these things said what I was doing reminded them of Expressionism, for example the *Brücke* movement in Germany. I didn't know what the *Brücke* movement was. What people refer to when they say that my work is expressionist is simply the spontaneity and aggressiveness in each creation − like action frozen into form.' Interview, London, Serpentine Gallery, 1989.

8　The Western Allies put such theories into practice in their plans for the denazification of occupied Germany. These were dropped only in 1948/49 when the rise of Communism in the East and the Cold War were regarded as greater threats than the possibility of a Nazi revival.

Plate I

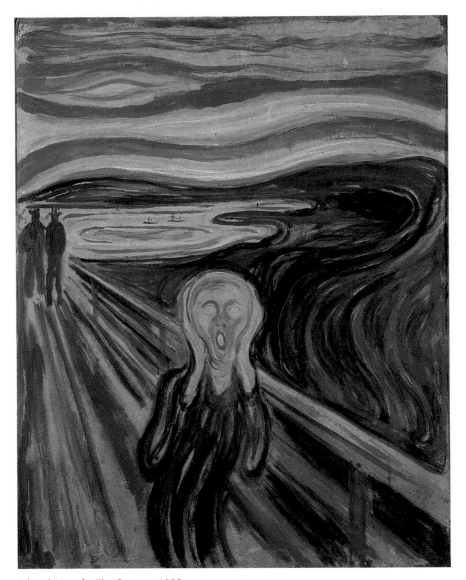

Edvard Munch, *The Scream*, 1893

Plate II

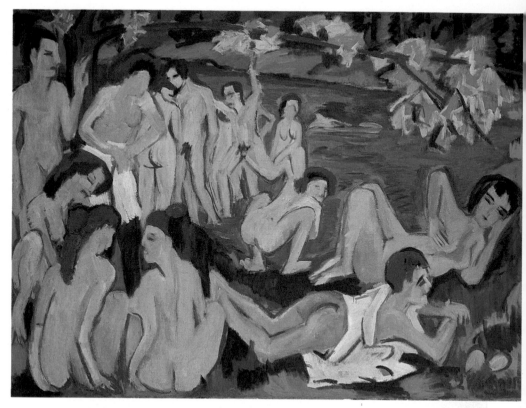

Ernst Ludwig Kirchner, *Bathers at Moritzburg, c.* 1909–26

Plate III

Georg Baselitz, *A New Type*, 1966

Plates IV & V

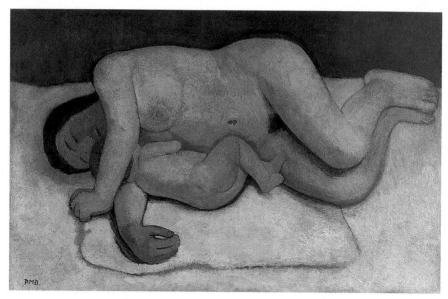

Paula Modersohn-Becker, *Reclining Mother and Child* (Mutter und Kind, Liegende Akte), 1906

Wassily Kandinsky, *Scenario for Third Act of 'Violet'*, 1914, pencil, watercolour and inks

The visual arts

'The ascent to nature' – some metaphors of 'Nature' in early expressionist art

Gill Perry

Progress in my sense. I too speak of a 'return to nature', although it is not really a going back but an *ascent* up into the high, free, even terrible nature and naturalness where great tasks are something one plays with, one *may* play with. (Friedrich Nietzsche, *Twilight of the Idols*, 1888.)

In *Twilight of the Idols* Nietzsche inverts – or at least reworks – some of the traditional post-Rousseauesque associations of the idea of a 'return to nature'. As opposed to a 'return' he claims an 'ascent' to nature and naturalness in the cause of expressive freedom and subjectivity. In the context of his critique of modernity, 'nature' is allied with man's salvation and his critical potential as an alternative 'modernity'. It is important to reiterate that men are the exclusive agents of social change in Nietzsche's writing. His ideas had an important influence on many artists and intellectuals working in Germany around the turn of the century. During this era of various neo-romantic revivals, nature cults, anti-urban movements and early forms of cultural modernism, notions of 'Natur', like those of 'Kultur', were profoundly unstable, the focus of contemporary debate. Nietzsche's attempt to reconstruct the category 'nature' seems to anticipate this instability.

It is precisely because 'Nature' was both a dominant and a fluid concept – often ideologically loaded – that we find visual metaphors and representations abounding in the art of the period. To develop this point I have chosen to look at examples from areas of artistic practice often designated pre- or early expressionist, in which the preoccupation with 'nature' or the supposedly 'natural' subject seems to be dominant: the work of the Worpswede community and Paula Modersohn-Becker. The problem that preoccupies me is one of interpretation and meaning. How are the contemporary discourses of 'nature' and their possible associations read out of the heavily mediated processes of painting? How do these literal and symbolic meanings function and can they be

reinforced – or challenged – through the actual processes and techniques of painting?

It is often argued that the idea of 'zurück zur Natur' (back to Nature) in art was developed in a literal sense in the formation of so many rural artists' communities in Germany around the turn of the century. In his book on German artists' colonies, Gerhard Wietek[1] lists over eighteen organised groupings of artists who worked in peasant villages or rural contexts at this time, of which Worpswede is one of the better-known examples. Although the cult of 'the going away'[2] was a European phenomenon which involved the pursuit of various myths of the 'primitive' peasant life, it took on a specific character in the German context, in which nature cults and anti-urban movements were gaining ground. The relationship of these to an accelerated process of industrialisation in late nineteenth-century Germany is now a well-aired topic.[3]

However, the extent to which the formation of these artists' communities involved a retreat to the supposedly remote rural margins of society is open to question. Artists also went in pursuit of the cheaper living costs in the country. Communities like Worpswede were formed in villages which had become accessible to a nearby urban centre – in this case Bremen – through the developments of the railway, which increased the tourist appeal of the village, and in its turn the local economy. The myth of the uncorrupted rural German peasant was, of course, gathering potency at a time when such ideal forms of rural life were less and less likely to be found.

The village of Worpswede is situated in the moors about twenty miles north of Bremen on the local railway line. From about 1889 onwards, when the village was largely populated by peasant farmers and peat cutters, it became the site of pilgrimage for a group of ex-art students from the Düsseldorf Academy. By the early 1890s Fritz Mackensen, Otto Modersohn and Hans am Ende (who had studied in Munich) had settled in the village, to be joined over the following years by Fritz Overbeck, Carl Vinnen and Heinrich Vogeler. Paula Modersohn-Becker settled in the village in 1899, after a series of visits.

The context and associations of this north German village had a special appeal for many contemporary artists and writers who directly or indirectly had been absorbing so-called 'Volkish' ideas, particularly those disseminated to artists through the influential medium of Julius Langbehn's book *Rembrandt als Erzieher* (*Rembrandt as Educator*), published in 1890. Langbehn's eccentric, rhetorical and wildly popular book, associated as it was with the various reactionary currents of 'Kulturkritik', argued that art – or 'Kunstpolitik' – must lead the

struggle for new spiritual 'freedoms', a form of anti-modernism which opposed bourgeois liberalism and (as Langbehn saw it) the evils of modern industrial society. Langbehn exalted the spiritual values which he felt were still latent in the uncorrupted 'Niederdeutscher' or low German *Volk*, which in this case could include peasants from the Netherlands – hence Rembrandt's heroic status.[4] Much work has now been done (by Mosse, Stern among others) on the origins and dissemination of Volkish ideas.[5] Langbehn's idea was the type of 'Niederdeutsche' peasant who had originally lived in the north-western plains of Germany, an area which could be conveniently extended to include the northern moors around Bremen and Worpswede.

Thus many Langbehnian ideas, particularly those embodied in the so-called 'Rembrandt book', were especially seductive to the Worpswede artists. In a retrospective manuscript written in 1938 Fritz Mackensen recalled that the early artists had all devoured *Rembrandt as Educator*, describing it as a 'wonderful artistic ideal ... totally free and independent'.[6] Although by this time Mackensen's espousal of right-wing ideologies would have encouraged him to emphasise the earlier Langbehnian interests of the community, contemporary documents and diary entries seem to reinforce this representation. Modersohn-Becker's Album, a personal collection of readings and selections from works she had read began with an extract from *Rembrandt as Educator*.[7]

Of course, Langbehnian ideas were among many diffuse sources – often with contradictory political associations – which the artists were absorbing. These included the writings of Nietzsche, Tolstoy, Ruskin, and modern German and Scandinavian literature. The point that I want to develop is that some of the currents of *Kulturkritik*, in particular Langbehn's ideas, made available a set of cultural and political meanings about the status and identity of the local peasant or 'Volk' – and by implication 'Nature' – which became part of contemporary artistic discourse. How then were these ideas mediated through the artistic practices of the Worpswede artists?

In the first Worpswede group show in Bremen Kunsthalle in 1894/95 Mackensen exhibited two works which attracted much critical attention: *Mother and Infant*, 1892 (fig. 3) and *Service on the Moors*, 1894 (Hannover). Clearly, Mackensen was reworking some French and German precedents for the representation of peasant subjects, including those established by Gustave Courbet in the mid-nineteenth-century or Wilhelm Leibl in the 1880s. Courbet's work was influential in Germany after he had exhibited at the Munich Glaspalast in 1869. His choice of 'ordinary' rural subjects was seen to carry with it anti-Wilhelmine

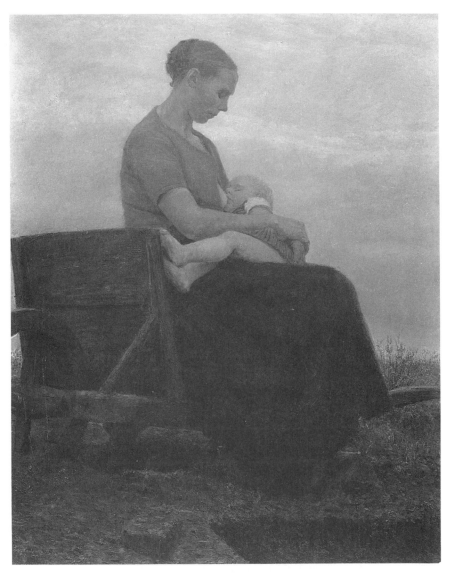

3 Fritz Mackensen, *Mother and Infant* (Der Säugling), 1892

associations.[8] Mackensen's works would have been associated with the anti-academic values of a Courbet-influenced school of realism, but as local images they conveyed some other meanings.

Mackensen's *Service on the Moors*, represents a local village custom, a religious ritual through a detailed 'realist' technique. Yet Courbet's relatively unsentimental representation of rural life, in works such as his famous *Burial at Ornans,* 1849, encouraged rather different social

and political readings. Mackensen uses a carefully ordered composition to idealise the humble stoicism of this Protestant community. Moreover, a link is clearly made between religion, nature and the past, for the group is shown worshipping in nature itself, in traditional local dress, reinforcing its historic roots. In this work then Mackensen constructs both a literal and symbolic representation of a close relationship between the north German countryside, its indigenous people and its spirituality; between the land, the *Volk*, its religious piety and its spiritual source – or 'Nature'.

Mackensen's *Mother and Infant* (originally titled *Der Säugling*, or Breast-feeding Infant) can also be read as a visual representation of this kind of spiritual relationship. Mackensen was reworking a well established convention within nineteenth-century European art and culture in general, that is the representation of rural or peasant woman as close to nature, as a symbol of the simple natural life. The repetition of this kind of imagery of peasant woman has been seen in the context of a post-Enlightenment culture in which woman as 'nature' is often opposed to man as 'culture', a set of oppositions and symbolic associations which, as Ludmilla Jordanova, among others, has shown, may be deeply embedded in cultural practices.[9]

But the symbolic 'other' which woman represents in this work is also inflected with some specifically German nuances of meaning. Shortly after it was first exhibited in Berlin in 1893 it became known by some other titles, including *Woman on the Peat Cart*, *Madonna on the Moor* and *Worpsweder Madonna*, which evoke different emphases. The peasant woman is seated on a peat-cart, symbol of the local industry. The low viewpoint forces us to look up at the mother and child group as if it were a Renaissance altarpiece. The Virgin, enthroned by the peat-cart, has assumed the role of an ordinary peasant who lives close to the earth – a 'Worpsweder Madonna'. Moreover she is breast-feeding in nature, reinforcing her literal and symbolic role within the natural organic cycle. Mackensen then draws on a set of gendered associations to represent 'Nature'. In the process he uses the image itself – the relationship of figure to ground – to suggest an intimate bond, a natural flow between peasant and land.

To a contemporary audience steeped in neo-romantic ideas, this image would have been easily read as a representation of the Volkish idea of 'rootedness'. As Stern and Bradley have shown, Volkish writers, among them Langbehn, tended to express the relationship of the peasant to the soil in terms of the 'roots' through which a community somehow extracts its life source and its history.[10] Thus Mackensen's

worshipping and breast-feeding peasants could be seen as visual metaphors – or metonyms – for Nature and the natural cycle. Despite the parallels, this 'Nature' is not, however, to be conflated with the Nietzschean 'Nature' of free uncultivated expression.[11] Mackensen's 'Nature'. has a geographical and cultural specificity; it is imbued with an ominous cultural chauvinism.

Of all the Worpswede artists, Mackensen was the one whose work lent itself most easily to these kinds of readings. The work of Worpswede landscape painters such as Otto Modersohn or Fritz Overbeck, in which peasants toil in poetic landscapes, often indistinguishable from the landscape around them, was easily appropriated for the Volkish cause.[12] However, the diluted borrowings from pro-French Impressionist techniques, particularly in Modersohn's landscape paintings, tended to generate more ambivalent and less chauvinistic forms of criticism. Contemporary critical representations of the Worpswede group as a whole, particularly after the Bremen show of 1895, tended to emphasise their neo-romantic status, claiming this aspect for the cause of artistic innovation. The problem, as I have already suggested, was that doctrines of artistic radicalism which drew on ideas of 'Nature' and the supposedly 'primitive' life could be appropriated by differing critical and political interests. Thus the critic of the *Kölnische Zeitung* described the Worpswede Bremen show as revealing something 'new', 'original', and 'fresh', as breaking new ground in resisting academic constraints.[13] However, for right-wing critics such as Paul Schultze-Naumburg their 'modern' quality was more closely tied up with their representation of the *Heimat* (homeland) and 'the spirit of the country and its people'.[14]

The dividing-line between critical representations of the group as innovative and anti-academic neo-romantics, or as champions of a new art of the German *Heimat* was often blurred. In his monograph on Worpswede, first published in 1903, Rainer Maria Rilke constructed a picture of these artists as neo-romantics, conflating their youthful anti-academic primitivism with a spiritual quest, 'seeking something mean-ingful in the midst of uncertainty'.[15] Like many German intellectuals of his era, Rilke saw the artists as engaged in a spiritual mission to repair a severed relationship with nature. According to Rilke, within the Worpswede community 'Nature' itself became 'a source of meaning'.[16]

Rilke's 'Nature' then was a neo-romantic projection, but one which could be massaged to fit with Volkish ideas. But most contemporary reviewers had problems fitting the work of two other members of the community into this set of representations: Heinrich Vogeler and Paula Modersohn-Becker. Although he had been living in the community

since the mid-1890s Vogeler was sometimes accorded less critical attention than Mackensen and the landscape painters. And although Modersohn-Becker had been working there since 1899, Rilke excluded her from his monograph.

Vogeler's interest in English Arts and Crafts ideas was not incompatible with a Volkish mystification of peasant life. But his mixture of Jugendstil and English Pre-Raphaelite interests and his taste for themes from European fairytales[17] meant that his early Worpswede work fitted somewhat uneasily with the romanticised local landscapes of his fellow artists. Local critics had even more problems representing the work of Modersohn-Becker. Her exclusion from Rilke's book was partly because as a woman artist her work was taken less seriously. As a pupil of Mackensen between 1897 and 1899 she may still have been seen as a mere 'student'. She had also married Otto Modersohn in 1901 and at that time was probably seen by Rilke as the 'artist's wife' rather than an artist in her own right. I would also argue that Rilke's omission had much to do with the readability of her work to a contemporary German audience.

In later letters and diary entries, made after she had spent some time working in Paris, she dissociates her work from that of the more insular Worpswede artists.[18] However, even her later work which was heavily influenced by French post-Impressionism, remained rooted in a German artistic and intellectual context. Her iconographical preferences, in particular her enduring interest in local peasant subjects, including the themes of peasant women and mother and child groups would seem to place her work clearly within a Worpswede context. However, the formal language and artistic conventions which she developed to represent these peasant subjects were actually seen by some contemporaries as undermining their local neo-romantic associations. Local exhibits of her work were badly received[19] and she sold few paintings during her lifetime. Even some of those Worpswede colleagues who (somewhat patronisingly) defended her work against the crudest of philistine attacks were ambivalent about the value of her so-called 'primitive' style, falling back on the idea that some of her work was 'immature'.[20] The problem was that around 1900, as the catalogues of the annual Munich Glaspalast exhibitions show, there was a strong market in Germany for peasant subjects painted in anecdotal realist or quasi-impressionist styles. While the work of Modersohn-Becker's Worpswede colleagues conformed to this demand, the technical interests which she adopted did not. Such (apparently) 'immature' artistic conventions served to confuse the expectations aroused by her choice of peasant subject matter. To a contemporary German audience, the 'primi-

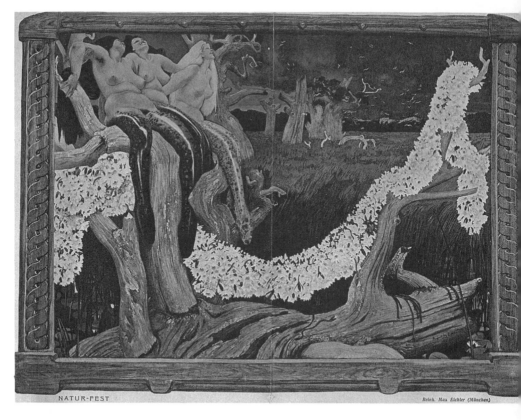

NATUR-FEST Reinh. Max Eichler (München)

Fidus

4 Max Eichler, *Festival o[f]
Nature* (Natur-Fest), 190[3]

5 Fidus, *Nature and her
Kind* (Natur und die
Geschlechter) 1903, and
[*facing*] *Excluded*
(Ausgeschlossen), 1903

tive' in art was still coded according to established artistic conventions.

I want to argue that it is in Modersohn-Becker's repetition and reworking of the theme of the nude, in particular the female nude, that this confusion of artistic associations and meanings is most in evidence, rendering this aspect of her work a rich source of study and debate. In pre-war Western culture in general, the female nude had well established symbolic associations as a visual metaphor for 'Nature' and the uninhibited natural life. The body, like the 'Nature' which it often represented, was an image with a wide range of literal and symbolic resonances in both the 'high' and popular art forms of the day. In the context of a German visual culture, the body could be coded to evoke a variety of contemporary and local meanings. We have only to look through the pages of the popular art magazine *Die Jugend* from a single year, 1903 for example, to see how some of the various contemporary discourses of 'Nature' intersect around the theme of the female (and occasionally male) nude. In this volume we find Max Eichler's double-page *Natur-Fest* (fig. 4), a grotesque, hedonistic Jugendstil fantasy in which serpent-like women disport themselves, alongside a more conventional symbolic image *Natur und die Geschlechter* (Nature and her Kind) (fig. 5). In both these images nude women are employed as symbols of the 'Natur' in the titles. In the same volume, nude female

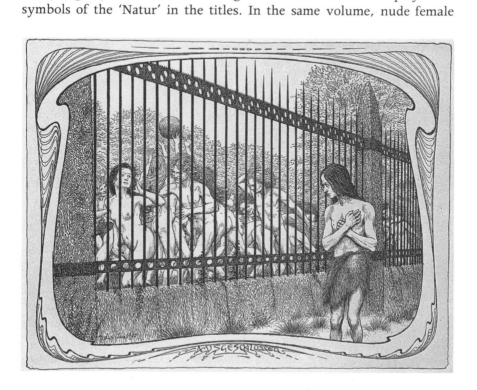

and male bodies form the subject matter of more obviously satirical images on the issues of nudist cults (*Ausgeschlossen* (Excluded)), and censorship and the nude in the art academies, not to mention the appropriation of the theme in many advertising images.[21]

The nude had become the focus of a whole range of cultural and artistic debates. These included debates about academic, Jugendstil and avant-garde art practices, and contemporary nature cults and *Nacktkultur* which were sometimes allied with liberal ideas about sexual freedom and anti-bourgeois lifestyles. Many of these debates, particularly those which focused on the nude as a symbolic representation of 'primitive' or natural values, were inflected with gendered associations.

Modersohn-Becker was steeped in this contemporary culture of the nude. She was brought up in Dresden, which, with its growing network of sanatoriums and health resorts, was becoming an important centre for outdoor bathing, nature cures and the culture of the body by the turn of the century. It is no coincidence that it was within this environment that the *Brücke* group developed their own interest in the theme of the nude.[22] Significantly, perhaps, Modersohn-Becker was the only Worpswede artist who worked so extensively on the theme of the nude. As we have seen, the fully-clothed local peasant was the image which best suited the more chauvinistic primitivism of her Worpswede colleagues. But in her work we often find the merging of various symbolic conventions for representing 'natural' values, as in her many studies of nude peasant women, or the nude mother breast-feeding her child, *Reclining Mother and Child*, 1906 (plate IV), the model for which may have been a local Worpswede mother.[23]

While on one level this *Reclining Mother and Child* can be read as a literal and symbolic portrayal of supposedly 'primitive' values in both its subject matter and techniques, it is also a work which fits uneasily with the various artistic languages available for the representation of the theme. The female nude in a reclining 'Odalisque' pose was embedded in a set of conventions, largely developed by male artists, which even in their most 'modern' form stressed the sexual availability and sensuality of the subject.[24] Modersohn-Becker's nude mother is monumentalised in the manner of Gauguin's primitivised mothers,[25] yet that very monumentality is used to subvert the connotations of a nude Odalisque pose. Her mother is a simple nurturer, without the erotic sensuality of Gauguin's 'primitive' symbols. As a woman artist, she seems to have refused some of the more voyeuristic associations of the reclining female nude, replacing them with an unsentimental image of woman as nurturer. A similar refusal of the connotations of sexual

availability can be found in one of her last paintings, *Kneeling Mother and Child* 1907 (Ludwig-Roselius Collection, Bremen), another monumentalised image of motherhood. This breast-feeding mother is surrounded by fruit and plants, traditional symbols of fertility which were often employed by Gauguin in his Tahitian canvases. But this is not a sensual nude reminiscent of Gauguin's tropical paradise. Her schematic almost ugly – primitivised face and unerotic body suggest another construction of the 'feminine', albeit one which sustains the associations of a fecund, life-giving, natural force.

Modersohn-Becker's interest in the theme of the female nude encapsulates the ambivalent and sometimes contradictory relationship of her work to contemporary German preoccupations in art and culture. For her the nude could also function as a powerful symbol of her pro-French avant-garde interests – of her search for what she called a 'great simplicity of form', which, she believed, explicitly denied any insular chauvinistic concerns in iconography or technique.[26] Within the Worpswede context such interests certainly rendered the meanings of her work less accessible – or less transparent – than those of her colleagues. They also confound attempts to provide neat categories for the range of visual symbols and images through which 'Nature' was represented to a contemporary audience.

Notes

1 G. Wietek, Deutsche *Künstlerkolonien und Künstlerorte*, Munich, 1976.

2 I discuss this phenomenon in Europe as a whole in 'Primitivism and the Modern', Part one of *Primitivism, Cubism, Abstraction*, New Haven and London, 1993.

3 Many contemporary German commentators, among them the sociologist Werner Sombart (whose portrait Paula Modersohn-Becker painted in 1906) were quick to identify the causes of intellectual revolt in the rapid growth of an industrialised materialistic culture and the modern German state.

4 F. Stern has shown that by the 1890s the term 'Niederdeutscher' had become rather looser in its usage and could be used to describe anyone whose ancestors had been associated with the peasantry of the north-western area. See F. Stern, *The Politics of Cultural Despair*, Anchor, 1965, pp. 178ff.

5 See, for example, Mosse, *The Crisis of German Ideology*, and W. S. Bradley, *Emil Nolde and German Expressionism – A Prophet in his Own Land*, Ann Arbor, 1986.

6 The manuscript was entitled *Das Weltdorf Worpswede*, 1938, and a copy is kept in the Worpswede Archives. Extracts have been reproduced in local newspapers.

7 *Paula Modersohn-Becker in Briefen und Tagebüchern*, Frankfurt, 1979 (Introduction by G. Busch and L. von Rinken); Otto Modersohn is also fulsome in his praise of Langbehn in his *Tagebuch* in 1890 (manuscript in Worpswede Archives).

8 Wilhelm II's artistic preferences were outlined in speeches delivered during the 1890s and 1900s. Some of these are reproduced in J. Penzler (ed.), *Die Reden des Kaiser Wilhelms in den Jahren 1901-Ende 1905*, Universal Bibliothek, Leipzig (no date). He became notorious for his disdain for German impressionist painters, and

the choice of ordinary or peasant subject matter which he associated with the 'modern' school of German painting. See his speech given at the opening of the Siegesallee, Berlin, 18 December 1901 (Penzler, *ibid.*, p. 57).

9 These symbolic associations are explored in L. Jordanova, *Sexual Visions: Images of Gender in Science and Medicine between the Eighteenth and Twentieth Centuries*, London, 1989.

10 These ideas are developed in relation to Nolde's work in Bradley, *Emil Nolde and German Expressionism*. See especially chapter 1, 'Man and Nature in Wilhelmine Germany', pp. 9-27.

11 This distinction is discussed in Bradley, *Emil Nolde and German Expressionism*, pp. 26-7.

12 Works by Modersohn in which peasants toil peacefully in poetic landscapes include *Herbst im Moor*, 1895, and *Sommer im Moorkanal*, 1896, both in the Kunsthalle, Bremen. The poetic landscapes of Fritz Overbeck, such as *Überschwemmung in Moor*, 1903 (Haus am Weyerberg, Worpswede) or Carl Vinnen, such as *Moorlandschaft mit Birken und Mond*, 1900, Sammlung Böttcherstraße, Bremen, were widely claimed as forms of neo-romanticism, and labelled 'Naturlyrismus'.

13 Reproduced in Bremen Kunsthalle, *Worpswede – Aus der Frühzeit der Künstlerkolonie*, 1970, p. 52.

14 'Die Münchener Jahresausstellung in Glaspalast II', in *Zeitschrift für bildende Kunst*, VII, 1896, p. 541.

15 *Worpswede Monographie – Monographie einer Landschaft und Ihrer Maler*, Bielefeld and Leipzig, 1903. Reprinted as R. Rilke, *Worpswede*, Bremen, 1970, p. 19.

16 Rilke, *Worpswede*, p. 20.

17 See for example, Vogeler's painted and graphic works on the themes of *Frühling* (Haus im Schluh, Worpswede) and *Melusinenmärchen*.

18 See, for example, *Paula Modersohn-Becker in Briefen und Tagebüchern*, 1979.

19 When Paula Modersohn-Becker exhibited at the Bremen Kunsthalle in 1899, her work was attacked by Arthur Fitger, who discussed her 'primitive' beginnings. See *Weser-Zeitung*, 20 December 1899.

20 In response to Fitger's attack, Carl Vinnen defended her work in the *Courier*, calling her exhibits 'immature studies' – *Courier*, 24 December 1899, 'Harmlose Randglossen zur Fitgerschen Kunstkritik'.

21 I have cited a single year of *Die Jugend* in order to show the concentration of different images on the nude theme. On the issue of nudist cults, Fidus's satirical drawing *Ausgeschlossen* (fig. 5b above) shows cavorting naturists excluding from their midst a more authentic 'primitive' wearing animal skins around his waist (p. 816) and the satirical drawing *Nuditäten-Flucht* shows a crowd of nude models and plaster casts fleeing from a censorious local bureaucrat (p. 930).

22 The relationship between the interests of the *Brücke* group and the development of nature cures and nudist cults in Dresden around the turn of the century is the subject of (largely) unpublished work by Paul Reece (Open University) for his forthcoming D.Phil. thesis. See P. Reece, 'Edith Buckley, Ada Nolde and *die Brücke*: Bathing, Health and Art in Dresden 1906-1911', in B. Keith-Smith, *German Expressionism in the U.K. and Ireland*, Bristol, 1985.

23 Paula Modersohn-Becker frequently used local peasant women as models. See G. Perry, *Paula Modersohn-Becker: Her Life and Work*, London, 1979.

24 In Germany see, for example, the works of Louis Corinth, including his *Reclining Nude*, 1896, Kunsthalle, Bremen.

25 See, for example, Gauguin's *Woman with the Mangoes*, or the *King's Wife*, 1896, Moscow.

26 Modersohn-Becker used this term in her diary, 25 February 1903. This preoccupation is discussed in Perry, *Paula Modersohn-Becker*, p. 53.

6

Expressionist sculpture c. 1910-30 and the significance of its dual architectural/ideological frame*

Erich Ranfft

One of the most pervasive and fundamental features of Expressionism in German sculpture lay in its direct or implied relationship to architectural space. This function was significant to the multi-disciplinary nature of expressionist ideals that received their impetus from developments in the Arts and Crafts movement at the turn of the century.

It is useful to define this relationship chronologically into three periods. The first, spanning the decade until the end of the First World War, was marked by the regionalised beginnings of so-called 'new German sculpture' or 'expressionistic sculpture'. Such examples sought a universal primitivism, characterised by a ritualistic function that linked the spectator with the communal in an ideological and architectural sense. In the post-war period, from 1919 until around 1924, these aims took on heightened focus through utopian aspirations for an activated religious art. Finally, while many of the expressionist impulses in German sculpture subsequently dissipated, a less apparent period until c.1930 can be described largely in terms of religious sculpture and the propagation of its architectural siting.

This essay will introduce these phases by proposing a complex synthesis of the architectural in sculpture (essentially figural), illustrated by the two-fold manifestations of relief and in-the-round sculpture: first, in the tradition of 'architectural sculpture', works related directly to an actual structure or proposed project (even if unfulfilled); and second, those conceived as autonomous yet nonetheless imbued with the significance of an implied architectural setting, for enactment in a church, temple or theatre. These aspects will be examined through their function within the dual-level concept of the architectural framework/ideological frame as contributing to the ideals of a *Gesamtkunstwerk*, in which architecture was to synthesise and regenerate all levels of art and society. Sculpture was to serve as a medium for

religious and spiritual ritual in activating heightened devotion and participation in the viewer.

Research on the scope of expressionist sculpture's relationship with the architectural has been minimal. Emphasis has been placed almost exclusively on significant works of 'architectural sculpture', with little attention paid to their socio-cultural and ideological parameters. This is due to the entrenched study of expressionist sculpture as a self-contained, formalist 'movement', distinct from the social traditions of sculpture and its fundamental links with architecture. This approach set up a hierarchy of artists whose production was judged on the basis of degrees of distortion and roughened woodcarving for emotive purposes. The works of *Die Brücke* painter-sculptors, in particular, Ernst Ludwig Kirchner, Erich Heckel and Karl Schmidt-Rottluff, are widely held up as the finest.[1] Architecture's ideological role can be shown to be crucial in reinterpreting this 'movement' as democratised and decentralised, pluralistic and inter-disciplinary. Only in recent research, as initiated by Magdalena Bushart for instance, are the beginnings of such an enquiry in evidence.[2]

During the first period, the newness of 'expressionistic sculpture' quickly came to represent an outward panorama, both categoric and synthetic, of 'primitive' figural types embodying Egyptian and Near-Eastern, archaic-classical, Oriental, Gothic, African and Oceanic sources.[3] For the 1912 Mannheim exhibition, *Ausdrucks-Plastik* (Expressive Sculpture), the catalogue essays seized on these features as being united by 'pure form' and *Bewegung* (suggestive of both physical movement and inner emotion). These characteristics were also informed by the dissimilar aesthetic values of the two most influential sculptors in Germany since 1900, Adolf von Hildebrand, who espoused an architectonic, planar order based on classicising principles, and his French contemporary, Auguste Rodin, whose sculptures articulated dramatic movement as self-referential, three-dimensional space.[4] It is, however, the impetus of Hildebrand's principles that can be seen to underlie much of the formal conception of expressionistic sculpture. Significantly, such qualities epitomised the new primitive sources which, conceived as planar-relief, were removed from their original architectural locations.[5] This was to be the 'mainstream Expressionism' in sculpture, while the aesthetic values of *Die Brücke* painter-sculptors represented but one aspect of the fostering of a complex and expanded concept of primitivism.

The eclectic historicist reference to the past must be contextualised within the developing reformist programmes of the pre-war years.

Along with similar currents in the fine and applied arts, these sought to engender communality by revitalising the greatness of architecture's past in accordance with modernising concepts of design.[6] Such aims centred largely around the *Deutsche Werkbund*, the 'German Union of Work', established in 1907. At its 1914 Cologne Exposition, the new sculpture's public function reached a culmination. Particularly exemplary were the contributions of Gerhard Marcks, Richard Scheibe and Moissey Kogan for a factory and offices (no longer extant) designed by the architect Walter Gropius.[7] Their reliefs for doors, walls and cabinets depicting universal themes of daily work and leisure (by Kogan in the form of female nudes dancing) were executed in stylised Egyptian and archaic-like designs, complementing Gropius's hints of monumental Egyptian architecture in the overall framework.

This civic function of expressionistic sculpture was best exemplified by Bernhard Hoetger's numerous architecturally related works. Starting in 1912, in the *Berner Volkshaus* (Berne Community Centre), and spanning the following two decades in single and grouped edifices in Bremen and Worpswede, Hoetger's decorations were characterised by an eclectic primitivism.[8] The most ambitious, the *TET-Stadt* (TET-City) project for Hannover, 1916-19, constituted a large-scale, visionary development. It was commissioned by the biscuit manufacturer, Hermann Bahlsen, who had a longstanding fascination for the Egyptian heritage. In 1900 he had his business logo incorporate the 'TET' hieroglyph, signifying 'the eternal and the constant', which has continued to appear on the packaging of Bahlsen sweets since 1903. He planned to incorporate a residential community within a new factory complex, and Hoetger conceived a model inspired by Egyptian and Babylonian architectural sources, featuring relief and free-standing sculpture.[9] The project never saw fruition, however, as the post-war recession severely affected Bahlsen's output.

Notwithstanding these circumstances, Hoetger produced commissioned stone-carved busts and full-length figures of the Bahlsen family that were informed by Egyptian portraiture. Though little evidence remains, Bahlsen and Hoetger appear to have intended most of these sculptures to adorn the TET-Public Relations Building, including its 'Honorary Room', solely to highlight Hoetger's work. Hence, these could have been intended to function as devotional cult-symbols of the city's two 'founders' who aspired to the higher realm of integrating art and community. Uniting the role of these works was a statue destined for its own 'Hall' in the Administrative Building, the *TET-Göttin* (TET-Goddess), of which a model from 1918 survives (fig. 6). Cast in bronze,

a young girl represents the deity. She is seated in an oriental, meditative pose, a seed of cereal held between the fingers confirming her eternal role as spiritual guardian over the City's collective prosperity.[10]

In 1917 Hoetger produced a bust of *Sent M'Ahesa*, the stage-name of a popular German dancer of spectacular Egyptian 'rituals'.[11] He represented her in the guise of Nefertiti, the Egyptian queen, and it soon achieved the status of an icon of expressionistic sculpture. Though not related to the project, the image can be interpreted within the architectural/ideological frame of *TET-Stadt*, for it functions as a devotional object. Moreover, it can be seen to represent the inspiration that many expressionist sculptors sought from the euphoric and spiritual aspirations of the 'new German dance' or *Ausdruckstanz* (expressive dance) that flourished soon after the war.

Many sculptors maintained close contact with solo dancers, nearly all women, who modelled for them. Milly Steger's acclaimed life-size figure of 1918-19, *Jephthas Tochter* (Jephtha's Daughter), inspired by Mary Wigman's dances, epitomised this phenomenon.[12] Among the features that attracted sculptors to *Ausdruckstanz* was the desire for an

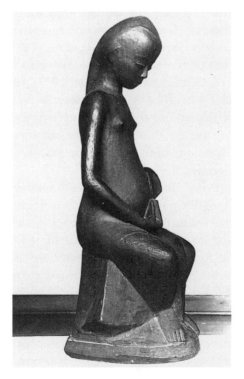

6 Bernard Hoetger, *TET-Goddess* (TET-Göttin), 1918, bronze

'architectonic' space in articulating a framework, as propagated through neo-platonic principles by the leading choreographer, Rudolf von Laban. Furthermore, it entailed a plethora of ritualistic body movements and hand gestures that were meant to evoke spiritual transcendence.[13] Finally, the ostensible dance narratives were frequently inspired by ancient, far-Eastern and Germanic-Gothic themes, a very popular format being the 'temple dance', involving processional or cyclical rituals.

At the start of the post-war period many expressionist sculptors identified with utopian and socialist ideals for the spiritual regeneration of the individual and society. This was to be accomplished by uniting sculpture, painting and the crafts with architecture into the people's *Gesamtkunstwerk*, the cathedral, as a site for worship and communal activity.[14] These ambitions became the task of the *Arbeitsrat für Kunst* (Working Council for Art) and the *Novembergruppe* (November Group) in Berlin, which had as their chief protagonists the notable architects, Walter Gropius, Peter Behrens, Bruno and Max Taut and Hans Poelzig.[15] Many of the sculptors would have shared the same sentiments as Ernst Barlach when he stated in 1920: 'I lack the great opportunity. Missing for my sculpture is the sacral space.'[16] Certainly the sculptors' ideological function was at the mercy of visionary architects severely hindered by post-war recession, while the established Church did not, for the most part, accept the expressionistic, religious sculpture, or when the congregation did, they could not adequately defend it from public protests.

A case soon to be infamous was the highly emotionally-charged and exaggerated *Kruzifix* (Crucified Christ) by Ludwig Gies (1921), which was strongly reminiscent of medieval devotional figures in distorted anguish. The over-life-size woodcarving was quickly vandalised and removed from Lübeck Cathedral because of its 'offensive' nature and, although it survived, it suffered a similar but less violent fate at its showing in the Pavilion of Religious Art at the *Deutsche Werkbund* sponsored *Kunstgewerbeschau* (Exhibition of Applied Art) of 1922 in Munich.[17] Nevertheless, this Pavilion, designed by Peter Behrens, afforded a rare opportunity for a group of sculptors to have their work displayed in a quasi-real, liturgical context.

The site was in effect a chapel-like structure, envisioned as a *Dombauhütte* (Cathedral mason's lodge), which, according to Behrens, would symbolise the fraternity of artistic production in the Gothic spirit.[18] Yet his choice to have diverse sculptural works by Richard Scheibe dominate over others could be seen to demonstrate the latitude

of the ideal craftsman engaged in creating both functional decoration and aesthetic objects for devotion. The latter is appropriately exemplified in the centrally-placed figure by Scheibe, entitled *Auferstehung* (Resurrection), imbued with ceremonial gestures derived from *Ausdruckstanz.*[19]

In contrast, there were a number of visionary approaches to the integration of sculpture as part of and within the architectural frame. One of the few projects to be realised was the Wissinger family grave site outside Berlin, from 1922-23, where Max Taut constructed a skeletal mausoleum-like structure. Recently restored, it is made up of Gothic-inspired arches and supporting posts which, from the exterior, suggest stylised figures (fig. 7).[20] This can be read as a translation of the traditional caryatid sculpture motif into an expressionist symbol of dancers as goddess-guardians of the temple. Inside this structure, the sculptor Otto Freundlich placed a number of stone-carved objects on the central grave: these were destroyed in the summer of 1923, only several months after the project's completion, due to protest. The piece represented a Judaeo-Christian interpretation of the Golem ritual as the creation of the Golem giant and his return to the earth.[21] Thus, framed by Taut's vision for the new Cathedral, the sculpture embodied the enactments of the religious and mystical regeneration of the expressionist 'new man'. It is not unlikely that the sculpture had a point of reference to the second production of the expressionist film, *Der Golem, wie er in die Welt kam* (The Golem, how he came into the World), from 1920. In this myth, a clay statue of the giant is brought to life to save the Jewish people of medieval Prague from expulsion from the ghetto.[22]

Another point of reference to this film was the Egyptianised headdress of the Golem giant designed by Rudolf Belling. His career as a sculptor before 1914 included set designs and, in particular, small sculptures of performers for the theatre director Max Reinhardt.[23] In contrast to the privacy of the Wissinger piece, in 1920, Belling's theatrical apprenticeship informed his production of a sensational Cubist-like design for the ceiling of the Scala Dance-Casino in Berlin. At its centre, the ceiling featured a conglomeration of protruding triangular shapes strongly suggestive of crystalline domes. Belling undoubtedly also sought inspiration from the Utopian architects who derived their organic structures from sculptural processes that often included modelled versions.[24]

It is apparent that the dual architectural/ideological framework for autonomous sculpture was similarly characterised by the adoption of highly symbolic gestures as enactment of sacred architecture. For

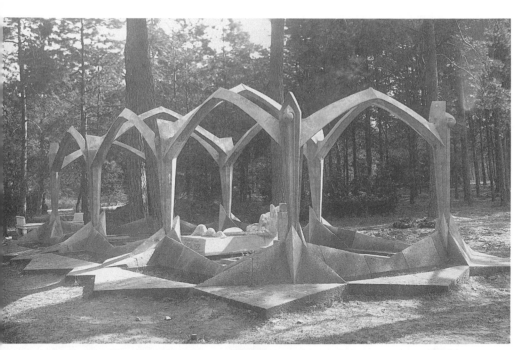

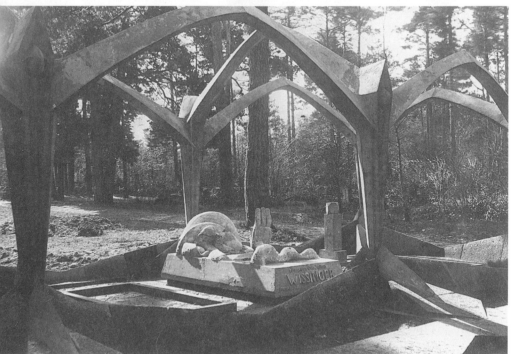

7 a, b Max Taut (architect) with Otto Freundlich (sculptor), *The Wissinger Family Grave (Das Erbbegräbnis Wissinger)*, 1922–23; structure in reinforced concrete and tuff

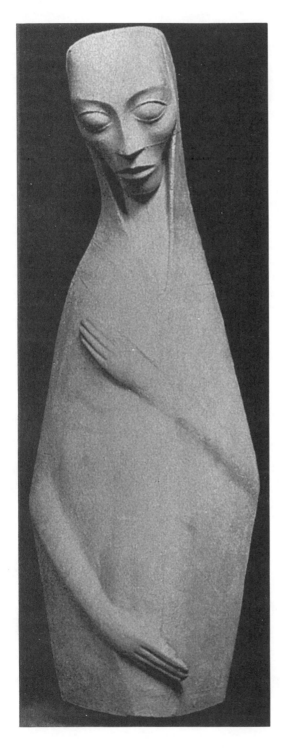

8 Emy Roeder, *Pregnant Woman* (Schwangere), 1919, terracotta

example, Belling's piece, *Dreiklang* (Triad), of 1919, presented three abstracted dance figures projecting out of a central base, which were seen to symbolise the three arts, painting, sculpture and architecture. Moreover, not unlike Max Taut's structure, the figures unite to form architectural space and celebrate its sacred function.[25] In its first showing with the *Novembergruppe* at the *Berlin Kunstausstellung* (Berlin Art Exhibition) in 1920, the guide book proclaimed: 'This is religion, this is architecture', while the exhibition catalogue stated that the original concept was supposed to be a 'six-metre high version built from brick with coloured plasterwork'.[26]

Also shown at this significant event was Emy Roeder's *Schwangere* (Pregnant Woman), 1919 (fig. 8). Alfred Kuhn, an art historian and ardent spokesperson for the expressionist sculpture, wrote at length about the figure's dual spatial and ritualistic presence with the final declaration: 'Her hands lie protecting the cathedral body which carries a Saviour.'[27] One can further extend the ideology of devotional display being advanced by Kuhn to other works by Roeder produced between 1918 and 1920 that deal with themes of conception and motherhood.[28]

A final example are the representations of the *Cathedral Dance* of Charlotte Bara by Paul Henning and Georg Kolbe in 1919 and 1922 respectively. Bara's immensely popular and highly stylised 'Gothic' rituals were compared to cathedral sculptures, transformed to life: 'Her dance is the realisation of faith in God. It is as if in the quietude of a cathedral the figure of a saint steps from its niche.'[29] Henning's three, abstracted 'busts' interpreted the dancer's ritual of spiritual transcendence by emphasising movements of her head within the 'structure' of her draped hood as emblematic of the holy site.[30] In Kolbe's full-figure, *Kathedrale* (Cathedral), the dancer is shown squatting, while the arms raise the hood, creating an overall pyramidal shape which conveys the enactment of ascension as the cathedral body itself.[31] Each sculptor sought to elicit ideological response from the spectator by evoking a holy frame within the object.

By the mid-1920s the divergent tendencies of Expressionism in German sculpture had largely been overtaken by differing attitudes toward a neutralised classicism imbued with monumental simplicity and a sense of naturalism. Yet expressionistic sculpture was still pursued on a visible front, to a great extent as part of a revitalised propagation of architecturally related sculpture with a strong emphasis on church and religious decoration (both Catholic and Protestant).[32] Berlin continued to be a motivating centre for the subsequent production, but widespread regional manifestations, especially across northern Germany, were apparent.

Interestingly, attempts were once again made by sculptors, in collaboration with other artists, to have their autonomous works simulate the desired effect of an architectural, religious framework. At the Berlin jury-free 'Exhibition of Religious Art' of 1927, Otto Hitzberger and Joseph Thorak contributed to altar-space installations, while Walter Kampmann conceived his own *Kultraum* (Cult Room). Thorak presented a life-size figure, *Der Gekreuzigte* (The Crucified), which stood with arms raised out against an invisible cross in a grotto-like 'chapel' designed by the architect Edgar Hönig and decorated by the Berlin expressionist painter, Willi Jaeckel.[33]

The expressionistic architectural sculpture during this period was most remarkable on the exteriors of sites where the sculptor strove for an integration with the surrounding space and with the function of the interior. Inducing the individual into a heightened state of spiritual devotion was crucial for Will Lammert with his monumental *Mutter Erde* (Mother Earth) figure which recalled Egyptian and Mexican/Aztec sources (fig. 9). It was executed in ceramic blocks and placed over the vertical entrance of the main façade of the crematorium at the Southwest Cemetery in Essen in 1926.[34] It formed the centrepoint of a group of relief and free-standing sculptures for the cemetery site. Thus, looming over this 'entrance to heaven' was the representation of an ancient goddess of fertility on Earth, carrying six bodies whose ashes will be borne into new life. Will Lammert had contributed a sizeable body of work for civic sites in Essen from 1922 to 1929, but the majority were destroyed by the Nazis beginning in 1933, including *Mutter Erde*.[35]

In Bremen between 1925 and 1931 Bernhard Hoetger transformed a stretch of buildings on the Böttcherstraße into a medievalised and legendary setting. This opportunity owed much to his patron and their owner, the industrialist and coffee magnate, Ludwig Roselius. The manufacturer held idiosyncratic and nationalist beliefs in the potency of Germanic mythical origins. Hoetger embellished exteriors with an eclectic range of brickwork reminiscent of northern German Gothic architecture and incorporated a mixture of earlier relief and three-dimensional sculpture, in replica, as if once again a 'museum' framework could celebrate both the artist and patron.[36] For the climax of the street, Hoetger imbued the entrance façade of the *House of Atlantis* with a visionary decoration highlighted by an over-life-size, Nordic god-figure *Odin* (completed in 1931, no longer extant). Its treatment echoed Hoetger's series of Africanised sculptures from 1919-20, but the motif was also invested with the significance of a crucifixion, as part of

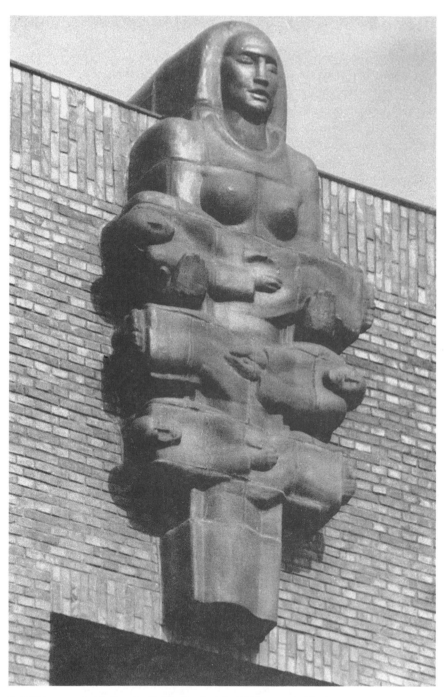

9 Will Lammert, *Mother Earth* (Mutter Erde), 1926, ceramic blocks

the overall *Lebensbaum* (Tree of Life) design. Furthermore, the figure was framed by a circular relief panel which depicted a symbolic programme of the signs of the zodiac. As Elizabeth Tumasonis has determined, 'This work was intended as an icon of a newly revived Nordic religion, which would precede a regeneration of the German race.'[37]

It is interesting that during this period Ernst Barlach was able to begin to realise several of the 'opportunities' he had earlier envisioned for religious architectural sculpture, such as commissions, predominantly of war memorials, for the Güstrow and Magdeburg Cathedrals (1927 and 1929) and for the University Church of Kiel (1928). His series of sixteen figures for the façade of the St Katharinenkirche in Lübeck, beginning in 1929, was to represent his most monumental act of service to a spiritual cause. But due to extreme public protest and resultant lack of financial sponsorship, only three figures were ever produced, which he named *Die Gemeinschaft der Heiligen* (The Community of Saints), or independently, *The Woman in the Wind*, *The Beggar* and *The Singer*.[38] They were the struggling, common people he had so often depicted, but he intended them in their final brick substance to merge with the Gothic brick west façade, and we can thus interpret this 'Community' as stepping out to represent the holiness of all mankind.

By the late 1920s the socio-cultural aspirations of the expressionist phenomenon in Germany could not be made to serve a function any longer. But through its sculpture of two decades the complex expressionist impulse, as outlined above, went beyond the perpetuation of aesthetic formuli of religious prototypes. Hence, it was insufficient merely to juxtapose illustrations like Barlach's *Relaxing Wanderer* with a Gothic high-altar carving of a reclining Moses, as was reproduced in *Das Kunstblatt* in 1917.[39] The sculpture's dual architectural/ideological frame demonstrated Expressionism's fundamental attempt to engage the individual's private space into an actualisation of communal and public devotion.

Notes

*The author gratefully acknowledges the support of the Social Sciences and Humanities Research Council of Canada, Doctoral Fellowships programme, and the kind assistance of Hans Tallasch, Böttcherstraße GmbH, Bremen; Marlies Lammert, Berlin; Detlev Wissinger, Lüneburg; Christoph Fischer, Berlin; Ursel Berger, Georg-Kolbe-Museum, Berlin; Matthias Schirren, Architecture Division, Berlin Akademie der Künste; and Petra Kuhlmann-Hodick and the archival and library research staff of the Städtische Kunsthalle Mannheim.

1 The prime example is Barron, *German Expressionist Sculpture*, pp. 13-28. Of great importance is Tümpel, *Deutsche Bildhauer 1900-1945 Entartet*, which contains the most recent survey of modern German sculpture labelled 'degenerate' by the Nazis.
2 Bushart, *Der Geist der Gotik und die expressionistische Kunst*. Pertinent to sculpture

is the section, 'Der Geist der Gotik und die Utopien der Nachkriegsjahre', pp.145-96.

3 Rarely did sculptors systematically alternate between specific 'primitive' styles, with the exception of Bernhard Hoetger and his production from c. 1907 onwards, which was often described as eclectic. On the question of the new *Stilkunst* see R. Breuer, 'Zwischen Gotik und Rokoko', *Deutsche Kunst und Dekoration*, XXXI, 1912/13, pp. 458-62; Bushart, *Der Geist der Gotik und die expressionistische Kunst*, pp. 25-92.

4 G. Kolbe, 'Moderne Plastik', in *Ausdrucks-Plastik*, catalogue for the fourth exhibition of the *Freie Bund zur Einbürgerung der bildenden Kunst*, Mannheim Kunsthalle, February-March 1912, p. 1. Hildebrand's treatise, *Das Problem der Form in der bildenden Kunst*, Strassburg, 1893, was published in ten editions by 1918. The third revised and expanded edition (1901) became the final and 'modern' version.

5 Hildebrand and his conception of planar relief space was also recuperated by Alfred Kuhn, a critic and promoter of expressionist sculpture, and interpreted as a version of the Gothic 'style'. See his *Emy Roeder*, Leipzig, 1921, p. 7.

6 See J. Heskett, *German Design 1870-1918*, New York, 1986, pp. 106-50.

7 For a comprehensive study on the 1914 Exposition, see: *Der westdeutsche Impuls 1900-1914. Kunst und Umweltgestaltung im Industriegebiet: Die Deutsche Werkbund-Ausstellung Cöln 1914*, Cologne, 1984; on Gropius's building with two illustrations of Marcks/Scheibe contributions, pp. 143-54. See R. Breuer, 'Die Cölner Werkbund-Ausstellung', *Deutsche Kunst und Dekoration*, XII/3, 1914, p. 433, which illustrates Kogan's frieze of dancers. Other progressive sculptors who participated in the Exposition were Georg Kolbe, Milly Steger, Hermann Haller, Ludwig Vierthaler, Will Lammert and Otto Hitzberger.

8 See D. Golücke, *Bernhard Hoetger: Bildhauer, Maler, Baukünstler, Designer*, Worpswede, 1984, pp.106-15, pp. 166-221, and on the 'TET-Stadt' pp. 238-49. Also Tümpel, *Deutsche Bildhauer 1900-1945 Entartet*, pp. 71-82.

9 On Bahlsen and the history of his factory see H. Kessler, *Hermann Bahlsen*, Hannover, 1969.

10 These works have been minimally researched to date; see S. Drost, *Bernhard Hoetger 1874-1949*, Bremen, 1974, work catalogue, nos 72-90 (no. 81: *TET-Göttin/ Sitzendes Mädchen m. Ahre)*; Golücke, *Bernhard Hoetger*, pp. 58-61.

11 'Sent M'Ahesa' was the stage-name of Else von Carlberg, a Swedish woman. See F. Winther, *Körperbildung als Kunst und Pflicht*, Munich, 1919, second edn, figs 85-9. On the bust see Drost, *Bernhard Hoetger*, no. 80; A. Beloubek-Hammer (ed.), *Mensch-Figur-Raum: Werke deutscher Bildhauer des 20. Jahrhunderts*, Berlin (East), 1988, no. 110, p. 270.

12 The title refers to a biblical dance of death. See J. Müller, *Milly Steger (1881-1948)*, Hagen, pp. 2-3 and fig. 1; Barron, *German Expressionist Sculpture*, pp. 198-9, fig. 1.

13 On Laban's 'architectonics' of space, see his manifesto text, *Die Welt des Tanzers*, Stuttgart, 1920. Also pertinent to dance's relationship to space and architecture is Winther, *Körperbildung als Kunst und Pflicht*, pp. 69-73. For historical critiques of many solo dancers see H. Brandenburg, *Der moderne Tanz*, Munich, 1921; for overview, M. Kuxdorf, 'The New German Dance Movement', in Bronner and Kellner, *Passion and Rebellion*, pp. 350-60.

14 It should be recognised that the far-eastern, Indian temple was also heavily propagated as a utopian centre for devotion; see Pehnt, *Expressionist Architecture*, pp. 52-3.

15 *Ibid.*, pp. 89-106; Boyd Whyte, *Bruno Taut and the Architecture of Activism*; *Arbeitsrat für Kunst 1918-1921*, Berlin, 1980; Weinstein, *The End of Expressionism*, pp. 23-106.

16 Quoted in Bushart, *Der Geist der Gotik und die expressionistische Kunst*, p. 179, note 151.

17 See Barron, *German Expressionist Sculpture*, pp. 37-42 and B. Ernsting, 'Scandalum Crucis – Der Lübecker Kruzifixus und sein Schicksal', in *Ludwig Gies 1887-1966*, Leverkusen, 1990, pp. 57-71.

18 See P. Behrens, 'Die Dombauhütte', *Deutsche Kunst und Dekoration*, XXVI/4, 1923, pp. 220-30 (with ten illustrations). A. Windsor, *Peter Behrens. Architect and Designer*, London, 1981, pp. 156-8.

19 Behrens, 'Die Dombauhütte', p. 226, illustration of *Auferstehung*. For related works see U. Berger, *Hommage à Richard Scheibe*, Berlin (leaflet, Heft. 2), 1984, fig. *Wächter*, 1922, and photographic documentation from the Scheibe-Archiv, Georg-Kolbe-Museum.

20 On the Taut/Freundlich collaboration, see C. Fischer and V. Welter, *Frühlicht in Beton: das Erbbegräbnis Wissinger von Max Taut und Otto Freundlich in Stahnsdorf* ('Geschichte und Hintergründe der Entstehung, Dokumentation der Restaurierung'), Berlin, 1989.

21 *Ibid.*, R. Wildegans, 'Otto Freundlichs Skulptur im Erbbegräbnis Wissinger', pp. 48-56.

22 The first version of the film was from 1915. On the film's narrative and sets (by Hans Poelzig and his future wife, the sculptor Marlene Moeschke) see Eisner, *The Haunted Screen*, pp. 56-63.

23 See W. Nerdinger, *Rudolf Belling und die Kunstströmungen in Berlin 1918-1923: mit einem Katalog der plastischen Werke*, Berlin, 1981, cat. nos 4-7, p. 224.

24 *Ibid.*, pp.44-7; P. Westheim, 'Auftakt des Architekturwollens', *Das Kunstblatt*, IV/12, 1920, pp. 366-73.

25 Nerdinger, *Rudolf Belling*, pp. 21-38, on Belling's piece and the artistic context of its production.

26 First quote from Bushart, *Der Geist der Gotik und die expressionistische Kunst*, p. 194; second from Nerdinger, *Rudolf Belling*, p. 24.

27 A. Kuhn, *Die neuere Plastik*, Munich, 1921, p. 105, pl. 51. For further reference and illustrations see also Kuhn, *Emy Roeder*, p. 11 and figs. 2 and 22.

28 See Kuhn, *Emy Roeder*, figs. 9-11, 23, 24, 28, 31.

29 From F. and H. Winther, *Der heilige Tanz*, Rudolfstadt, 1923, pp. 23-5, quoted by P. Guenther, 'Henning', in Barron, *German Expressionist Sculpture*, p. 98. On Bara see also E. Blass, *Das Wesen der neuen Tanzkunst*, Weimar, 1922, pp. 38-40; H. Szeemann (ed.), *Monte Verita*, Milan, 1978, pp.130-2; and Karl-Robert Schütze, 'Charlotte Bara', in *Mitteilungen des Vereins für die Geschichte Berlins*, LXXIII/3, 1979, pp. 320-2.

30 Guenther, 'Henning', pp. 98-9, plate 51.

31 Illustrated in Beloubek-Hammer, *Mensch-Figur-Raum*, p. 186.

32 Little research exists on late expressionistic sculpture. For commentary on 'institutionalisation' see W. Pehnt, 'Zum Verhältnis von Architektur und Plastik in den 20er Jahren', in *Entmachtung der Kunst; Architektur, Bildhauerei und ihre Institutionalisierung 1920 bis 1960*, M. Bushart, B. Nicolai and W. Schuster (eds), Berlin, 1985, pp. 55-60.

33 See exhibition catalogue *Juryfreie Kunstschau Berlin 1927*, 'Landes-Ausstellungs-gebäude am Lehrter Bahnhof', nos 1166-1326 and sections 'K, b / K, e / K, g' for texts on and reproductions of the installations.

34 See Marlies Lammert (sculptor's daughter-in-law), 'Werkverzeichnis' in P. Feist and M. Lammert, *Will Lammert*, Dresden, 1963, no. 42 and plate 26, p. 144.

35 For further documentation on Lammert's Essen period and subsequent defamation by the Nazis see M. Lammert, 'Dokumentation', in, *Will Lammert (1892-1957): Plastik und Zeichnungen*, L. Horst-Jörg (ed.), Berlin, 1992.

36 See Golücke, *Bernhard Hoetger*, pp. 114-15, 192-7, 206-15.

37 E.Tumasonis, 'Bernhard Hoetger's *Tree of Life*: German Expressionism and Racial

Ideology', *Art Journal*, LI/1, 1992, Spring, pp. 81-91 (p. 87).

38 The project had been initiated by Carl Georg Heise, the director of the *Museum für Kunst and Kulturgeschichte* in Lübeck. He published his interpretation of the works and recounted the historical context of their production in *Ernst Barlach: Der Figurenschmuck von St Katharinen zu Lübeck*, Stuttgart, 1956. For the catalogue raisonné entries, including the models, see F. Schult, *Ernst Barlach; das plastische Werk*, Hamburg, 1959, nos 352-8. Five more figures were completed in 1947, in terracotta, by Barlach's contemporary Gerhard Marcks. The eight now have their place in niches on the façade.

39 See *Das Kunstblatt*, I/4, 1917, p. 127; reproduced in Bushart, *Der Geist der Gotik und die expressionistische Kunst*, p. 98 (see also p. 97 and note 12).

7

Expressionist architecture today

Dennis Sharp

> Architecture is Symbol. Radiation. Tendency of order – music, of an
> impetus to the end. Embracing and dissolution. The building is no longer a
> block, but a dissolution into cells, a crystallisation from point to point. It is
> a structure of bridges, joints, shells and pipes. Shells, enveloping and
> discharging air between themselves like fruit. Pipe supports. Within it air
> flows making it firm and curved.
>
> Architecture is passionate love. Rearing. Revolving. Oppressed like us,
> jerking. Symbol. The flash of a fire signal. What transforms reality into a
> piece of art is the flash. The burning cities. The burning landscapes
> Architecture is the royal leader. All the materials are put into its hands:
> iron, steel and glass, wood and china, fabric and paper, out of which
> develops a sense for material structure and the build-up of any substance.
> Out of germinating walls furniture burst and long ago reedhuts of the
> natives grow into fantastic grass towers.
>
> Architecture, ingenious as a machine, as the underground train, the air
> cabin. Anonymous.
>
> Arthur Korn, 'Analytical and Utopian Architecture'.[1]

It can hardly be argued that expressionist architecture exists today.
There is no such thing. Its influence is acknowledged, however, and
what is apparent is the desire on the part of a number of architects to
revive and develop some of the ideas and to perpetuate characteristics
(if not the problems) of inter-war Expressionism. This is largely in
order to enrich their own work which can be characterised by its
vitality, current relevance and timeliness.

Much of this ongoing production is individualistic and self-suffi-
cient, architecture which expresses the designer's psyche. It is not an
architecture held in thrall by despair and anguish or displaying that
spiritual searching so characteristic of the expressionist period. It is
much looser, exciting, freer and technically more proficient.

We are constantly reminded that artists seldom admit to being
expressionist. Similarly, not many architects, with the possible excep-
tion of members of the so-called Amsterdam School and the editor of
Wendingen, would use the word to describe their work.[2] The term
Expressionism, itself, remains imprecise and its application to what

Pevsner and Richards called an 'anti-rationalist' tendency has proved thoroughly confusing.[3] This association is inadequate and has led many lesser critics to label as 'expressionist' any architecture that relies on free or irregular plan shapes, angular or curved external forms, jagged and complicated outlines. However, the architecture of this period had a much wider basis than angles, points and curves.

A break was demanded from the eclectic past, from existing analogous and stylistic anachronisms. References to the new dynamic angularity, to curved shapes and to free plans were not simply a contrast to more conventional Platonic solids but were an indication of the occurrence of fundamental changes in building and in the use of new materials. Expressionist architecture drew on a rich vocabulary from Cubist and Futurist sources on the one hand to pure and natural forms on the other (organic, or biomorphic, in the case of Hermann Finsterlin (fig. 10), and inorganic, or crystalline, in Wenzel Hablik's work). It was an atavistic and activist architecture inspired by historical and spiritual metaphors, particularly the Gothic.

Within the general movement of Expressionism, architecture played a significant, if somewhat peripheral, role. As a blueprint activity it was capable of creative speculation on a vast scale from single family dwellings of the graphically adventurous and biomorphic kind to complete utopias. This utopianism was an essential ingredient in the radical post-First World War dream of reconstruction. In the revitalisation of a battered and rudderless society the importance of creating a new environment was beginning to be explored. Bruno Taut's Scheerbartian glass dream (fig.11) and Mendelsohn's vigorous and freely sketched-out architecture in steel and concrete were two of the main components of the new symbolic and radical architecture

Erich Mendelsohn's building and drawings (fig.12) of the immediate post-war period recognised that there were new basic principles at work. These lay mainly in the use of materials such as glass, concrete and steel. The principles of loading had altered, as well. It was no longer necessary in an architecture made up from the new materials to carry loads vertically through columns. Those generated could be distributed over wall surfaces or concentrated into points of support through ribs and planes. Slanted and angular wall surfaces were feasible, as were vast double-glazed walls. Analogies could be drawn with nature, both with organic and inorganic models. Skins could be stretched over armatures of structure as tightly as a wet-suit. Plastic surfaces, as adventurous as Mendelsohn's *Einstein tower* (figs 13 and 14) in Potsdam of 1919 or Steiner's *Goetheanum* (1923), looked as if they

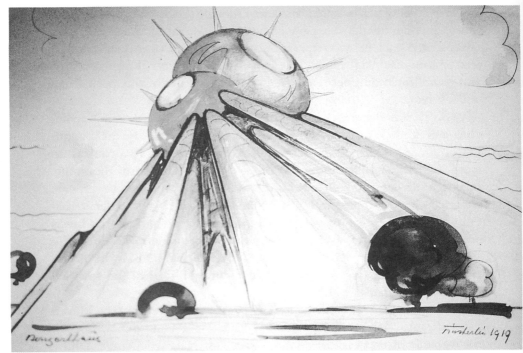

10 Herman Finsterlin, Utopian sketch for *Atlantis*, 1920s

11 Bruno Taut, elevation of the *Glass Pavilion* with a Scheerbart aphorism, 1914

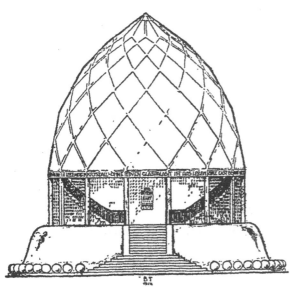

DER GOTISCHE DOM IST DAS
PRÄLUDIUM DER GLASARCHITEKTUR

might have been created from upturned baking moulds. The dynamic principles behind this new architecture were directly related to their flowing economic and exquisitely compact forms. Some projects – Mendelsohn's cinema, optical factories and aerodromes for example – attempted a shaping that corresponded emphatically with the building's function. This fact has not escaped more recent literalists like Herb Greene in the United States whose evocative *Prairie House* in Oklahoma seems to resemble a full-blown buffalo, although it has already been dubbed a 'prairie chicken' in deference to its feathered surface rather than to its scale! In the same vein the Spanish engineer-architect Santiago Calatrava invests his language of form with metaphors that derive from skeletons and birds.[4]

It is interesting to examine the atavistic notions that underscore the generic expressionist architecture of Bruno Taut. In the folio *Alpine Architektur* (1919), he revealed a passion to restore deep human values in the souls and minds of his countrymen. Attempting to revive hope, Taut conceived of a new society located in the safety of the Alps in luxuriant gardens where art and the 'delight' in building would thrive. This was set against a backdrop of an architecture of luminous, evocative and coloured crystal, an idea inspired by his mentor, the expressionist poet Paul Scheerbart. 'Crystal masts border the way,' he wrote in one of his captioned drawings, 'They sparkle in the sun; particularly the tallest ones which revolve in light. Crystal standards. Landing pads for aerial landings.'[5]

Taut's other idea for a *Stadtkrone* carried echoes of Howard's Garden City manifesto – a document that had been taken up with fanatical

12 Erich Mendelsohn, sketch for the proposed Astronomical Tower for the Potsdam Observatory, 1919

intent in Berlin and Dresden.[6] Demanding the humanistic and artistic renewal of an idealised Berlin, Taut claimed that modern society would insist on building cities with their centres entirely devoted to the arts and culture. These would be free from purely commercial considerations and conceived in terms of arcades and meeting places, with theatres, museums and libraries. Hence, Taut's idea was the very antithesis of Sant' Elia's *Città Nuova* or Le Corbusier's 1925 skyscraper project. Disappointingly, however, just like both these other utopians, he gradually allowed people to be subsumed by the grandeur of his own aesthetic vision. In *Alpine Architektur* and other projects, he created a number of images that bear more resemblance to scenes from Fritz Lang's *Metropolis* than Howard's Arcadia at Letchworth. Nonetheless, the one lesson Taut's projects do contain is that they were directed to the total regeneration of mankind in order to restore confidence and faith in the devastation resulting from the First World War.

Perhaps one might have expected that the same sort of idealism would have accompanied the Second World War period, and in a way it did. Homes for heroes, post-war reconstruction opportunities and the urban redevelopment, new town and city programmes throughout Europe all ushered in a utopian mandate. But Expressionism had been left far behind and the architecture of the newer modern International Style prevailed. There were the exceptions of course with a few bizarre experiments in mass housing in France that took the expression of *joie de vivre* quite literally, with huge murals, coloured surfaces and curved walls. Some concrete sculptural essays for churches and halls were built but until the sixties few alternatives of significance emerged that could be called neo-expressionist.

In the late 1920s a few new waves of expressionist architecture had ebbed and flowed. They carried the flotsam of the old ideas forward as each new wave broke on new shores. Max Reinhardt – an important patron of Poelzig's expressionist architecture – transferred his stage shows to the USA and linked up with theatre architect Norman Bel Geddes to produce a number of expressionistic sets including the full-blown drama *The Miracle*. Bel Geddes in his many projects showed a keen awareness of the dramatic nature of expressionist buildings and drew angular, curvilinear and crystalline theatre projects of his own, some of great originality.[7]

Norman Bel Geddes may have brought a fresh approach to the architecture of Expressionism, but the original concepts of the 1920s remained the prerogative of those who had developed them. Peter Behrens went on to work for IG Farben in mid-decade in an

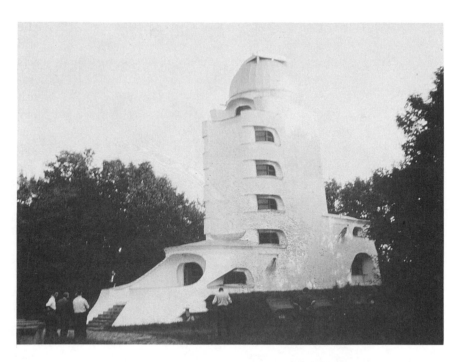

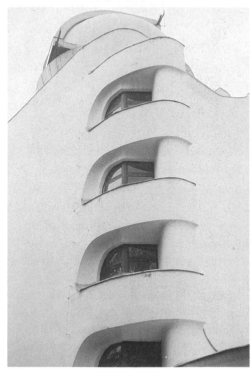

13, 14 Erich Mendelsohn,
general view and detail of
Einstein Tower, Potsdam, 1919

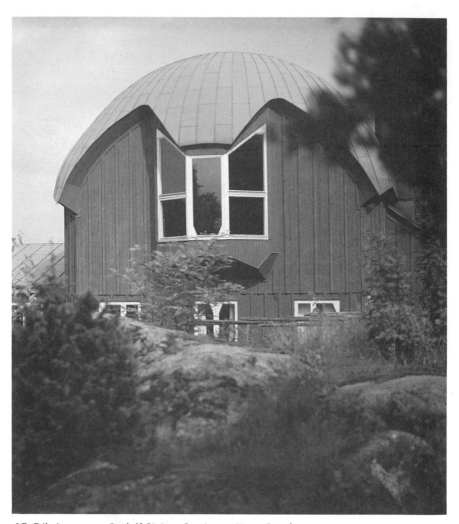

15 Erik Asmussen, *Rudolf Steiner Seminary*, Järna, Sweden

expressionistic mode. Frederick Kiesler (1890-1965) took his ideas to the States in the late 1920s where he developed his 'Endless' projects. For a short period Mendelsohn came to Britain where among other activities he produced (with Serge Chermayeff) the De la Warr Pavilion at Bexhill-on-Sea, the most Germanic building in Britain. It is distinguished by its expressionistic and flowing curved staircase and great glass walls. However, the term Expressionism was not used in Britain to describe architecture by anyone other than H. G. Scheffauer, a US-based German journalist and playwright, who contributed articles on the architects Taut, Poelzig and Mendelsohn to the *Architectural Review* in the late 1920s. Indeed few critics in Germany, with the exception of

Oscar Beyer, Adolf Behne and Gustav Platz, employed the term at all in relation to architecture.

At the end of the 1940s the distinguished Italian architect, editor and critic Bruno Zevi maintained that the phrase 'Expressionist Architecture' really meant nothing at all. What was important, he argued, was not the progeny of such a term, but the understanding that all architecture is organic and arranged: 'There is no architecture unless it is organic, but also there is no architecture unless it is at the same time arranged.' In this quotation from his celebrated (if now somewhat overlooked), *Towards an Organic Architecture* (1949), Zevi was playing upon the two words 'Organic' and 'Arranged' used by Claude Bragdon, an American architect, mystic and man of the theatre who acted as Louis Sullivan's editor and was an enthusiastic advocate of Sullivan's kind of Organic Architecture.[8] Bragdon's further words, that architectural design is the result of the 'melting and fusing by creative heat' – what he called the organic-psychic – were delivered to the Chicago Art Institute in 1915 but might just as well have come from a German Expressionist source. Bragdon was referring to the production of organic architecture, 'the architecture of democracy' as he was to call it. His ideas and words are particularly pertinent to this subject. I stress the value of the words at this juncture because so much work that is of an overtly symbolic or expressive kind is nowadays more often than not referred to as 'organic', as sculptural and individualistic. There are certain similarities in the current usage of the word organic and in the original uses of the term expressionist in the twenties that best describes an architecture with spiritual overtones and characteristics, although it cannot be said that there is either an organic or an 'expressionist' style as such. Both impulses really lack cohesion. Yet beyond that debate which inherently arises over their definition, the terms have proved useful in recent architectural discussions.

Probably one of the best demonstrations of this, and one that leads into a broader discussion of recent architecture is to be found in Arthur Drexler's *Transformations in Modern Architecture*, which originally formed the catalogue for the Museum of Modern Art's 1979 exhibition of the same title.[9] For Drexler, 'latter-day Expressionism', is exemplified in the sculptural work of the angular, faceted and largely opaque masses of Gottfried Böhm's churches. Indeed, he stresses that post-war interpretations of Expressionism (and Cubism) 'are seen primarily as the invention of sculptural form'. Thus, it is seen in schemes in which structural design dominates, in the work of New Brutalism in particular, as well as in regional and vernacular architecture.

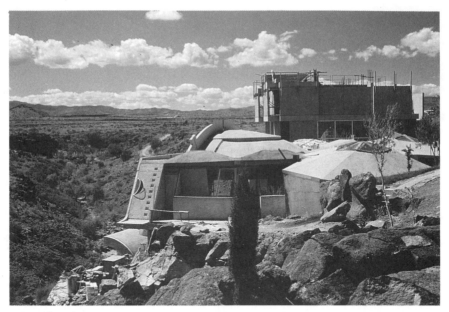

16 Paolo Soleri, *Arcosanti*, Arizona

One can detect this in relation to the buildings of the Hungarian avant-garde, the so-called 'Green' buildings and in the work of those who follow the holistic theories of Rudolf Steiner. Anthroposophical architecture, exemplified in the work of architects like Erik Asmussen at the Rudolf Steiner Seminariet in Järna, Sweden (fig. 15), and the Waldorf schools of Billing Peters and Ruff in Germany, relate architectural ideas to nature, living organisms and even bodily metaphors in the pursuit of curvilinear rather than rectilinear buildings. As Drexler says, such architects are concerned 'with the psychological effects of enclosure' and argue for a genuinely radical break with all forms of right-angled, cellular composition.[10]

Freedom, individualism and the dynamic nature of form motivate the work of these designers who hark back to the biomorphic forms, cave- and tower-motifs of Expressionism found in the work of Poelzig, Taut, Mendelsohn and Finsterlin. The range of contributors is wide, from Soleri to Calatrava and Frei Otto and even to the cave-houses of Arthur Quarmby. It is to visionaries like Paolo Soleri that one must look to see the assimilation (or the reinterpretation) of expressionistic utopian ideas for settlements, although Soleri himself seems to know little about German Expressionism *per se*.[11] Featured in Conrad's and Sperlich's *Fantastic Architecture* as early as 1959, Soleri's own interest in the expressionist period was retrospective. Initially he put forward his

views in terms of philosophical principles derived from the Catholic theologian Teilhard de Chardin. Gradually he developed his own thesis for his Arcologies (architecture plus ecology), building his prototypes and transferring them to a mesa site at Cordes Junction, Arizona (fig. 16), which now has enough structures on it at least to constitute a *cultural* core, à la Taut!

Reyner Banham referred to Expressionism as a SILENT ZONE in his magisterial *Theory and Design in the First Machine Age*, first published in 1959. He was one of the first architectural historians to explore the subject with any real seriousness, the short chapter in his book called 'Expressionism, Amsterdam and Berlin' providing a useful summary of bipartite developments in these places.[12] However, his view that expressionist architectural ideas were merely late manifestations of attitudes to design that had been part of the main body of European architecture before 1914, was inaccurate. Rather, they can be seen as a pillar placed in a cultural bridge that clearly spans the stream of creativity from *Jugendstil/Art Nouveau* to the period of individualistic Expressionism after 1914. In its sculptural sense it still continues today. Perhaps the most obvious example of a modern sculptural approach is the hugely successful and emblematic Sydney Opera House by the Danish architect Jorn Utzon. It is as clear an example of expressionist architecture today as anything that one can think of. Its roots can clearly be seen in relation to the biomorphic sketches of Finsterlin and his followers.

Hans Scharoun's Berlin Philharmonic Hall (1956-63) also springs to mind as a modern, if not a literal example, of late- flowering Expressionism. It also provides a direct connection with the original expressionists and the general movement; Scharoun was a young and enthusiastic member of Taut's Glass Chain Group whose richly planned work remains a key element in latter day organic/functional and internationally recognised architecture. The Berlin *Philharmonie* also provides a pertinent reminder of the desire of expressionists to design a cultural vessel in which all the arts could come together in a symbolic celebration of art and life.

Notes

1 Extract from English translation in D. Sharp (ed.), *Planning and Architecture*, London, 1967, pp. 162-3, essay originally published in P. Westheim, *Das Kunstblatt*, XI-XII, 1923, pp. 336-9. Arthur Korn (1891-1978) was my tutor at the AA School, London, and I owe my interest in German expressionist architecture to his inspiration.

2 See D. Sharp, *Modern Architecture and Expressionism*, London, 1966, for an attempt to define Expressionism and 'Expressionist Architecture'. Also, W. Pehnt, *Expressionist Architecture*, London, 1973.

3 N. Pevsner and J. Richards, *The Anti-Rationalists*, London, 1973.

4 See A. Tischhauser, *Calatrava: Dynamische Gleichgewichte/Recent Projects*, Zurich, 1991. The essay by T. Kobler, 'Dynamic, Mimetic and Geometric Forms in Santiago Calatrava's Work', is particularly revealing.

5 *Alpine Architektur*, a series of watercolour plates, was published in Hagen, 1919. It was reproduced in black and white form in an English translation in D. Sharp, *Glass Architecture: Alpine Architecture*, London, 1972, pp. 75-127.

6 *Die Stadtkrone*, also published in Hagen, 1919, was dedicated to the memory of Paul Scheerbart who died in 1915. Taut's Glass Pavilion at the Werkbund Exhibition in Cologne, 1914, was also dedicated to Scheerbart.

7 Norman Bel Geddes's designs were widely published in the USA. See, in particular, 'Six Theatre Projects', *Theater Arts*, XIV, 1930. A recent article summarising Geddes's work in the US is W. Condee, 'Norman Bel Geddes, Architect of the Modern Theatre', *World Architecture*, XV, 1991, pp. 48-51.

8 B. Zevi, *Towards an Organic Architecture*, London, 1949. Zevi drew on Claude Bragdon's undated essay (c. 1915) published in *Architecture and Democracy*, New York, 1918, pp. 46-59.

9 A. Drexler, *Transformations in Modern Architecture*, New York, 1979.

10 For a discussion of the Rudolf Steiner Seminariet at Järna, Sweden, see G. Coates and S. Siepl Coates, 'More Holistically than Thou?', *World Architecture*, VI, 1990, pp. 58-68. A special issue on Erik Asmussen's work appeared in the journal, *Architektur*, VI, 1984, July-August.

11 There is extensive literature on the work of Paolo Soleri, including his own monumental publication, *Arcology: The City in the Image of Man*, Cambridge, 1969. See also P. Soleri, 'Two Suns Arcology', *AA Quarterly*, VII/2, 1975, pp. 33-41, and the supplement, D. Sharp, 'Paolo Soleri', *Building*, 10 November 1972, pp. 75-82.

12 Undoubtedly, Reyner Banham, together with Professor Nikolaus Pevsner, brought expressionist architecture to the notice of English readers in exploratory articles, in particular, 'The Glass Paradise', *Architectural Review*, 1959, February, pp. 87-9. Scheerbart's *Glasarchitektur* was re-issued in German in the Reihe Passagen series, Rögner and Bernhard, Munich, 1971.

Expressionism and film:
the testament of Dr Caligari

Werner Sudendorf

In recent years, cinema in the Weimar Republic has been the subject of numerous cultural and historical investigations. Some of its elements have been analysed in terms of theme and motif. In psycho-sociological studies the medium has also been interpreted as an expression of modernism which has relevance even today. This essay does not concern itself with *Doppelgängers*, magicians, or the innocent woman and the monster. My interest lies in the effect which Expressionism has had on the development of cinema as an independent, not borrowed, language of image and form.

There is great confusion over the definition of expressionist cinema. Referring to literature on the subject, one will encounter authors who include only German films made between 1919 and 1924 in this category.[1] Others trace expressionist elements to the cinema of today.[2] In his pioneering work *Expressionism and Cinema*, Rudolf Kurtz studied only *Caligari* and five other explicitly expressionist films;[3] however, he also established a relationship between Expressionism and the pure or abstract films by Hans Richter, Viking Eggeling and Walter Ruttmann. Leonardo Quaresima, an Italian specialist in expressionist cinema, recently pointed out that German critics at the beginning of the Weimar Republic already perceived elements of Expressionism in films preceding Caligari.[4] As examples he cites Robert Reinert's *Nerven* (Nerves) and Ernst Lubitsch's *Rausch* (Ecstasy) which were both made in 1919. But the confusion I referred to was probably initiated by the subtitle of Lotte H. Eisner's history of cinema, *The Haunted Screen*: *Expressionism in the German Cinema and the Influence of Max Reinhardt*, which first appeared in French in 1952.[5] Suddenly, all the classic German films made during the Weimar Republic were termed 'expressionist'. Lotte Eisner's efforts to clarify this misunderstanding have been tireless; in 1958 she seemed almost resigned when she wrote, 'alongside Caligari, the only purely expressionist films are *Von morgens bis mitternachts* (From Morning till Midnight) and especially the third

cycle of the *Wachsfigurenkabinett* (Wax Works).'[6]

We could probably discuss at length the elements in Murnau's films which are or are not expressionist. I would prefer not to dwell on this rather academic question and to proceed by naming major characteristics of expressionist cinema: the instability of definition and the uncertainty surrounding its canon. Due to this state of affairs, the classification 'expressionist cinema' has frequently been used as an operative term to describe a group of films that refer to the same cultural and historical background. These are usually of the fantastic-romantic genre and are also characterised by extreme if not eccentric set designs, combined with lighting and camera-techniques, which distort perspectives. This very broad definition would, in fact, include a wide range of very different German silent films, but also American films of the *film noir* genre or those by Orson Welles. It would even extend to films, such as *Barton Fink* by the Coen brothers and Woody Allen's film *Shadows and Fog*. It is not my intention to condemn this list of films as incoherent; it does, however, lead to a quite arbitrary set of rules, to the point where the term becomes devoid of any real meaning.

Why then is there this lack of a clear definition? Several reasons may be given which relate to the medium of film in general and to *The Cabinet of Dr Caligari* in particular. This is why *Caligari* will be the focus of my argument, although much has been written about it already. I do not intend to analyse it as an individual film, but as a prototype.

First of all, I would like to consider the situation of cinema in Germany between 1914 and 1920, the years before *Caligari* was made. As one may well be aware, Expressionism in German cinema only emerged at a relatively late date. Cinema differs from theatre, literature and graphic arts, in that it is not only an art form, but also a commercial product. It is therefore an integral part of the industry which makes a living from its distribution and also of the public who accepts or rejects this art-product. Consequently, the characteristics of style in cinema, more so than in other areas of artistic endeavour, depend not only on the autonomous decision of an artist, but on a much larger number of non-artistic factors.

German cinema and the production of films in Germany during the First World War were largely isolated from international developments. Films were made almost exclusively for the domestic market. Although there were a few exceptions, such as *Homunculus*, the screen was dominated by domestic servants, dramas, comedies, detective films and politically inspired series. After 1918, the trauma of a lost war found expression in socially-aware dramas or, what one would call nowadays,

social soap-operas. In these films, father-figures, who have become alienated from their sons, turn the rocky road of life into a hopeless battle with destiny and finally sacrifice their lives. Towards the beginning of the twenties, sentimentalism, self-pity, a narrow-minded sense of honour and melodramatic behaviour went hand in hand in popular cinema. Feelings of despair, resignation and anger among the population are combined with an ever-present feeling of the temporariness of all actions. Planning for the future loses all validity, there was only room for strategies for survival. Daily life was permeated by irrationality and a lack of understanding. In this context, German cinema found images of magicians, mad people and artificial creatures, who played arbitrary games only explicable with the existence of an imaginary diabolical spirit. It moved into the world of apparitions where it transformed speculations about an unsettled present and an uncertain future into images of a frightening, unknown territory of supernatural powers.

A list of the films made in 1920 in Babelsberg, German's biggest film studio at the time, illustrates this traumatic spellbound gaze, fearful and, at the same time, delighting in this fear: *Sieger Tod* (Death the Victor), *Tötendes Schweigen* (Killing Silence), *Das Blut der Ahnen* (The Ancestors' Blood), *Die Augen der Maske* (The Eyes of the Mask), *Die Tophar Mumie* (The Tophar Mummy), *Das Zeichen des Malay* (The Sign of the Malay), or *Die Jagd nach dem Tod* (The Hunt for Death). All these titles give a name to the experience of a latent and omnipresent threat which is fascinatingly alien and potentially destructive of life.[7]

This was the context in which *Das Kabinett des Dr Caligari* (The Cabinet of Dr Caligari) was released in 1920. It was in many ways an experiment for the film industry and its novelty and revolutionary techniques were to have a radical effect on the making of films. These lay in its setting (fig. 17), an entire universe compressed into an extremely small space, the decor which was representative of social strata and the expressive performances of Conrad Veidt and Werner Krauss. The combination of all these elements, the emphasis on total artificiality and the conscious exclusion of nature, clashed with existing cinematic techniques.

Until then, cinema had followed more or less consciously the rules of naturalism, aiming for a close resemblance to nature. Scenes which were set outside would always be filmed in studios made almost entirely from glass, so that sunlight could still be used. Lighting effects as such only existed where sunlight was reflected. It is certainly true that sunlight was sometimes excluded for special effects or to create a

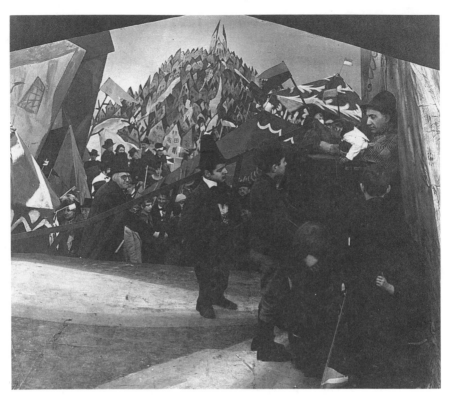

17 Scene from *The Cabinet of Dr Caligari*, 1919, directed by Robert Wiene

certain atmosphere; but never before had a world been created whose synthetic character had dared to emulate reality in such a radical way. As Béla Balázs wrote in *The Spirit of the Cinema* in 1924:

> The point is that a film only becomes a work of art when nature is stylised because, in cinema, nature as a neutral reality does not exist. Nature is always the environment and background to a scene and must carry, underline and accompany its mood.[8]

However, *Caligari* still shrank from the last radical change. A subtitle to the film explained that this was a madman's view of the world. Looking ahead a few years to Murnau's *Nosferatu*, nature, still recognisable as such, was altered to become a cipher for threat, turmoil and disaster. The production of an artificial reality, of 'synthetic nature', in cinema was *Caligari's* first achievement.

In this film, a conventional, not very spectacular form of narrative, joined hands with a completely unconventional, actually expressionist, setting. With this combination, the film managed to forge a link with 'high culture', the style of the period that found expression in litera-

ture, the performing and graphic arts, without offending the viewing habits of a mass audience. An example of this familiar and conventional narrative is the framework of the story in *Caligari*. This was definitely not, as some film-legends suggest, added at a later date, but it had been outlined in a somewhat different form in Carl Mayer's manuscript. Using flashbacks as a narrative framework is a technique which had already been introduced into the language of cinema as early as the first decade of the twentieth century.[9] *Caligari's* carefully balanced position between vanguard and convention made it a great success with the audience.

In contrast, its contemporary *Von morgens bis mitternachts* (From Morning till Midnight) which was more radical, especially in its use of camera-work, was rejected by the audience like all other films in the narrow field of purely expressionist cinema. *Caligari* was a risk the film industry had calculated carefully, and it may be interesting to know that Erich Pommer, probably erroneously known as the film's producer, spoke out vehemently against the making of its sequel *Genuine* one year later.

Caligari is without doubt the product of one of the film industry's more progressive strategies which involved targeting new audiences and entering the realm of 'high culture' by drawing on contemporary art movements. This strategy was already evident in 1913 in the film *Der Andere* (The other Man) featuring Albert Bassermann, a German example of the French 'art film'. Ufa, Germany's big national film studio, used the same strategy in 1928 by screening Hans Richter's pure or abstract film *Inflation* before a drama set during a time of inflation *Die Dame mit der Maske* (The Lady with the Mask). The same still happens today when recognised directors, such as Federico Fellini, direct the shooting of a commercial or a music video. Consequently, *Caligari* was much more than just an experiment; it was a well-calculated attempt to break away from the insalubrious triviality that dominated German cinema at the time, in order to reach for new audiences.

Leaving aside the economic aspects of this strategy, the creation of a synthetic world in a studio without lighting led to an essential discovery which was to leave its mark on the aesthetics of cinema - the discovery of light which requires darkness to become effective. Only a short while afterwards, Fritz Lang, a real pioneer in this field, was the first to insist that for his film *Dr Mabuse*, the realistic set of a street should be filmed in a dark studio. What had initially been a necessity, since the representation of *Caligari's* world was only possible in

artificial light, changed into an aesthetic principle. It was Lang's aim to expose the horror of demons working secretly in the real world, thus destroying the idea of a one-dimensional concept of reality with the use of magic. To achieve this, he aimed for total control over the representation of the world we are familiar with. In practical terms this meant an inversion of *Caligari's* principle. The latter had placed imaginary events in a fantastic setting, accessible to ordinary people only if they had lost their way. In Lang's *Dr Mabuse*, real events in an ordinary world became products of a sick, omnipotent imagination. 'What are your views on Expressionism?', *Dr Mabuse* is asked by his adversary Count Told. Mabuse answers, 'Expressionism is a game - but why not? Today, everything is a game.'

When *Dr Mabuse* was made, purely expressionist cinema was already dying out. Yet Lang adopted all the elements of Expressionism he could use in the visualisation of his ideas. Following Karl Heinz Martin's *Von morgens bis mitternachts*, he took the liberty of not colouring the film, but of showing it in black and white instead. Lang's work may be described as an amalgamation of different art movements, and we can therefore identify expressionist traces, as well as those of *Jugendstil* and *Neue Sachlichkeit*. Examples range from the framework narrative of *Der müde Tod* (Tired Death), through Alberich's underworld in *Nibelungen*, adapted from Poelzig's great playhouse (*Grosses Schauspielhaus*, Berlin), and finally to the exploding world of objects in *Das Testament des Dr Mabuse* (The Testament of Dr. Mabuse).

There are probably as many different myths regarding the origins of *Caligari* as there are about the discovery of Marlene Dietrich for *Der blaue Engel* (The Blue Angel). All versions agree, however, that the ideas of the architects Reimann, Warm and Röhrig gave the impulse for expressionist set designs. Crooked houses, zig-zags, streets narrowing in perspective, painted shadows and grotesquely towering cityscapes dominated the scenery. For the first time, cinematic architecture was given clear primacy, which also radically demonstrated that this concept could help create a dynamic link between actors, setting and the modelling force of light. Natural forms, architecturally abstracted, were turned into an extremely subjective experience of a world which was both synthetic and real. Other films like *Raskolnikoff* and *Genuine* adopted this striking style of architecture, but reduced it to a purely decorative and static plane, thus losing its dynamism. The revolutionary innovation evolved into a fashionable trend that proved to be fleeting. However, cinematic architecture, as a component of visual delight and dramatic emphasis, remained a significant stylistic element in German cinema.

With reference to popular cinema a critic wrote in the *Neue Berliner Zeitung*: 'In the experiment of *Dr Caligari*, the search for ever new sensations results for the first time in some kind of real cinematic style, and expressionist cinema in Germany is thus born.'[10] The emergence of expressionist cinema in Germany altered the understanding of film genres. This was of significance for future aesthetic practices and for society's perception of cinema. Thematic criteria employed to categorise films, such as detective films, educational films, popular or socially-aware drama, no longer dominated the definition of genres. They were replaced by stylistic elements which gradually crossed the boundaries of such definitions. The alpine-film (*Bergfilm*), for instance, was origi-nally a narrowly defined genre of a topographical nature. But its name was and is instantly associated with an aesthetic content. It is surely no coincidence that one of the first alpine-films, *Heiliger Berg* (Sacred Mountain) by Arnold Fanck, showed two lovers walking towards a dream-like landscape which could have been designed by Poelzig. Following in the footsteps of expressionist cinema a whole range of new film genres emerged which used similar elements although they were not entirely related to it: intimate theatre films, folk-stories, film novelettes and, finally, the pure or abstract film and those of the *Neue Sachlichkeit*.

Initially I spoke about the difficulties associated with defining the term 'expressionist cinema'. *Caligari* is a prototypical example of a film which initiated a latent development that would have emerged sooner or later, but not quite so vehemently. Alternatively, I might say: the effect of expressionist cinema on the development of cinema in general is comparable to a powerful flash of lightning. Its significance may be on a par with the discovery by Eisenstein and Russian revolutionary cinema of the principle of montage as a second source of modernism in cinema. Directly resulting from this were various small blazes - the relatively small canon of purely expressionist cinema. Indirectly, how-ever, its glow from afar is still visible today. Two examples will suffice to support this argument.

Artur Robison's *Warning Shadows* could be defined as a fantastic film, but also as a prototype of a psychological intimate drama. Its subtitle 'A Nocturnal Hallucination' throws light on to the film which is in fact an indulgent fantasy, a journey into the mind which opens the doors of the subconscious. Here again we encounter the classic formula: *Doppelgängers*, sleeping and awakening evil, the beauty and the beast, death and dreams, the medium and its travelling master.

Shadows is an intimate drama with nameless character types: the

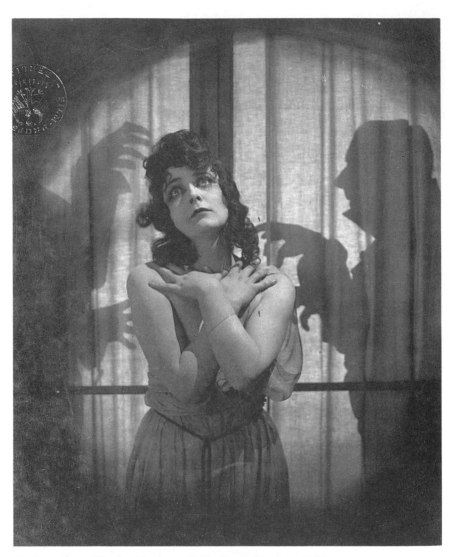

18 Scene from *Warning Shadows*, 1923, directed by Artur Robison

man, the woman, the lover, the guests, the servants, the magician. They are introduced in silhouette on a stage, and a curtain opens and closes each act. A shadow-play is performed, with the stage and the auditorium changing places. The audience becomes the cast, the film puts an end to the show, the dream begins. The really new experimental element in this film is the subject of appearances which may be deceptive. The director Robison does not keep his illusion a secret. In the prologue, the characters are introduced in silhouette. The magician stages a shadow-play for the evening guests who in turn become the

characters in the play. The silhouettes convey to us the experience of subjective truth. At the very beginning of the play, Robison hints at this. While the mistress of the house is getting dressed, the guests can see her moving silhouette (fig. 18). One after the other, they advance and trace her imaginary body. From the husband's perspective this looks as though the guests are actually touching her and the audience is deceived as much as the husband. In one scene, we see Kortner grimacing jealously; he leaves this scene and then reappears, this time unrealistically close to the camera. The face we believed to be real was in fact only its reflection in a mirror, but did that make it any the less real?

With his cleverly contrived set, Robison conveys a purely cinematic experience of space which has no reference to probabilities, but represents a reality in its own right. The central drawing room is also a stage, its festive dinner table is later transformed into a pagan sacrificial altar. Corridors lead from it to forbidden chambers of lust. But the walls seem to be alive. They are transparent and offer the possibility of a simultaneous glimpse of heaven and hell.

In these rooms, objects are alive, walls talk and every former point of reference is lost. The dream fades away, reconciliation, reward and a burlesque conclude the nocturnal drama. Nevertheless, there still remains a trace of uncertainty, a hint that maybe this was not just a dream. While the guests are leaving the house, the servant is sitting in the corridor by the door. Asleep, he is still clutching his mistress's necklace she had given him in the dream. The piece of jewellery fades away slowly, almost as if by magic, just as the figures in the dream do not disappear abruptly, but slowly flee from the dawning light.

As if these figurations from *Warning Shadows* had been resurrected, Kenneth Branagh's film *Dead Again* features a hypnotist, a sleeping beauty and the awakening evil, dream visions, and the beautiful woman with her husband/monster. And just as in *Warning Shadows*, future and past both meet in the context of a threatened present. Nothing could prove the relevance of Expressionism in the late twentieth century as clearly as *Dead Again* and Woody Allen's *Shadows and Fog*. Incidentally, the German translation of *Dead Again* renders it as *Shadows of the Past*. A more sophisticated translation might have been *The Testament of Dr Caligari*.

Translation by Ulla Knodt/Vick Mitchell

Notes

1 J. Kasten, *Der expressionistische Film*, Münster, 1990.
2 See J. Barlow, *German Expressionist Film*, Boston, 1982; F. Courtade, *Cinéma expressionniste*, Paris, 1984; M. Verdone, *Carl Mayer e l'Espressionismo*, Rome, 1969.
3 R. Kurtz, *Expressionismus und Film*, Berlin, 1926.
4 L. Quaresima, 'Der Expressionismus als Filmgattung', in *Filmkultur zur Zeit der Weimarer Republik*, U. Jung and W. Schatzberg (eds), Munich, 1992.
5 L. Eisner, *L'Ecran Démoniaque*, Paris, 1952; Eisner, *The Haunted Screen*, London, 1969.
6 L. Eisner and H. Friedrich, 'Stile und Gattungen des Films', *Fischer Lexikon Film-Rundfunk-Fernsehen*, Frankfurt, 1958.
7 For the production of silent films in Babelsberg see W. Sudendorf, 'Kunstwelten und Lichtkünste', in *Babelsberg 1912 Ein Filmstudio 1992*, W. Jacobsen (ed.), Berlin, 1992.
8 B. Balázs, *Der sichtbare Mensch*, Vienna - Leipzig, 1924. Now in B. Balázs, *Schriften zum Film*, I, Munich, 1982, p. 99.
9 See E. Dupont, *Wie ein Film geschrieben wird und wie man ihn verwertet*, Berlin, 1919.
10 F. Podehl, 'Der expressionistische Film', *Neue Berliner Zeitung*, 12-Uhr-Blatt, 7.2.1920.

PART III

Music

Musical Expressionism: the search for autonomy

Christopher Hailey

Music has few professed expressionists, so in the absence of volunteers historians have pressed into service a disparate selection of works found loitering in the intersection of the arts. In the traditional narratives of musical Expressionism Schoenberg's *Erwartung, Die glückliche Hand*, and Orchestra Pieces Op.16, Berg's *Wozzeck*, and Webern's compressed miniatures form a Viennese core around which are clustered an array of works by Strauss, Hindemith, Bartók, and Weill.[1] These composers – confederates of such expressionist insiders as Wassily Kandinsky, Oskar Kokoschka, Georg Kaiser, and that ur-expressionist Georg Büchner – are said to have captured contemporaneous impulses from artistic, literary, lyric, and dramatic Expressionism in music of rhapsodic fervour. They explored new expressive terrain by spicing heightened Romantic sensibilities with incursions into the chaos of the subconscious; anxiety and paranoia joined *Sehnsucht* and *Weltschmerz* in the arsenal of musical affects. This is musical Expressionism as eruptive revolt, as blind but progressive rebellion by fierce, disturbed prophets of a new age. One *hears* in their music what one *sees* and *reads* in the art, theatre, and literature of Expressionism – garish orchestration, dynamic, timbral and registral extremes that reproduce the violent juxtapositions of primary colours; drastic abbreviation and melodic angularity that mimic aphoristic lyric compression and contorted syntax; musical architecture with heightened rhythmic and formal contrasts that mirror a dramaturgy of fits, starts, and turns. It is above all in pushing ever further into that dense thicket of late-Romantic chromaticism that music's most radical 'expressionists' arrived at the final frontier of dissonant, athematic atonality, the musical equivalent of artistic abstraction.

Such depictions of musical Expressionism inevitably concentrate upon works rather than aesthetic programmes, upon stylistic hallmarks rather than artistic impulses, arguing backwards from qualities of style that suggest an affinity with isolated features in those arts in which an

expressionist programme was both articulate and intended. Lacking the testimony of manifestos and programmes, the narrative of musical Expressionism has always been more descriptive convenience than historical reportage, an evocation of a syntax that is distorted, violent, or emotionally tortured. So vague a concept can be (and has been) as readily applied to Charles Ives as Gesualdo, losing thereby both geographic focus and temporal specificity, and becoming nearly useless as a coherent historical category. The appealing analogies that seem to link musical Expressionism to the other arts are at best superficial similarities. As a category, musical Expressionism may be a useful 'adjective', but it is bad history. Its analogies attempt to situate selected works and composers in an aesthetic sensibility that was only marginally operative in musical circles. It is a category that is both insufficiently sensitive to differences between the arts and incapable of explaining the catalyst that between 1909 and 1924 drove those arts toward their intersection in the first place. What are the impulses that account for the pre- and post-war disjunctures in a movement whose energies were first intensified then dissipated by war, revolution, and inflation? Was the *Neue Sachlichkeit* that followed Expressionism a backlash, a sober reaction, a disillusioned regression, a rejection of bold exploration? Did a new generation recoil from the abyss to seek refuge in neo-classicism (just as Strauss is supposed to have shrunk from the terrifying consequences of *Salome* and *Elektra* in *Der Rosenkavalier*)? Or did pioneers of Expressionism such as Schoenberg and Kandinsky, grown older and more mature, lead the way in distilling and redirecting self-indulgent individualism towards responsible formalism? To insist upon Expressionism as a discrete chapter in the history of the arts is to invite ragged ends, because after the war most if not all of Expressionism's surviving practitioners went on to other styles and preoccupations. Where is the common thread that allows for the historical continuity of biography, the conceptual framework that takes into account the sources and ultimate goals of Expressionism, the narrative that addresses processes rather than properties?

One such narrative was formulated by Clement Greenberg in the late 1930s.[2] Drawing upon the critical writing of Walter Pater and Irving Babbitt,[3] as well as on his personal exchanges with the German-American pioneer of abstract Expressionism, Hans Hofmann (1880-1966), Greenberg maintained that the avant-garde of the late nineteenth century, born of the disillusionment of 1848, sought to rescue itself from society's ideological schisms by abandoning the idea of art as a 'vessel of communication' and according it its own self-sufficient value.

This avant-garde, propelled by the need for self-preservation, was undermined, however, by a Romantic legacy of aesthetic mixed signals in which art, literature, and music sought to imitate each other's traits and functions, in short, escaping the problems of one medium 'by taking refuge in the effects of another'. Music in particular, Greenberg thought, exercised a baleful influence upon poetry and painting, and was itself compromised by efforts to simulate narrative and pictorial effects in programme music. But for nineteenth-century aestheticians – from Tieck and E. T. A. Hoffmann to Schopenhauer and Hanslick – music was an art apart. Its innately non-referential abstraction offered a paradigm of 'purity' and 'self-sufficiency' which, Greenberg contends, brought avant-garde artists in other disciplines to the realisation that 'it is by virtue of its medium that each art is unique and strictly itself'.

Concentration upon the medium led to a search for ways of heightening its expressive resources, not, Greenberg insists, 'in order to express ideas and notions, but to express with greater immediacy sensations, the irreducible elements of experience'. However, in reaching for the immediate, for expressive limits, artists broke away from imitative realism and moved inevitably toward abstraction with its 'sterilization of the expressive factors'. In the process, Greenberg argues, avant-garde painting gradually surrendered 'to the resistance of its medium', embracing the flat plane of the canvas and abandoning the effort to create realistic perspectival space. By this means painters hoped to create art valid solely on its own terms, to turn away from the subject-matter of common experience towards inner experience related directly through the medium of the artist's craft. With inspiration derived from the medium, the medium itself – in painting that means tone, line, mass, colour – becomes the subject matter. Unfortunately, such self-absorbed artistic specialisation began a process of alienating an audience 'unwilling or unable to acquire an initiation into craft secrets.'

Greenberg, writing in the late thirties, was anticipating the triumph of abstract art. Today, fifty years later, awash in post-modernism, indeed from the vantage point of post-modernism, Greenberg's ideas take on new significance as a reading of those forces that shaped early twentieth-century modernism in art, architecture, literature, drama, cinema, and poetry. It is a stimulus demonstrably at work in music as well and was recognised as early as 1917 by the music critic Paul Bekker.

Bekker, born in Berlin in 1881, was active as a violinist and conductor before he turned to music criticism; by 1911 he had been appointed chief music critic of Germany's leading daily, the *Frankfurter Zeitung*. Bekker was a trenchant observer of contemporary musical life

and in his reviews, feuilletons, essays, and books he developed a body
of critical theory of singular influence and importance. In the midst of
the First World War, during which he served on the Western Front,
Bekker published an essay in the *Frankfurter Zeitung* entitled
'Musikalische Neuzeit' (New Musical Age), in which he lamented
music's continuing dependency upon extramusical stimuli that ranged
from poetry and painting to nature, history, and philosophy.[4] The
programme music of Richard Strauss, the Wagnerian *Musikdrama*, even
Brahmsian classicism, Bekker asserts, fed upon a Romanticism that
disdained organic self-containment and sought to embrace as many
opposites as possible. The universal ideal of the *Gesamtkunstwerk*
resulted in painters painting literature, poets writing music, and
musicians composing pictures. Music, with its innate abstraction, had
in fact forfeited its birthright in pursuit of a 'supra-individual union of
the arts' under its sceptre. But a healthy reaction was at hand. In the
visual arts Bekker found a

> striving for inner independence, towards liberation from the tutelage or
> collaboration with other arts. Painting for the sake of painting, drawing for
> the sake of drawing, recasting all the other means of expression borrowed
> from the other areas to expression that is pure painting, pure drawing.

Far from being puritanical withdrawal, far from abandoning the height-
ened emotion and broadened imaginative horizons of Romanticism, this
reaction sought rather to forge a variety of expressive impulses into a
single, ruling, medium-specific expressive value. 'Call it Cubism, Futur-
ism, Expressionism,' Bekker wrote, 'these are just names for various
attempts at solving the problem of transvaluation.'[5]

Music, Bekker reasoned, must follow a similar path and move away
from romantic multiplicity, with its influences from literature, philoso-
phy, and painting, and instead strive for organic unity, for solving
formal problems with means unique to the medium. This was likewise
no retreat, no surrender of the riches brought by the other arts, no
'heavy-handed reactionary simplification and abandonment of every-
thing in between', but the attempt to create 'new, independent,
uniquely musical values out of music.' The organic integrity of
Mozart's classicism was a model, but among his own contemporaries
Bekker cites Max Reger, Rudi Stephan, Ludwig Rottenberg, Franz
Schreker, Arnold Schoenberg, and especially Gustav Mahler as compos-
ers who sought to derive new values from musical syntax and form.[6]
Unlike Greenberg, Bekker felt that music's avant-garde, by speaking
again in terms of music and not ideas, could wean listeners from their

over-intellectualised need to understand music and teach them once again how to hear and feel it naively.

'Musikalische Neuzeit' was a decisive turning-point in Bekker's critical thinking and served as the bridge from the hermeneutics of his *Beethoven* (1911) and the music sociology of *Das deutsche Musikleben* (1916) to the music phenomenology of *Von den Naturreichen des Klanges* (1925) and *Organische und mechanische Musik* (1928). Through these and other works Bekker traced key aesthetic transformations he observed during the crucial years between 1910 and 1925. His profound knowledge of and sympathy with contemporary trends in music and art lend his critical writing authority and relevance when considering some of the more familiar documents of the period.[7]

Through its theosophic haze Kandinsky's *Über das Geistige in der Kunst* (Concerning the Spiritual in Art), 1912, is at heart an artist's meditation upon his medium, upon what Kandinsky called 'painting's two weapons', colour and form.[8] Compelled to confront the inner truths of their craft, painters had begun a journey towards abstraction, towards purely artistic composition. 'Consciously or unconsciously,' he wrote, 'artists are obeying Socrates' command – Know thyself. Consciously or unconsciously artists are studying and proving their material, setting in the balance the spiritual value of those elements, with which it is their several privilege to work.' Like Pater, Kandinsky looks to music's abstraction for inspiration and instruction in his search for expressive identity, and like Greenberg he is keenly aware of the dangers inherent in the superficial imitation of effects: 'One art must learn first how another uses its methods, so that the methods may afterwards be applied to the borrower's art from the beginning and suitably.' Thus, he continues, 'at different points along the road are the different arts, saying what they are best able to say, and in the language which is peculiarly their own. Despite, or perhaps thanks to, the differences between them, there has never been a time when the arts approached each other more nearly than they do today, in this later phase of spiritual development.'

Schoenberg's 'Das Verhältnis zum Text' (The Relationship to the Text), published in 1912 in the almanac of *Der Blaue Reiter*, is in many ways a musical pendant to *Über das Geistige in der Kunst*.[9] From Schoenberg's standpoint music's abstraction has been a curse, since there are so few capable of 'understanding, purely in terms of music, what music has to say.' Instead, people search for images and associations and are disappointed if they go away empty-handed. 'Nobody expects such a thing from any other art,' Schoenberg laments,

but rather contents himself with the effects of its material, although in the other arts the material-subject, the represented object, automatically presents itself to the limited power of comprehension of the intellectually mediocre. Since music as such lacks a material-subject, some look beyond its effects for purely formal beauty, others for poetic procedures.

Schoenberg longs for the day when music can declare its independence, assert its autonomy, and be judged on its own merits: 'One has to hold to what a work of art intends to offer, and not to what is merely its intrinsic cause.' It is with this argument that Schoenberg defends the works of Wagner and Mahler as musical organisms which achieve the highest goal, self-expression, through a unity of material and construction. 'In art,' Schoenberg writes, quoting Mahler, 'it is matter of appropriate means of expression!' This is the inspiration he draws from Kandinsky's manifesto and his own experience with the other arts:

> When Karl Kraus calls language the mother of thought, and Wassily Kandinsky and Oskar Kokoschka paint pictures the objective theme of which is hardly more than an excuse to improvise in colours and forms and to express themselves as only the musician expressed himself until now, these are symptoms of a gradually expanding knowledge of the true nature of art. And with great joy I read Kandinsky's book *On the Spiritual in Art*, in which the road for painting is pointed out and the hope is aroused that those who ask about the text, about the subject matter, will soon ask no more.

It is no surprise that Schoenberg was drawn not to the biomorphic architecture of the Rudolf Steiner church or the grotesqueries of the Reinhardt theatre in Berlin but to the austerity of Adolf Loos's Haus am Michaelerplatz. Schoenberg's aesthetic precepts were never overtly 'expressionistic' but motivated, like those of Loos, by a quest for functional integrity and a moral crusade against extraneous ornament. Here, and not in superficially analogous surface qualities, is where we must begin to seek the impetus that brought musicians and the expressionists together. Here is where contradictions disappear and paradox begins.

Reading Greenberg, Bekker, Kandinsky, and Schoenberg, not to mention Pater, Babbitt, and others, suggests that the key to exploring music's relationship to Expressionism begins with the nature of the medium itself, its self-referential abstraction. From Wackenroder to Pater, E. T. A. Hoffmann to Schoenberg, it is this very non-representational abstraction that has accounted for music's mysteriously transcendent expressive power. Intensification of musical affects – as opposed to lateral augmentation through association with other arts – implied a narrowing focus upon the materials of music, toward purity of purpose and a union of means and ends. Herein lies a central paradox of

Expressionism, for its aesthetic of bold directness, its tendencies away from imitative realism, away from the material and toward the spiritual, are achieved by means that are concretely, emphatically material. The focus upon constituent elements favoured an aesthetic of expressive extremes while at the same time fostering modernist formalism.[10]

Critical categories, whatever their merits, whatever their historical legitimacy, become false when they cease to challenge imaginative thought, when the glow of inquiry and conceptual discovery is replaced by the convenience of descriptive cliché, when the action of a verb becomes the descriptive stasis of an adjective. The clichés of Expressionism have inhibited critical inquiry into underlying causes and affinities. Seeking a broader perspective challenges us to re-examine works. Such a perspective is crucial to understanding how Schoenberg's atonal idiom developed into the twelve-note method, or how Ferruccio Busoni could move from the radical vision of his *Philosophy of a New Aesthetic of Music* of 1907 to an espousal of 'young classicism' in his 1919 open letter to Paul Bekker.[11] Such a perspective also suggests how forays into opera and across disciplines were driven less by a need for enrichment – the Romantic union of arts – than by the ambition to amplify each discipline from its core. Consequently, one might ask whether the diverse means of Schoenberg's *Die glückliche Hand* are not used to serve essentially musical ends, or those in Kandinsky's *Der gelbe Klang* artistic ends. Certainly such was the case with the birth of modern dance, where a new language and subject-matter grew out of the expressive medium – the human body. Gordon Craig sought to tap similar energies for the theatre, and in this light Strauss's volte-face after *Elektra* is no fearful retreat but a creative response to Hofmannsthal's restless exploration of the very idea of theatre from Greek drama to classical comedy, commedia dell'arte, and beyond. The engine driving change, then, was medium-specific autonomy, with Expressionism functioning like a railway turntable, or better still, a gear-box for engaging with and invigorating the medium. Like Antaios, early twentieth-century artists were rejuvenated by contact with the earth of their medium. The arts were thrust toward their intersection not by visions of a *Gesamtkunstwerk* but by a fierce centripetal force unleashed by the individual arts as each became the vortex of its own renewal.

Expressionism's intensity, the very primacy of expression, was more a means than an end, and once achieved, that end – medium-specific autonomy – allowed the means to be modified or abandoned. Extreme subject matter, like abstraction and dissonance, was a possible but not necessary consequence of this new way of seeing, a seeing that was

influenced by the medium and its attributes. Kandinsky's later abstract painting, for instance, by no means eschews representational motives or meaning, but rather seeks to adapt them more fully to a medium which does not deny its native properties.[12] In music, identifying Expressionism with stylistic categories such as dissonance and atonality has obscured critical appreciation of profound ties between composers as diverse as Stephan, Schreker, Reger, and the Second Viennese School. What is more, neo-classicism and *Neue Sachlichkeit*, as well as the music phenomenology of the twenties, are not so much reactions to as extensions and natural consequences of Expressionism, suggesting parallels with the eighteenth century, when neo-classicism and *Sturm und Drang* co-existed, indeed, fed from the same sources in the works of Haydn and Mozart, Gluck and C. P. E. Bach, Goethe and Schiller. Like the *Sturm und Drang* movement, Expressionism was in a sense not so much revolutionary as profoundly reactionary, a kind of taking stock, a critical reassessment as in Lessing's *Laokoön*, a search for purification and necessary prelude to an aesthetic of classical balance.

It is certainly not the intent of these remarks to force the considerable and varied energies of Expressionism into a formalist straightjacket or to imply that expressionist pronouncements were not the articulation of genuine aesthetic purpose. Indeed, few movements have been as highly coloured by ideology and exalted imagery. But letters, diaries, pamphlets, and proclamations can obscure the simple fact that these artists, musicians, poets, and playwrights had dirty fingernails; that the many solitary hours engaged with the rudimentary materials of their craft were the source of a profound exhilaration that infused the movement with its special passion. Theirs was not a 'search for the wild' but rather an inquiry into those forces that gave the wild its searing intensity. 'Like ourselves,' Kandinsky wrote of primitive craftsmen, 'these artists sought to express in their work only internal truths, renouncing in consequence all consideration of external form.' In their search for 'internal truths', for forms obedient only to inner tensions, expressionists, whether in music or art, were also seeking themselves, an identity ultimately defined by their own expressive vehicle, their medium.

Notes

1 Strauss's one-act operas *Salome*, 1905, and *Elektra*, 1908, occupy the place of precursors; early operas by Hindemith (*Mörder, Hoffnung der Frauen*, 1919, and *Sancta Susanna*, 1921, on texts by Oskar Kokoschka and August Stramm, respec-

tively) and Weill (*Der Protagonist*, 1925, on a text by Georg Kaiser) are often cited as post-war manifestations, while several of Bartók's post-war works, especially the ballet *The Miraculous Mandarin*, 1919, the Third String Quartet, 1927, and the Violin Sonatas, 1921 and 1922, are, by virtue of their harshly dissonant style, often considered related phenomena.

2 The following discussion draws primarily on Greenberg's essays 'Avant-Garde and Kitsch', first published in *Partisan Review* in the fall of 1939, and 'Towards a Newer Laocoön', first published in *Horizon* in September 1940; both essays are reprinted in C. Greenberg, *Perceptions and Judgments, 1939-1944*, J. O'Brian (ed.), Chicago and London, 1986, pp. 5-22 and 23-41, respectively.

3 Greenberg cites in particular Pater's 1877 essay, 'The School of Giorgione' and Babbitt's *The New Laocoön: An Essay on the Confusion of the Arts*, first published in 1910.

4 'Musikalische Neuzeit' was first published in the *Frankfurter Zeitung* on 29 July 1917; it was reprinted in Bekker's collection of essays *Kritische Zeitbilder*, Berlin, 1921, pp. 292-9.

5 It is interesting to note that Bekker's second wife, whom he married in 1919, was Hanna Bekker vom Rath, an artist, collector, and dealer closely associated with a number of first- and second-generation expressionist artists.

6 Bekker singles out Reger for his innovations in harmonic language, and Rottenberg, Schreker, Schoenberg and Mahler for their respective efforts to revitalise the Lied, opera, instrumental music, and the symphony. Rudi Stephan (1887-1915), who was active in Munich, was particularly noteworthy for a small body of instrumental works each bearing the generic title 'Musik für ...' (... Orchester, Geige und Orchester, etc). Stephan was a close friend of the expressionist writer Kasimir Edschmid and based his single opera on Otto Borngräber's proto-expressionist drama *Die ersten Menschen* (1905). He died on the Eastern Front in Galicia.

7 Bekker left his position at the *Frankfurter Zeitung* in 1923 and served as Intendant of the Kassel and Wiesbaden State Theatres from 1925-27 and 1927-32, respectively. In 1933 he left Germany for France, where he served as music critic for the émigré paper *Pariser Tageblatt*, and in 1935 he emigrated to the United States, where he wrote for the *New Yorker Staatszeitung*.

8 Quotations in the following discussion are drawn from W. Kandinsky, *Concerning the Spiritual in Art*, tr. M. Sadler, London, 1914.

9 This discussion of 'Das Verhältnis zum Text' uses the translation 'The Relationship to the Text' found in Schoenberg, *Style and Idea*, pp. 141-5.

10 In his excellent article 'Musikalischer Expressionismus', Jost Hermand arrives at a similar conclusion based in particular upon his reading of the writing of Heinz Tiessen (1887-1971), one of the few composers who at any point identified himself as an expressionist. Hermand's article is also valuable for its overview of the contemporary literature on musical expressionism.

11 Bekker's papers, including his correspondence with Busoni, are housed at Yale University.

12 In her recent work on Kandinsky, Peg Weiss has shown the degree to which symbols and images from the artist's earliest works can be found throughout his oeuvre. She has provided an illuminating discussion of this aspect of Kandinsky's art in relation to the artist's friendship with Arnold Schoenberg in 'Evolving Perceptions of Kandinsky and Schoenberg in the Twentieth Century: Toward the Ethnic Roots of the "Outsider"', a paper delivered at the conference 'Constructive Dissonance: Arnold Schoenberg and Transformations of Twentieth-Century Culture: Vienna, Berlin, Los Angeles' (15-17 November 1991).

'Wilde Musik': composers, critics and Expressionism

Peter Franklin

The opera has been denounced again as naive, as 'Kitsch';[1] and there, in one of its most characteristic moments, we have it: the street-lamps glimmer and die above the faded prostitute who abandons herself to her recalled theatre-experience ... 'Ach, die wilde Musik!' she murmurs, fascinated by the thought that its composer, the man she had once loved, still longs for her. The curtain falls and we, like Grete, are engulfed in the great 'Nachtstück' of *Der ferne Klang* Act III. In 1912 it delighted its first audience with its almost improvisatory accumulation of sighs, visions and flights of ecstatic abandonment that give way to a naturalistic dawn-chorus. However, in 1905 Franz Schalk had extended Grete's reaction to this 'wild' music by dismissing it as 'muddled, impossible stuff that will cause a scandal'.[2] That reaction anticipates scandals of the kind with which we like to validate the authenticity of canonic works of musical modernism, those of Viennese Expressionism not least. In the absence of contemporary manifestos defining the aims and characteristics of a specifically musical Expressionism, the term might even seem retrospectively applicable to Schreker's passionately expressive and apparently iconoclastic work. Yet it jars against our currently renewed experience of *Der ferne Klang*. The opera, whose compositional history stretches well back into the Jugendstil period, does not, after all, sound very much like the contemporary music of Schoenberg or Berg which has more conventionally come to be accepted as expressionist.

The reasons are not hard to find, given the more explicit implications of the term in the sphere of painting, drama and poetry. The wildness of Expressionism is not Grete's wildness. Hers is clearly alluring, liberating and overtly sensual in its promise of passionate self-realisation beyond the oppressive restrictions of the Real World which might, just might be like that, if only But that 'if only' was what historical Expressionism in its aspect as enacted criticism of bourgeois Art was most resolutely opposed to. Hard truth, born of expressive necessity,

not soft fantasy born of inner psychological need, was what Expressionism came to signify. Oskar Kokoschka, for example, recalled his proto-expressionist Viennese play *Mörder, Hoffnung der Frauen* of 1909 as a piece of improvised provocation: 'The wild atmosphere was intensified musically by drumbeats and shrill piping and visually by the harsh, shifting colours of the lighting. My performers, most of them drama students, hurled themselves into their parts as if acting for dear life.'[3]

As other papers in this book take care to point out, the theoretical difficulties of categorisation are legion in this field. By focusing a contradiction inherent in historical definitions of Expressionism, music, even that more familiarly associated with the term, valuably raises specific questions about improvisational spontaneity and the problem of culturally constructed 'form'. Although the concept of improvisation was alluded to by Schoenberg with reference to his manner of composition around 1909, his métier clearly remained composition – with its traditional labour of notation, scoring and part-preparation – for all that the music was to be born vehemently and uncompromisingly of what Kandinsky called 'inner necessity'.[4] Literal improvisation, as a performance activity, in fact played a marginal role in Viennese avant-garde music at that time. In painting the term was more frequently and precisely invoked, as in titles by Kandinsky to works that were often produced in the course of a spontaneous, quasi-improvisatory act of creation, whose impulsive speed violently rejected the 'composition' of the conservative studio.

This rough-hewn immediacy of execution – supposedly related to the art of children and those whom the Expressionists still liked to call 'primitives' – was specifically and polemically rejected by the anti-expressionist painters of the *Neue Sachlichkeit*, who thus assisted in a retrospective assessment of what the term Expressionism had come to imply by the 1920s, complex and often contradictory though the theories and developmental trajectories of individual artists may have been. In fact composers, Schoenberg included, very rarely used the term 'expressionist' in writing about themselves or each other. Nevertheless, Schoenberg's association with Kandinsky and the Munich *Blaue Reiter* encouraged others frequently to apply the term to him. His music was widely heard to be unpredictable, disruptive, chaotic and anarchic – all terms popularly understood to be descriptive of Expressionism. Characterisations of this sort were usually intended to be unflattering to Schoenberg, but Theodor Adorno was retrospectively to validate them in his more positive critical analysis of what he called the 'soul-seismographic' features of Schoenberg's expressionistic manner.

Erwartung was, in this reading, to be considered a 'psychological case-study' in music, a naturalistic registration of 'traumatic shocks':

> Radical music perceives ... the untransfigured suffering of man. His impotence has increased to the point that it no longer permits illusion and play. The conflicting drives, about whose sexual genesis Schoenberg's music leaves no doubt, have assumed a force in that music which has the character of a case-study – a force which prohibits music from offering comforting consolation. In the expression of anxiety as 'foreboding', the music of Schoenberg's Expressionistic phase offers evidence of this impotence. The monodrama *Erwartung* has as its heroine a woman looking for her lover at night She is consigned to music in the very same way as a patient is to analysis.[5]

In fact Adorno, in his tendentious reading of this phase of Schoenberg's development, highlights the problem about spontaneity to which I have referred. The unnamed Woman of *Erwartung* is, after all, an artistic creation; she has not composed her own opera, is a woman maddened to male order. Schoenberg has proceeded with the deliberate calculation of any artist inspired by intellectual conception to which he may wish to give artistic form, artistic 'expression'. I make this point in deliberate awareness of the blasphemy it entails so far as some of Schoenberg's own aesthetic pronouncements are concerned. These point still further into the problematics of Expressionism, not least as manifested in the 1930s debate that developed between Georg Lukács, the arch-critic of Expressionism, and other pro-modernist Marxists such as Adorno and Bloch. It will first be helpful to consider more closely the usage of the term 'Expressionism' in musical literature and criticism of the period 1909 to 1921.

That the term only arrived in general musical discussion after the First World War can be demonstrated by comparing the 1913 and 1921 editions of Walter Niemann's encyclopedic history of contemporary music. First published by Schuster & Loeffler in 1913 as *Die Musik seit Richard Wagner* (Music since Richard Wagner), the book had been retitled *Die Musik der Gegenwart* (Music of the Present Day) in 1921; the contents were fundamentally the same, although revised to take account of more recent developments and the effect of the First World War. The most interesting changes, for our present purposes, were in the third of the volume's four 'books', entitled 'The Moderns'. The relevant chapter in both editions follows consideration of Strauss and the New German School, then of Reger and the development of Brahmsian classicism. In 1913 the chapter's full title was: '*Der französische Impressionismus:/ Claude Debussys malerische Stimmungsmusik. Seine/ Jünger und Zeitgenossen*' (French Impressionism:/ Claude Debussy's

pictorial mood-music. His/ Disciples and Contemporaries).[6]

Schoenberg was discussed relatively briefly here, between Skryabin and Szymanowski, in a section that is signalled in the contents pages as dealing with '*Anfänge des musikalischen Futurismus in Wien (Schönberg)*' (Beginnings of musical Futurism in Vienna [Schoenberg]). Impression-ism is taken to be the defining modern manner, by contrast with which the pathological nerve-states and anarchy of Schoenberg's music are consigned to the lunatic fringe of a movement that the studious but essentially conservative Niemann found inherently problematic. (His book ends with two chapters grouped under the heading *Nation, Volk und Stamm* (Nation, Folk and Race); it concludes with a plea for Nature and *Heimatkunst* (Homeland art) in which a youthful group of singing *Wandervögel* (Youth ramblers) make an inspirational appearance before he issues his demand: 'Back to Nature, to Popularity [Volkstümlichkeit], to health! Without these three art dies!')[7]

The equivalent chapter in the post-war edition of 1921 was entitled: *Der musikalische Impressionismus und Expressionismus,/ Claude Debussys musikalischer Impressionismus,/ Arnold Schönbergs musikalischer Expression-ismus/ und ihre Jünger und Zeitgenossen.*[8]

The treatment of Schoenberg is now more extended and considered in tone, although the fundamental assessment is no more favourable. Terms like 'pathological', 'anarchic' and 'fanatic' abound in Niemann's treatment of Schoenbergian Expressionism in music as a manifestation of the degenerate tendencies of the extreme left:

> Music dissolves into speech, musical speech into screaming, groans, stam-mering and babbling. Musical colour melts into a senseless orgy of sound. But Fantasy, *Urmutter* of all creation, is bewitched and violated by wild faces and horrible visions ... what in painting the ultra-modern cubists and futurists specifically aim for is a metaphysical dream-art in which all is ghosts and ugliness and where clarity and beauty count for nothing ... this end – it would really mean the end of music – is what the most radical Impressionists and Expressionists of all cultured nations strive for.[9]

Astonishingly, the conclusion of Niemann's book is not significantly different from what it had been in 1913, although the *Wandervögel* have disappeared. He was even able to regard the war as having led to a renewed healthiness in which the re-emergence of Nationalistic feeling was to be welcomed.

Small wonder that he despairingly consigns Schoenberg and Expressionism to the anarchic Left, where Adorno would have us celebrate them. But it is here that deeper and darker questions about Expressionism, not least those that were to be ventured by Lukács,

become relevant – particularly in *musical* culture, and even more so in the case of Schoenberg, whose later development led him ever further from ostensibly leftist or anarchic positions. I have already indicated that the precision and calculation of his 1909-style expressionist manner problematises its supposed spontaneity; what is also striking about Schoenberg's own aesthetic formulations in the period is their unmistakable tendency towards elitist idealism. In 'The Relation to the Text', Schoenberg's contribution to the 1912 almanac *Der Blaue Reiter*, an early disparaging reference to 'the limited intelligence of the intellectual bourgeoisie' is soon made less specific and more general in its application, not only to critics but also to the wider popular audience of lay music-lovers: 'This capacity for pure vision is very rare and only to be found in highly cultured people. It is understandable that the most uninformed in art are lost when a few accidental difficulties bar their way.'[10]

The context of this statement is the rehearsal of a version of Hanslick's old dictum that the subject of music is music itself. Schoenberg is concerned to extend the implications, via a reference to Schopenhauer, of what is involved in the 'purely musical' inspiration of the gifted composer. He invokes the ancient mystical notion of a direct link between music and the immaterial, between musical inspiration and spiritual essences which can be expressed in no other way than in the untranslatable medium of 'pure' music. The interesting cultural-historical problem is that this aesthetic strategy was precisely that of the anti-modernists. Hans Pfitzner's 1920 polemic, *The New Aesthetic of Musical Impotence*,[11] was in substance an elaborate extension of Schoenberg's rejection of the notion that a non-musical literary or philosophical idea might constrain the purely musical imagination of a great composer. But Pfitzner, like other right-wing conservative German aestheticians, implicitly regarded Schoenberg as part of an international Jewish-Bolshevik conspiracy to corrupt the German spirit and, probably, overthrow the German nation. Perhaps the ever-thickening plot is surprisingly clarified by Walter Niemann's strategic comparison of Schoenberg with Schreker. The latter he associated with a sensuality of effect which was compromised by its success in appealing to a wide audience. However neuropathological his works, Schoenberg was at least, as Niemann put it, a fundamentally honourable and genuine artist 'of enormous knowledge'. As a result, he was probably to be considered a 'more deep, more inward' composer who might yet outgrow his extremism.[12] Did Niemann sense, after all, a spiritually-inclined German idealist beneath the fanatical expressionist? In somewhat the same

spirit, James Huneker, who had written a virtuosically shocked review of *Pierrot Lunaire* for the *New York Times* in 1913,[13] concluded his chapter on the composer in *Ivory Apes and Peacocks*, 1915, with the prophecy: 'I shouldn't be surprised if ten years hence Arnold Schoenberg doesn't prove quite as conventional as those other "anarchs of art" [by which he meant Strauss and Debussy].'[14] Oddly tending to confirm this prediction, Schoenberg's later development offers itself tantalisingly to anti-expressionist criticism like that of Lukács, which is too infrequently drawn into musical discussion of this period.

The debate that raged in the Moscow-based periodical *Das Wort* around 1937 was centred upon Lukács's long-developing, Realism-orientated opposition to both historical Expressionism and the current work of Brecht. For Lukács, Expressionism had exemplified an anti-rational, even deliberately *ir*rational impulse within European modernism. Irrationalism he regarded as causally related to both Fascism and Imperialism. Expressionistic immediacy and subjectivity inevitably led to abstraction, to avoidance of the material basis of the dissatisfaction to which it had claimed to give voice. Ernst Bloch had answered by stressing the critical force inherent in the Expressionists' shock-tactics, but failed to change Lukács's art-suspicious insistence upon the need for fragmented consciousness to be represented in the context of a reality that is independent of it, if any truly critical reflection is to be generated by it.

For all the much discussed problems with Lukács's critical method, the warning of Livingstone, Anderson and Mulhern that 'the real history of the period affords no comfort to facile retrospective alignments, in either aesthetics or politics'[15] is strikingly underlined by the increasingly compromised and polemical idealism of Schoenberg and his followers. Time and again it becomes clear that for Schoenberg 'true expression', free of the lying clichés of traditionally determined form, is not of any individually mediated perception, but of the same unmediated mystery that Anton Webern, Hans Pfitzner and the theorist Heinrich Schenker all regarded as rooted in Nature and being characterised by its 'organicism'. After claiming, in his *Blaue Reiter* essay, to have correctly understood the 'real content' of some of Schubert's Lieder without any knowledge of the texts they set, Schoenberg expressed his musical essentialism in language of revealing violence: 'I concluded that a work of art is the same as any perfect organism. It is so homogeneous in its composition that it reveals its true inner essence in each detail. If you cut any part of the human body, the same blood will flow.'[16]

The path was already prepared that would lead to the gloomily mystical and spiritual concerns of the middle and later parts of Schoenberg's career, to the authoritarian, anti-liberal and anti-democratic tone in which his aesthetic elitism expressed itself. Like Schenker,[17] Schoenberg believed that most of the human race was unmusical and that in any case music mattered more than people and politics. Special racial and historical circumstances played a baleful role in determining his later position, but he was a man of fiercely independent mind, and the practical redundancy of his 1950 declaration of his political attitudes reinforces its potent historical interest:

> Before I was twenty-five, I had already discovered the difference between me and a labourer; I then found out that I was a bourgeois and turned away from all political contacts. I was much too busy with my own development as a composer, and, I am sure, I could never have acquired the technical and aesthetic power I developed had I spent any space of time to politics. I never made speeches, nor propaganda, nor did I try to convert people ... after the unfortunate ending of the [First World] war and for many years thereafter, I considered myself as a monarchist, but also then did not participate in any action ... I was never a communist.[18]

The double trajectory of Schoenberg's critical reception and of his respondent ideas and aesthetic philosophy from the First World War period offers itself as a startling confirmation of criticism of the movement elaborated variously by Lukács, Musil (in the second volume of *Der Mann ohne Eigenschaften*, [The Man without Qualities], 1932), Kokoschka[19] or Kracauer.[20] Peter Bürger's alignment of institutionalised avant-garde art with Marcuse's notion of 'affirmative culture'[21] might lead to the following tentative analysis: a momentarily oppositional and avant-garde musical Expressionism succeeded initially in exposing the lie of bourgeois idealism by replacing the artistic illusion of spiritual beauty with an authentic expression of the painful and contradictory reality which that idealism affirmed. But that moment rapidly passed, and what Schoenberg then did was to reconstruct the ideology of an ancient or 'classical' idealism that openly accepted the necessary gulf between the beautiful insight of the few and the material preoccupations of the many. Now the beautiful insight was reinterpreted as a mystery that is *of its nature* closed to the majority of listeners who experience it only as violence and ugliness. That ugliness mimics their pain while consistently humiliating them with its claim to a transcendent truthfulness that they cannot apprehend, since they lack the 'pure vision' that is found only in 'highly cultured people'.

The multiple ironies of the allegiances of Schoenberg's ideas and the

cultural marginalisation of his style might well bring us back to Schreker, and to Grete's *wilde Musik* as the echo of an alternative, perhaps complementary moment of oppositional modernism in which music was permitted its enactment of utopian sensuality in the context of a drama whose tawdry naivety affords a challenging glimpse of the true contradiction between Fritz's ideal and the world of human relations that he has neglected. By contrast, the justly acknowledged masterpiece of expressionist opera, Berg's *Wozzeck*, seems strangely intent upon aligning 'higher' musical form with the Fate that relentlessly crushes its most sympathetic characters. Bourgeois musical culture, assisted by the academy, has of course survived. As Niemann suspected, Schoenberg's 'spiritual depth' won the day and surreptitiously closed the gap between himself and the mandarins of institutionalised idealism, such as Pfitzner and Schenker, who had so resolutely opposed him. Voice-leading graphs and row-charts came jointly to proclaim the organic mystery of Great Music that Expressionism, for all its wildness, had never really threatened at all.

Notes

1 Reviews of Opera North's production of Franz Schreker's *Der ferne Klang* (premièred in Leeds, 14 January 92) were uniformly ambivalent about the work. The word 'kitsch' was explicitly used in Robin Holloway's article, 'Bewitching flim-flam', in *The Spectator*, 25 January 1992, p. 35.
2 G. Neuwirth, *Franz Schreker*, Vienna, 1959, p. 24.
3 O. Kokoschka, *My Life*, tr. D. Britt, London, 1974, p. 28.
4 See Kandinsky's essay 'On the Question of Form', in *The 'Blaue Reiter' Almanac*, New Documentary Edition, K. Lankheit, (ed.), London, 1974, p. 153.
5 Adorno, *Philosophy of Modern Music*, p. 42.
6 W. Niemann, *Die Musik seit Richard Wagner*, Berlin and Leipzig, 1913, p. 211.
7 *Ibid.*, p. 288.
8 W. Niemann, *Die Musik der Gegenwart*, Berlin and Leipzig, 1921, p. 229.
9 *Ibid.*, p. 256.
10 *The 'Blaue Reiter' Almanac* [see n. 4], p. 93.
11 H. Pfitzner, *Die neue Aesthetik der musikalischen Impotenz – Ein Verwesungssymptom?*, Munich, 1920. See also P. Franklin: 'Audiences, Critics and the Depurification of Music: Reflections on a 1920s Controversy', *Journal of the Royal Musical Association*, CXIV, 1989, pp. 80-91.
12 Niemann, *Die Musik der Gegenwart*, pp. 252 and 255.
13 Reprinted in J. Huneker, *Ivory Apes and Peacocks*, London, 1915, pp. 91-9.
14 *Ibid.*, p. 120.
15 *Aesthetics and Politics: Debates between Bloch, Lukács, Brecht, Benjamin, Adorno*, R. Livingstone, P. Anderson and F. Mulhern (eds), London, 1980, p. 15. Relevant items from the Bloch-Lukacs debate are given in 'presentation I', pp. 16-59.
16 *The 'Blaue Reiter' Almanac*, p. 95.
17 See H. Schenker, *Free Composition*, tr. and ed. E. Oster, New York and London, 1979, xxiv: 'It is certain that almost half of mankind is unmusical'.

18 Schoenberg, *Style and Idea*, pp. 503-4.

19 Kokoschka, *My Life*, p. 66. Kokoschka here explicitly excludes the 'Blaue Reiter' group, with their 'art for art's sake' mentality, from the more politically committed Expressionism with which he retrospectively wishes to associate himself.

20 Siegfried Kracauer's *From Caligari to Hitler: a psychological history of the German film*, 1947, is usefully cited in the critical discussion of Expressionism to be found in Gay, *Weimar Culture* (1974), pp. 107-24.

21 P. Bürger, *Theory of the Avant-Garde*, tr. M. Shaw, Manchester, 1984, pp. 11-12. Bürger there cites H. Marcuse: *Negations, Essays in Critical Theory*, London, 1988, essay III, 'The Affirmative Character of Culture', pp. 88-133.

Defining musical Expressionism: Schoenberg and others

Stephen Hinton

Perhaps predictably, my territory for defining musical Expressionism is the German-speaking lands.[1] But my historical starting-point is not, as might be expected, the pre-war but rather the post-war period, the Weimar Republic: a time when the concept of Expressionism was first applied to music and when various composers took part in the frenzy of Expressionism's going public. Pre-war Wilhelmine censorship had been lifted and young musicians strove to assert - and of course 'express' – themselves in the invigorating turmoil of a new liberal Germany.

A common image of the Weimar Republic, and one which the epoch largely had of itself, is encapsulated in the slogan *Die Neue Sachlichkeit* or 'The New Objectivity'. However defined – whether as a widespread ideology; as an aesthetic shared by different art forms; or merely as a style of painting identified by the title of Hartlaub's 1925 Mannheim exhibition – *Neue Sachlichkeit* was seen at the time as a specifically post-expressionist phenomenon. The shift from Expressionism to *Neue Sachlichkeit* is needless to say a complex historiographical matter, easier to divine than define. Yet for the beginnings of the twentieth century it is a shift that can be seen as crucial – not in any chronological sense, of course, but in a cultural one. One of the shift's first philosophers was Emil Utitz (cultural philosopher and Professor at the University of Halle), who in 1927 published what he called 'characterological studies of contemporary culture' under the title *Die Überwindung des Expressionismus* (The Overcoming of Expressionism). Throughout the book Utitz unflaggingly expounds his 'post-expressionist conviction'[2] – in itself a negative category, which he provides with a negative definition by describing 'the merits and demerits of Expressionism'. He lists the following:

> a struggle against the merely rational, a beatifying devotion to drives and emotions, an aversion towards the civilising, a flight into nature, into the primordial and primeval, a tendency towards myth and legend, and also the ecstatic and intuitive as well as a radicality of the entire attitude to life.'[3]

The Expressionists, it would seem, instinctively promulgated a raucous, radical subjectivism, picking up where the early Romantics had left off. According to Utitz, the adherents of the post-expressionist trend '*Die neue Sachlichkeit*' took their philosophy lessons in a quite different school, that of contemporary phenomenology:

> It is not, to begin with, expression, drives and emotions etc. but rather perception of whatever valuably "exists" in life, this orientation towards that which "is", the most decisive abandonment of any kind of autism. The existing world is affirmed.'[4]

Hence the relevance to the New Objectivity of phenomenology's 'return to things [Sachen] themselves', as Heidegger sloganised in his epoch-making *Sein und Zeit*, published in the same year as Utitz's book.[5] If the Expressionists had tended to emphasise the gap between art and life, between subjective reality and a malevolently philistine outside world, the adherents of the *Neue Sachlichkeit* sought to close it. For Utitz the shift also implied a polemic against artistic autonomy. At their most extreme, then, its implications are both anti-subjective and anti-aesthetic. As Utitz proclaimed: 'It is neither aesthetics nor the beautiful that provides and consecrates the link, but objective (ethical) values [*das sachliche Wertsein*].'[6] The New Objectivity has nothing to do with objectivity in the conventional scientific sense but rather with shared, intersubjective social values established from a phenomenological perspective – a perspective, that is, which seeks to minimise any distinction between subject and object.

Turning to musical matters, one does not have to look hard for ways in which 1920s composers participated in such an 'objectivisation' of music. Paul Hindemith is perhaps the most obvious example. After building a reputation as an iconoclastic *enfant terrible*, he turned to composing works in which he pursued, as he himself put it, 'pedagogic or social tendencies', by which he meant primarily his music composed expressly for amateurs.[7] In the circles of the Youth Music Movement, with which Hindemith aligned himself more purposefully than any of his generation, music-making in itself became an 'objective ethical value'.

Yet if, as has been frequently suggested, Hindemith himself was part of early Weimar Expressionism, then any subsequent 'overcoming of Expressionism' must have been something in which he participated not just as an iconoclast but with a keen sense of personal involvement. Take, for example, the following statement, made by Kurt von Fischer in his edition of the early songs with piano accompaniment: 'As with the one-act opera *Mörder, Hoffnung der Frauen* from the same year, the *Whitman Hymns*, composed in the summer of 1919, complete Hindemith's

turn to an expressionist style.'[8] It is not just that Hindemith drew on texts from the sphere of literary Expressionism, such as Kokoschka's one-act play of 1907, which is generally regarded as inaugurating expressionist drama. He also set those texts with musical means that are considered, by some at least, as 'expressionist'. But what does that mean, what do we understand by the term 'musical Expressionism'? It is only by answering this general question that we can answer other, more specific ones such as, 'To what extent can Hindemith be counted among the Expressionists?' and, 'What is it that permits us to call his early style "expressionist"?'

Von Fischer is just one among many who answer the question of whether Hindemith can be considered an Expressionist with nothing much more than an undifferentiated 'yes'.[9] The hermeneutic circle is inevitable: whether we decide for or against an expressionist phase in Hindemith's development is not without influence on our definition of musical Expressionism, and vice versa. 'What is decisive', to quote Heidegger again, 'is not getting out of the circle but getting into it in the right way.'[10] Rather than breaking the circle with an arbitrary definition, then, it would seem preferable to proceed with caution by identifying some of the difficulties that confront any attempt to apply the term 'expressionist', not just to the works of the young Hindemith, but to any composer. I will proceed, then, by considering the notion of Expressionism in terms of an epoch in German music history and then as a stylistic category, which inescapably involves Schoenberg. I will then turn to Hindemith and his near-contemporary Weill.

As a description of the period between 1908 and 1923, Expressionism seems less appropriate for music than for any other art form. Literature and painting have their movements and journals such as *Die Brücke*, *Der Blaue Reiter*, the so-called *Sturm* circle. But in music such things scarcely exist. Which composers would one include, for example, in an imaginary musical equivalent of *Menschheitsdämmerung* (Twilight of Humanity), the anthology of expressionist poets edited by Kurth Pinthus in 1919 with the subtitle *Symphonie jüngster Dichtung* (Symphony of Recent Poetry)? It is symptomatic that mention of an expressionist movement in music did not occur until 1919, and that when it did, in Arnold Schering's article 'Die expressionistische Bewegung in der Musik', just one composer featured, namely Schoenberg, whose pre-war *Klavierstücke* Op.11 formed the basis of Schering's discussion.[11] On the other hand, music as an expressive art is *the* expressionist art form par excellence, as Pinthus's subtitle

Symphonie jüngster Dichtung evinces. If any epoch can lay the claim to Walter Pater's general dictum of 'all art constantly [aspiring] towards the condition of music' it is that of Expressionism. For example, in Wassily Kandinsky's synaesthetic theory of 'Stage Composition' the central categories are the 'vibrations of the soul' and the 'timbre' of artistic means.[12] This may increase music's stature in the hierarchy of the arts but, as I will argue, the extent to which it does so makes for problems in any discussion of musical Expressionism.

Music also forms the kernel of Ernst Bloch's *Geist der Utopie*, a philosophical work first published in 1918 and commonly regarded as an expressionist manifesto.[13] Although Bloch mainly applies the word 'expressionist' to painting, for example in the section where he writes about the 'expressionist realism of the "subject"', music is nonetheless best equipped to fulfil his expressionist programme. The ear, according to Bloch, 'acts as a representative for all the other senses', as it appeared to with Kandinsky's concept of *Klang*.[14] The tone, moreover, Bloch calls the 'last material of the soul, of the kernel, of latency, of the symbol of the self to which music is applied in the first place'.[15] Music is therefore the art which 'as a whole, as the inwardly utopian art, lies beyond everything empirically verifiable'.[16] Bloch does not content himself, however, with such descriptions; he also tries to lend technical substance to his thoughts through the concept of 'Expressionslogik' ('the logic of expression'). It is here that he reveals Expressionism's roots in Romanticism. By 'Expressionslogik' he means not merely the laws prescribed and proscribed by expressive need, but specifically 'the expressive dictates of genius'.[17] 'Whoever is capable', he writes 'may write how he desires. Everything forcefully disperses in favour of whomever feels an inner imperative.'[18] His principal theoretical source here is Schoenberg's *Harmonielehre* (Manual of Harmony). Inner drives express themselves as a perpetual expressive dictate realised through artistic novelty, through breaking established grammatical rules and other artistic conventions. 'It is quite correct', he says, 'when a chord sounds very expressive that Schoenberg should wish to identify the cause of that expression in nothing other than novelty.'[19]

Spawned by the artist of genius at the service of expression, the unceasing evolution of musical material obeys a historical dynamic. The artist who contributes to that dynamic is, as Bloch says, 'geschichts-philosophisch fähig';[20] in other words, he has a 'historical capacity' that accords with a Hegelian concept of historical progress. Yet although formulated with Schoenberg's help, Bloch's concept of musical expression is not restricted to Schoenberg's compositions, nor even to

contemporary works. It includes music at least since Beethoven, if not since Bach. On the other hand, Bloch traces a progressive development, subject to the laws of 'expressive logic', which undergoes a quantum leap with Wagner (especially *Tristan und Isolde*) before becoming what he foresaw as a 'prophetic language of overt *musical* distinctness'.[21]

Bloch grasps musical history as gradual stages in a development whose principal motor is the 'logic of expression'. The development has two sides: an increasing subjectivisation and intensification of musical expression on the one side and, on the other, the attendant individualisation of musical language and form – a process which eventually leads to the dissolution of common-practice tonality. It also invites a justifiable objection. If the net is cast so wide, is there really any point in talking about musical Expressionism? For Bloch, at least, the concept verges on the tautological. For him, virtually all music has expressionist traits. If there seemed too little evidence for the case of musical Expressionism as a movement or epoch, then the opposite is true for the case of musical Expressionism as a style. The term becomes too inclusive; there is a surfeit of music to which the label, as defined by Bloch, could apply; and to apply it becomes as pointless as talking about a realism movement in photography.

Adorno proposed a solution to the dilemma by admitting as Expressionist only the music 'whose impulses and techniques are connected to the contemporary movements of Expressionism in painting and literature'.[22] The problem here is that of translating Expressionist ideology or 'Weltanschauung', as described by Utitz for example, into specifically musical traits. But here again the dilemma of exclusivity versus inclusivity by no means disappears. Expressionist music, according to Bloch's interpretation, embraced too great a time-span to allow one to talk of an expressionist style. Expressionism in music is too inclusive a term. On the other hand, the expressive ideal of immediacy or, to quote Utitz again, the 'beatifying devotion to drives and emotions ... the ecstatic and intuitive as well as a radicality of the entire attitude to life' – such an ideal undermines the very idea of style. By obeying the perpetual dictate of expression, each expressionist work is obliged to create a new style. As Bloch observed, citing Schoenberg, in a technical sense Expressionism is the perpetual negation of accepted musical language and convention. Utitz would no doubt have included such a negation as part of 'an aversion towards the civilising'. For Adorno, the dialectician, the negation was also something positive; hence the central section in the Schoenberg half of his *Philosophie der neuen Musik* entitled the 'dialectics of loneliness'. Where the composer's radical

reform of musical language may, to conservative ears, suggest nothing more than wanton solipsism, it is actually expressing the true state of modern industrial society as a community of alienated individuals. (Up to a point, then, the two analyses agree with each other, in the same way that Adorno's diagnosis of Stravinsky's music in the *Philosophie der neuen Musik* relies on metaphors of mental illness similar to those employed by the detractors of so-called 'degenerate art'.)

But Adorno is far from being consistent in his grasp of expressionist music. In his *Ästhetische Theorie*, for example, he describes Schumann's 'Der Dichter spricht' (last of the *Kinderszenen*, Op.15, and by analogy applicable to postludes in other Schumann piano works and song cycles) as 'one of the earliest models of expressionist music',[23] while in the originally unpublished dictionary article on 'Musical Expressionism' he affirms his view, implicit in his *Philosophie der neuen Musik*, of Schoenberg's *Erwartung* as 'one of the ultimate creations of musical Expressionism', because it reaches both the high-point and end-point of expressive immediacy.[24] The dilemma is especially apparent in Adorno's writings on Berg's *Wozzeck*. In the 1950s essay 'On the Characteristics of *Wozzeck*', for example, he describes the opera as 'Expressionist insofar as every musical event refers to an internalised, psychological world'.[25] Yet a decade or so earlier, in *Philosophie der neuen Musik*, he had cast doubt on such a verdict because 'the certainty of the form turns out to be the medium of absorbing shocks. The suffering of the helpless soldier in the machinery of injustice calms down into style.'[26]

To summarise, then: if it is to have any specific significance, musical Expressionism means *espressivo* in music without manifest underpinnings in traditional compositional means, whether syntactical, formal or tonal; a music which is, as it were, beside itself. In that sense it cannot describe a repeatable and repeated style, still less a school of composition or an epoch in music history, but at best a point of crisis, in this instance the brief period of radical atonality (called 'free' atonality in Germany) during which Schoenberg composed his works opus 11 to opus 22 and whose pinnacle is undoubtedly *Erwartung* – the handful of 'freely atonal' compositions by Schoenberg's pupils Berg and Webern notwithstanding.[27] Philosophies and histories of twentieth-century music that place Schoenberg's Expressionism centre-stage do not identify a representative trend so much as reflect one or more of the following: 1) a tendency to posit a European mainstream running from the First to the Second Viennese School via Wagner and Brahms with origins in Bach; 2) a widespread historiographic preference for crisis over stability; 3) a lazy adherence to the methods of *Geistesgeschichte*, which

places all the arts under a common umbrella. It is for similar reasons that Ernst Krenek, in his 1937 monograph *Über neue Musik*, preferred to talk about the Second Viennese School as the 'Espressivo-Sektor' rather than as Expressionists.[28]

Where does this leave Hindemith and Weill? Hindemith's early, so-called 'expressionist' compositions scarcely stand comparison with Schoenberg's. His musical language does reach a stage, around 1919, where it employs atonality and heightened *espressivo*, such as in the sixth song of the Op.18 collection 'Du machst mich traurig – hör' (Else Lasker-Schüler). This is one of Hindemith's most expressively intense compositions. Yet the pervasive mood, as in other of his slow movements, notably in the *Kammermusiken*, is one of resigned melancholy, largely due to the quasi-tonal sigh motif which in the first *Kammermusik* is provided with the instruction 'klagend', plaintively. As the rest of the song cycle shows, this 'expressive' vocabulary belongs to one of several styles that comprise Hindemith's experimental eclecticism.

The Op.18 collection of songs is just one of the many possible examples which could serve to illustrate Hindemith's ambivalent attitude to *espressivo*, an attitude especially apparent, as with so many of Hindemith's contemporaries, in relation to Wagner, in particular to *Tristan und Isolde*. A telling instance can be found in the one-act opera *Mörder, Hoffnung der Frauen* mentioned earlier, a *Literaturoper* which adopts Kokoschka's historically important text with hardly any alteration. Having cast the opera in a clear sonata form, Hindemith relies for the lyrical second group on a near-quotation from *Tristan*, in this case the motif referred to by Bayreuth label-slappers as either the 'Slumber Motif' or 'Motif of Love's Rest'. In any event, either label seems ironically inept when, as here, transplanted to a work centred around the uncompromising battle of the sexes à la Otto Weininger.

More obviously parodic is Hindemith's almost literal quotation of *Tristan* in the third of his triptych of one-act operas, the burlesque *Das Nusch-Nuschi*. The Emperor launches into an impassioned lament at the alleged seduction of his concubines by his own General, with King Mark's monologue ('Mir dies?' etc) supplying part of the text and most of the music, including the beginning of the 'Love Motif' played on the trombone. *Tristan und Isolde* serves a symbolic purpose, representing the tradition of *espressivo* which Bloch embraced in the spirit of expressionist philosophy. If Hindemith had thereby 'overcome' Expressionism through parodic distancing, he had done so with reference to the entire late-Romantic tradition which *Tristan* symbolised and in

many ways still symbolises. Such was Hindemith's allegiance to so-called 'Frankfurt Expressionism': the post-war reception, in Frankfurt, of expressionist writers hitherto censured from the public sphere.[29]

Kurt Weill's attitude to *espressivo* was similarly ambivalent. *Der Protagonist*, composed in 1924 and the first of Weill's collaborations with the expressionist playwright Georg Kaiser, is expressionist on account of its subject matter rather than a document of musical Expressionism. Weill employs so-called 'free' atonality, it is true, but he does so to convey the emotional excesses of method-acting displayed by the eponymous protagonist, who murders his own sister after enacting a rage of jealousy in a pantomime. If anything, the work as a whole is critical of Expressionism, raising the issue of artistic responsibility as did Hindemith's *Cardillac* a year or so later. Moreover, the pantomimes in *Der Protagonist* (a device copied by Hindemith) are anything but expressionist in style; they utilise a quite different idiom whose neo-classical angularity is indebted to Stravinsky rather than Schoenberg. Such mixing of styles to dramatic ends is characteristic of Weill's oeuvre as a whole. Stylistic fingerprints remain, of course. But he was not concerned with developing a personal style so much as with finding one appropriate to his needs as a composer for the stage. As his needs changed, so did his style. In that sense, he could no more have subscribed to a 'dialectics of loneliness' than Hindemith could have. That was the preserve of pre-war Schoenberg. Hence the subtitle of my attempt to define musical Expressionism: 'Schoenberg – and others'.

Notes

1 The present paper draws and expands on my earlier essay 'Expressionismus beim jungen Hindemith?', published in *Hindemith-Jahrbuch*, XVI, 1987, pp. 18-31.

2 E. Utitz, *Die Überwindung des Expressionismus: charakterologische Studien zur Kultur der Gegenwart*, Stuttgart, 1927, p. 168.

3 *Ibid.*, p. 167.

4 *Ibid.*, p. 79.

5 M. Heidegger, *Sein und Zeit*, XV, 1979, p. 27.

6 Utitz, *Die Überwindung des Expressionismus*, p. 96.

7 P. Hindemith, *Briefe*, D. Rexroth (ed.), Frankfurt am Main, 1982, p. 147.

8 P. Hindemith, *Sämtliche Werke*, VI/1, K. von Fischer (ed.), Mainz, 1983, p. X.

9 See, for example, H. Strobel, *Paul Hindemith*, Mainz, 1948, p. 21; P. Cahn, 'Hindemiths Lehrjahre in Frankfurt', *Hindemith-Jahrbuch*, II, 1972, p. 44; L. Finscher, in P. Hindemith, *Sämtliche Werke*, I/1, Mainz, 1979, p. IX; I. Kemp, 'Paul Hindemith', *The New Grove*, VIII, London, 1980, p. 576. The most extensive treatment of this topic to date is M. Wagner, 'Zum Expressionismus des Komponisten Paul Hindemith', *Frankfurter Studien*, II, D. Rexroth, Mainz (ed.), 1978, pp. 15-26. Wagner's study is flawed to the extent that the criteria which 'serve to define musical expressionism' are both imprecise and arbitrary. 'Sexual-

ity', 'Voyeurism', 'Ecstasy', 'Concentration Effect', and 'Description', as applied by Wagner to the three one-act operas, could just as well apply to music that has nothing whatsoever to do with Expressionism. I have discussed Wagner's study more fully in my *The Idea of Gebrauchsmusik*, New York, 1989, pp. 123-45.

10 Heidegger, *Sein und Zeit*, p. 153.

11 A. Schering, 'Die expressionistische Bewegung in der Musik', in *Einführung in die Kunst der Gegenwart*, M. Deri (ed.), Leipzig, 1919, p. 139. For a comprehensive history of the term 'Expressionism' as applied to music, see M. von Troschke, 'Expressionismus' (1987), *Handwörterbuch der musikalischen Terminologie*, Wiesbaden, 1972-.

12 W. Kandinsky, 'Über Bühnenkomposition', *Der Blaue Reiter*, Munich, 1912, reprinted in *Theorie des Expressionismus*, O. Best (ed.), Stuttgart, 1982, pp. 197-9. D. Borchmeyer has identified an anticipation of such synaesthesia in the work of Adalbert Stifter; see Borchmeyer's *Richard Wagner: Theory and Theatre*, tr. S. Spencer, Oxford, 1991, p. 357.

13 E. Bloch, *Geist der Utopie*, Frankfurt am Main, 1973; partial translation in *Essays on the Philosophy of Music*, tr. P. Palmer, Cambridge, 1985. See also K. Wörner, 'Die Musik in der Philosophie Ernst Blochs', *Die Musik in der Geistesgeschichte: Studien zur Situation der Jahre um 1910*, Bonn, 1970, pp. 1-20; R. Brinkmann, 'Schönberg und das expressionistische Ausdrucksprinzip', in *Bericht über den 1. Kongress der Internationalen Schönberg-Gesellschaft*, R. Stephan (ed.), Vienna, 1978, pp. 13-19.

14 Bloch, *Geist der Utopie*, p. 132.

15 *Ibid.*, p. 154.

16 *Ibid.*, p. 206.

17 *Ibid.*, p. 158.

18 *Ibid.*, p. 157.

19 *Ibid.*, p. 161.

20 *Ibid.*, p. 162.

21 *Ibid.*, p. 181.

22 T. Adorno, 'Musikalischer Expressionismus', p. 60.

23 Adorno, *Ästhetische Theorie*, Frankfurt am Main, 1973, p. 252. A recent survey of the concept of musical expressionism that takes issue, from an ideological standpoint, with Adorno's understanding of the term is Hermand's 'Musikalischer Expressionismus', pp. 97-117.

24 Adorno, 'Musikalischer Expressionismus', p. 61.

25 Adorno, *Alban Berg: Master of the smallest link*, p. 87.

26 Adorno, *Philosophie der neuen Musik*, p. 34.

27 The 'expressionist' elements of *Erwartung* have been succinctly discussed by Carl Dahlhaus in 'Expressive principle and orchestral polyphony in Schoenberg's *Erwartung*', *Schoenberg and the New Music*, pp. 149-55.

28 Krenek, *Über neue Musik*, p. 17.

29 'Frankfurt Expressionism' began in 1917 with a production at the Neues Theater of Georg Kaiser's *Bürger von Calais* (written 1912-13), and later included a production, at the same theatre, of *Mörder, Hoffnung der Frauen* in the original version by Kokoschka. The opera version by Hindemith, although composed in 1919, was not performed until 1921. The complete triptych (*Mörder, Hoffnung der Frauen, Sancta Susanna* and *Das Nusch-Nuschi*) received its première in March 1922 in Frankfurt, where it was a *succès de scandale*.

PART IV

Dance

The body and the dance: Kirchner's Swiss work as Expressionism

Colin Rhodes

Ernst Ludwig Kirchner's career as an expressionist is usually seen to be synonymous with his membership of the *Brücke* group (1905-13) and the years immediately following its dissolution; that is, for a decade or so from the time of the artist's middle twenties in Dresden, where both his work and way of life were informed by an overt eroticism, which owed much to the poetry of Walt Whitman, to the debilitating physical and nervous breakdown that he suffered in Berlin around 1916, mainly as a result of fears concerning military service. In contradistinction to this, I will argue that the work he produced in Switzerland subsequent to this breakdown should also be defined in terms of Expressionism if we are to understand Kirchner's work fully. Although the later work is often visually very different from that produced before the war, the ideas and intentions underlying his artistic production remain essentially consistent throughout. I will argue that the nature and development of these ideas can, perhaps, be seen most clearly when we address the complex and subtle relationship of Kirchner's work to the dance.

Kirchner's breakdown and his move to the Alpine village of Davos-Frauenkirch in Switzerland precipitated great changes in both his life and work. His self-imposed isolation and almost paranoid desire to exorcise the ghost of the *Brücke* resulted in new works which, through his constant struggle to remain at the forefront of Modernist developments in art, maintained a freshness of conception and execution rarely found in the post-war paintings of other ex-*Brücke* members such as Erich Heckel, who had continued to live and work in Berlin after 1919. The most noticeable difference in Kirchner's own post-war work is its relative calmness; there is nothing in the Swiss work which approaches the burning sensuality of his pre-war images of naked men and women, or the extreme, animated existential tension so characteristic of much of his Berlin work. Yet the expressionist desire to respond empathetically to one's surroundings does not disappear; rather it is transformed, through the artist's need to maintain a greater physical distance

between himself and his subject, into images which are more guarded, in which Kirchner no longer bares himself openly to the world.

Kirchner's self-conscious avant-gardism is one aspect of his artistic project that can legitimately be observed throughout his career. Although he chose to spend the last two decades of his life in Switzerland, he was acutely aware of the danger that his geographical isolation posed to his continued development of a cosmopolitan style, as well as to his reputation in the international art market. He attempted to surmount this mainly by reading widely (most notably books produced by the Bauhaus School, whose methods and Utopian aims were much closer to pre-war Expressionism than is usually credited),[1] as well as through contact with friends on the outside, and two long trips to Germany at crucial points in the mid-1920s.

The artist's sustained interest in the theme of dance and dancers began in the *Brücke* years in Dresden, where it took its place alongside a preoccupation with the theme of bathers and was, according to R. Ketterer, part of a 'constant search for new ways of treating the human body in motion and performing the most complicated movements' which was common to all the *Brücke* artists.[2] Kirchner produced countless drawings of dancers at this time, though significantly their subjects were largely confined to popular dance forms, especially from the variety theatres and *Tingeltangels*, where they took their place alongside other kinds of entertainment.

During the *Brücke* years the real potency of dance resided for Kirchner in its perceived 'otherness': movement in dance was not the same as ordinary movement and the dancer him- or herself, in common with other stage performers, was also regarded as being outside, or on the periphery of, normative culture. The essential 'otherness' of the performer has traditionally been utilised as a metaphor for the perceived isolation of the Modernist artist, and it has become a commonplace for the literature on the *Brücke* to note that the wives and girlfriends of the artists themselves were all dancers. In this respect Janice McCullagh is right to point out contemporary notions of a relationship between performers and so-called 'primitive' extra-Europeans:

> The attraction of circus performers for artists of this period was closely allied to their love of dance. Bareback riders, trapeze aerialists, clowns, and other circus performers also exhibited their skills of a physical art. Their acts spoke, and still speak, a universal language, presenting an exaggerated and colourful mirror of life. The authentic artist was not only the native of the South seas, but the artist of movement who performed on the stages of Europe. The costumed circus artists exhibited an aura of the exotic without being foreign.[3]

Both the preoccupation with 'low art' subjects and Kirchner's interest in extra-European art before the First World War can be seen as essentially part of the same discourse.[4] In view of this, when we turn to look more closely at Kirchner's Swiss work, we find the manifest importance of African and Oceanic art diminishing, this is really only part of a general shift in emphasis, which centres particularly on a movement from the exotic 'primitive' to the peasant, and from the Dionysian theme of mixed bathers to a more structured preoccupation with the interpretative dance of pioneers such as Rudolf von Laban, Mary Wigman, and Gret Palucca. Contained within this is a tendency for Kirchner to rely less on dance as a useful motif and increasingly to construct images which are informed by a more complex and subtle attempt to translate the language of movement into that of visual art.

Kirchner arrived in Davos in search of a cure for the first time in January 1917, having spent much of the previous year in various sanatoria in Germany, as a result of a nervous breakdown which had arisen partly from his fears concerning military service. In December 1916 he had suffered 'a new, grave nervous collapse aggravated by alcohol and narcotics'.[5] The dark years of 1915-19 are connected by an image of the dance: *The Dance Between the Women*, whose origins lie in a photograph of the artist in his Berlin-Steglitz studio. In the composition in question, the dancer assumes a symbolic importance, marking both an end and a beginning. The photographic source is the key to this, and for our purposes three elements are of note: most obvious is Kirchner dancing naked before three fully clothed people;[8] less so is the presence of both Erna Schilling *and* Doris Grosse (Dodo), the artist's two common-law wives (he had left Dodo for Erna in 1911). Erna is present in person and Doris is the subject of the painting behind Erna, *Dodo with a Large Fan* (1910; G. 158). Finally, there is the helmet on top of the bookcase, which serves as a reminder of the ever-present war.

The first version of the picture, a painting possibly begun in 1915 (G. 443), though left unfinished,[7] is an inversion of the artist's *Dance School* (G. 388), dating from the previous year, and represents a last attempt to recapture a sense of that freedom which Kirchner had experienced before the war. It is a Dionysian revel become dark. The identities of the women become clearly evident when we compare their physiognomies. The wide hips and small, high breasts of the woman on the left (of the painting) are characteristic of representations of Erna, while the softer, fuller form of the woman on the right must be read as Doris Grosse. In view of this, the artist's sense of being suspended between an irrevocably lost past and a portentous present is forcefully stated.

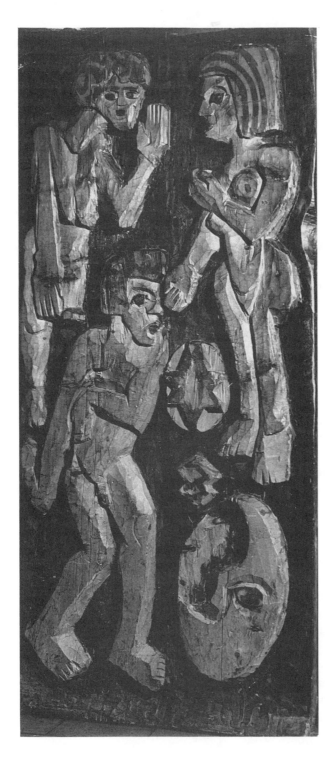

19 Ernst Ludwig Kirchner, *Dance Between the Women*, 1919, carved and painted wooden relief

Kirchner's move to his first permanent Swiss home in October 1918 coincided with an improvement in his health, and it would seem that for him it symbolised a new beginning. Why, then, did he return at this point to the equivocal subject of *The Dance Between the Women*? The answer to this question lies in its preoccupation with the relationship of past to present, for during the years 1918-21 the contents of Kirchner's Berlin studio were gradually sent to him in Switzerland by Erna, who was looking after his affairs in Germany. In the 1919 drypoint (DR. 289) and woodcut (DH. 403) a crescent moon appears behind the head of the male dancer (who now more clearly resembles Kirchner), and the gestures of the two female figures are more obvious. Erna, symbolising the present, points to her heart in a gesture of possession, while Dodo opens her palms, signifying her loss. Her position, adjacent to the dark side of the moon, fixes her firmly in the past.

The sense that we have witnessed an attempt by Kirchner to empty the past of its malignant power becomes stronger when we look at the wooden relief version of *The Dance Between the Women* (fig. 19), which, together with another relief, *Alpine Procession*, might have originally been intended as part of a decorative project for the architect Henry van de Velde. In this version of *The Dance* the identities of the figures have become less specific, while the association with night is sharpened by the newly prominent moon and stars. In contrast, *Alpine Procession* represents Kirchner's hopes for his new life in Switzerland. It depicts a different kind of formalised movement – a procession of peasants and their animals up a mountainside, executed with rough simplicity. The foreground is dominated by a peasant couple with heads bowed, and the scene is crowned by the sun.[9]

The first Swiss years were ones of great optimism for Kirchner, and as early as March 1919 he told van de Velde, '... for as long as I live I shall probably remain here. The people of the Grisons are good to me So I have a home here and do not need to burden others.'[10] Although Kirchner found much to admire in the apparently less complicated world view of the peasants, and despite his participation in their recreational activities, the artist was well aware of cultural differences that continually reaffirmed his separateness from their way of life. The sense that a certain dualism exists in Kirchner's work after 1917 becomes apparent when we consider other images of dancers made during the Swiss period. These consist of representations either of peasants or of Kirchner's bohemian friends and acquaintances; and a polarity emerges in which it is tempting to read a deliberate separation of the aspects of 'nature' and 'culture' within a common framework of

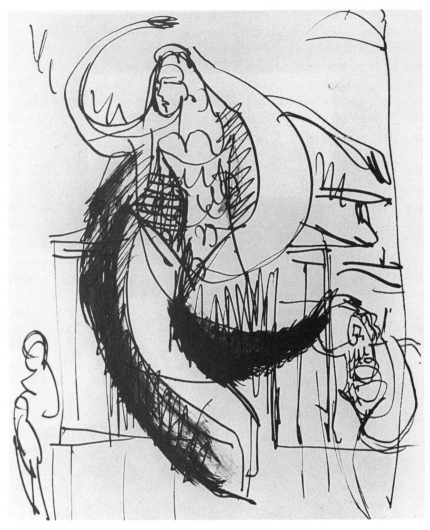

20 Ernst Ludwig Kirchner, *Dancer, c.* 1933, pen and pencil with wash

primitivism. While Kirchner's friends are inevitably shown nude, or else wearing fantastic costumes in artful evocations of the modern dance, such as *Dancer* (*c.* 1933) (fig. 20), the peasants are always represented as participants in communal dances, in images such as *Peasant Dance in the Alpine Dairy* (1920; DR. 296) which offer a crowded simplicity.

During the Swiss years it was not 'low art' (dance as mass entertainment) which most interested Kirchner, but the dance as 'high art', in particular the so-called *Neudeutsche Tanzbewegung* (New German Dance

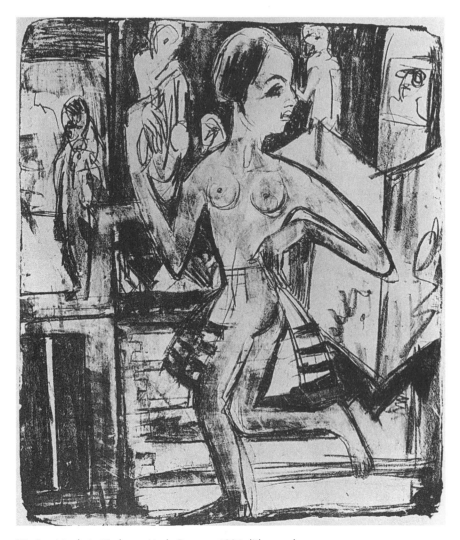

21 Ernst Ludwig Kirchner, *Nude Dancer*, 1921, lithograph

Movement) created by Rudolf Laban and his protégée, Mary Wigman.[11] Kirchner had been acquainted with the contemporary dance world since his Dresden years, and it is quite possible that he saw Mary Wigman dance in Davos in 1919.[12] But the importance of modern dance did not become manifest in his work until 1921, when he met the dancer Nina Hard in Zürich. Later that year, at Kirchner's invitation, she performed publicly at the 'Zürich Sanatorium' in Clavadel, with sets designed and made by the artist, as well as privately for Kirchner and his guests at his home. The artist produced many drawings of Hard

during her stay in Frauenkirch, as well as taking a number of photographs[13] which he used subsequently as the basis for paintings and prints (such as *Nude Dancer*, fig. 21)

Although Kirchner's work at this time retained much of the gestural quality of his Berlin style, in paintings like *Peasant in a Barn* (1921; G. 665), there is evidence of a new emphasis on flatness and broad, simplified forms which was to become increasingly important to him in the course of the 1920s. Nevertheless, the gradual abandonment of gestural mark-making in Kirchner's paintings (and thereby the appearance of 'spontaneity') does not indicate an embracing of formalism, but rather a transformation of his expressionism, which can be understood in terms of a perceived analogy between visual art and the theory underlying interpretative dance.

In January 1926 Kirchner made his first trip to Dresden since the war, and stayed with the art historian, Will Grohmann. It should come as no surprise that during the visit he sought the acquaintance of Mary Wigman (a lifelong friend of Grohmann) and one of her pupils, by now well-known in her own right, Gret Palucca. Wigman later told of Kirchner's frequent visits to her dance school in a letter to Lothar Grisebach: 'He came each day to the rehearsals for a *Dance of Death* that I was working on with my dance company. He made countless sketches. We had many good discussions, but most beautiful was the tacit agreement; the agreement in things artistic.'[14]

In his diary Kirchner noted his high regard for Wigman and similarly argued that they shared a common ground:

> I feel that there are parallels [with my work], which are expressed in her dancing in the movement of the volumes, in which the solitary movement is strengthened through repetition. It is immeasurably fascinating and exciting to make drawings of these physical movements. I will paint large pictures from them. Yes, what we had suspected has become reality: there is the new art. M[ary] W[igman] instinctively took much from modern pictures, and the creation of a modern concept of beauty operates just as much in her dancing as in my pictures.[15]

While stressing what he sees as the formal similarities between dance and painting, Kirchner also argues that he and Wigman have in common their purpose in employing these forms, which is the creation in their work of a 'beauty' which is unmistakably 'modern'. Significantly, for him, this beauty lies in the expressive potential of those forms.[16] If we are to accept Kirchner's comparison between his own art and that of Wigman, then the mechanism of that connection must be ascertained. I will argue here that this operates on an experiential level, in terms of

the embodied artistic process; it is understood as an *actual* unfolding in time and space in the dance, and as a *metaphorical* one in pictures.

In 1959 Wigman wrote that 'Movement is the one and only material of dance', and she defined this as, 'the *living breath*, which, when *made visible* through the human body, helps the dancer to find out about the qualities of his naturally given motions and emotions.'[17] The placing of this kind of emphasis on the absolute importance of human movement in dance was essential in the first half of the twentieth century to establishing the functional autonomy of dance as an artistic medium – as more, say, than merely an interpretation of music. Wassily Kandinsky implies this in his 'Abstract Synthesis on the Stage', where, though his general argument concerns the possibilities for a *synthesis* of the elements of theatre, he defines the specific function of dance in terms of 'organized movement ... temporal, spatial, abstract movements not of people alone, but of space, of abstract forms, subject to their own laws'.[18] Later, in an article on Gret Palucca, Kandinsky focuses on the human body, acknowledging the 'extraordinary precise construction of [Palucca's] dances in their temporal development'. Despite this he concentrates his analysis on what he describes as, 'the precise structuring of individual moments';[19] in other words, on *positions*. This must be seen as a retrogressive step, however, since one of the defining qualities of expressive, or interpretative dance is precisely a new emphasis, in movement, on 'the notion of a process of change', often articulated in 'metaphors of growth and a stress on the "natural" unfolding and "organic" development of a dance'.[20]

Moreover, David Carr is surely correct to argue that while it is important to regard dance as 'just organised movement in much the same way that music may be considered organised sound, it is not any sort of movement but *human* movement with which dance is concerned, and more specifically *intentional* human movement'.[21] The fundamental separation of performances of dance and music lies, partly, he argues, in the fact that the materials or instruments used by dancers are their bodies.[22]

> In the art of dance we are confronted, more than in any other art form, with a circumstance in which both the instrument or vehicle of expression of artistic ideas and intentions *and* the physical embodiment of the work of art itself are in themselves just forms or modes of human action.

An action, in this sense,

> is not just a sort of physical event which follows as the effect of a given thought, intention, or purpose; rather to describe a human practical or physical performance as an *action* ... is to characterise it as an *expression* of the intention or purpose for which it has been performed.[23]

In his schematic diagrams of Gret Palucca, Kandinsky appears to take the process of dance and make of it something static, in the sense of sculpture, although even these drawings do emphasise the fact that the forms created by the dancer *and* his or her artistic intentions are embodied in the performance. This is confirmed by Carr, writing in a slightly different context:

> the purposes and intentions whereby the physical performance is invested with meaning are related not causally or productively to the movement but logically and internally; the purposes are inherent in the movement rather than antecedent to it.[25]

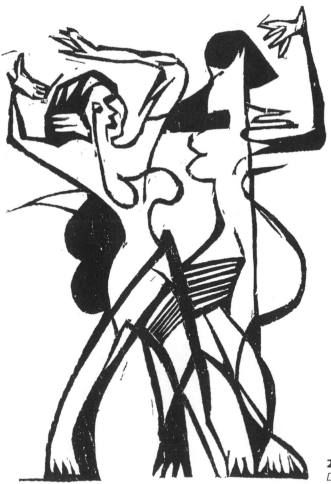

22 Ernst Ludwig Kirchner, *Dance*, 1927–31, woodcut

This is entirely consistent with expressive theories of visual art, which all argue, more or less, that the act of making an image is somehow embodied in that image; the artefact, it is claimed, contains the act. This is to say more than that a work of art reflects the result of an intentional human action, but rather that the artist invests experiential or emotional meaning into a work through his or her manipulation of materials (over and above any specific figurative content). Matisse provides the obvious paradigmatic example in 'Notes of a Painter' (1908):

> The thought of a painter must not be considered as separate from his pictorial means, for the thought is worth no more than its expression by means, which must be more complete ... the deeper is his thought. I am unable to distinguish between the feeling I have about life and my way of translating it.

He argues, furthermore, that a successful work must be more than the reflection of a single moment; that it must attain 'stability' through constant reworking, in order to arrive at a 'condensation of sensations' which does not 'isolate the present sensation either from that which precedes it or that which follows it'.[26]

Kirchner too, in an essay on his drawings, written under a pseudonym in 1926, argues from a similar position, although for him the artistic process must be grounded in a fundamentally empathetic response to the stimulus. Thus he tells us that his drawings 'reveal through line the inner life of what is represented ... what appears is not a real or apparent description of reality, it is a new form deriving from personal fantasy, a nonobjective hieroglyph'.[27] These 'hieroglyphs' are not conventionalised signs, though; for Kirchner, 'they are hieroglyphs in the sense that they change nature's forms into simpler two-dimensional shapes'. However, they 'do not so much represent specific objects per se. They receive their specific meaning from their position, their size, and their relationship to each other on the surface of the page.'[28]

Kirchner's use of the dance as subject matter acts as a metaphor for the artistic process, and reinforces the parallels that he felt existed between the two art forms. Its importance is affirmed not just in the many drawings he produced of Nina Hard in 1921, and at Mary Wigman's school five years later, but also in a series of photographs, taken in 1929, of an unknown dancer in the forest around Davos-Frauenkirch,[29] which were used subsequently as the basis for works in other media. Kirchner clearly used his studies of the dance as points of departure for his experimental 'abstractions' of the late 1920s and early 1930s. The concordance is, of course, most obvious in his many prints

of dancers, not only in the relatively fluid technique of oil paintings such as, *Nude Female Dancer, G. Palucca* (1929-30; G. 939) and *Mask-dance* (1928-29; G. 927), but also – and arguably more successfully – in the potentially less accommodating medium of the woodcut, which is evident in images such as *Dance* (1927-31; DH. 952) (fig. 22) and *Two Dancers* (1932; DH. 743). In these images figurative content continually threatens to give way to the agitated, expressive line without ever making the crossing into pure abstraction. This is by no means confined to images of the dance, however, as can be seen by comparing the woodcuts *Dance* and *Cows in Spring* (1933; DH. 643). Dance, as subject matter, merely highlights the importance of movement in general in the work of Kirchner. In drawings such as *Pair of Trotting Horses* (1930) and *Two figures in front of a Window* (c. 1930), Kirchner seeks to imply the temporal process of unfolding inherent in these subjects through his use of precisely the same forms that we have seen in his representations of the dance: emphasis is placed on surface pattern and there is a clear interpenetration of figures and their surroundings. Similarly, in the paintings, such as *Three Nudes in the Forest* (1934-35; G. 971) and *Café* (1928; G. 899), colour is often laid down in broad flat areas which are unbound by the linear skeleton of the image, thus performing a similar function to that of line and mass in the graphic works.

It seems clear that Kirchner attempts to employ the structure of interpretative dance metaphorically, in order to explore the concrete (that is, abstract expressive) qualities of paintings, thus bringing him closer than ever to the Bauhaus masters of form, particularly Schlemmer, Klee, and Kandinsky, in terms of artistic theory. This is the context in which *Colour Dance II* (1932-34; G. 968) should be read, rather than succumbing to the more obvious temptation to see in it Kirchner's failure to understand fully the picture on which his composition is so clearly based – Picasso's *The Three Dancers* (1925). *Colour Dance II* was Kirchner's second attempt at a centrepiece for a projected decoration for the foyer of the Folkwang Museum in Essen. It represents, in effect, a metaphoric reduction of the painter's art to its essentials – the musicalisation of colour, contained in a language of line which is closely related to that of modern dance. It is an image which attempts to lay bare the tools which identify the painter as an agent of creation. On closer inspection it will be seen that the abstract forms of the dancers and background are juxtaposed with realistic representations of mountain flowers. At first seemingly at odds with the rest of the image, they serve ultimately to highlight the parallel which Kirchner is attempting to draw between the artist as creator and that other creative force, Nature.

Notes

NB: Paintings and graphics referred to in the text are followed by a catalogue number. All numbers for paintings (e.g. G. 158) refer to: D. Gordon, *Ernst Ludwig Kirchner: with a critical catalogue raisonné*, Cambridge, Mass., 1968. Numbers for prints (e.g. DR. 208) refer to: Annemarie and Wolf-Dieter Dube, *E. L. Kirchner. Das graphische Werk* (2 vols), Munich, 1967. The drawings and photographs have not as yet been catalogued.

1 The contents of Kirchner's Library, sold at auction in 1951, included nine volumes of Bauhaus books, see K. Gabler, *E. L. Kirchner: Dokumente*, Aschaffenburg, 1980, p. 361. Kirchner wrote in his diary in 1926 that Kandinsky, the Bauhaus and he were 'das eigentlich Neue in unserer Zeit' (L. Grisebach (ed.), *Ernst Ludwig Kirchners Davoser Tagebuch*, Cologne, 1968, p. 136).

2 R. Ketterer (ed.), *E. L. Kirchner: Drawings and Pastels*, New York, 1982, p. 60.

3 J. McCullagh, 'The Tightrope Walker: An Expressionist Image', *Art Bulletin*, LXVI, 1984, p. 634.

4 For an extended discussion of the essential continuity of Kirchner's artistic project, and on the identity of the 'primitive' and primitivism in early twentieth-century art, see C. Rhodes, 'Primitivism Reexamined', unpubl. PhD thesis, University of Essex, 1993.

5 H. Bolliger, 'Biography and Bibliography', in Ketterer, *E. L. Kirchner*, p. 238.

6 The naked dancer in the photograph has been traditionally identified as Botho Graef's friend Hugo Biallowons. However, on the basis of photographic comparisons, it would seem more reasonable to identify the figure as Kirchner himself. Gabler also points to the possibility of this in *E. L. Kirchner: Dokumente*, p. 156. The importance of the subject for Kirchner is clear in the number of different versions which exist. These include two paintings (G. 443, G. 597), two etchings (DR. 208, 289), two woodcuts (DH. 403, 768), and a lithograph (DL. 459).

7 Although the '1915' version of *Dance Between the Women* was exhibited as early as 1919, there is no doubt that Kirchner left the painting in an 'unfinished' state. The recognition of this not only tells us something about Kirchner's method at this time, but it also prevents the picture's use as a significant example of his tendency to make male figures androgynous (and especially since the sexuality of the dancer is obvious in all other versions of the picture). Gordon's assertion that, 'the dancer is given a sexually ambiguous hair mass and a semicircular female breast' (Gordon, *Expressionism: Art and Idea*, p. 54), thus becomes nonsensical. In any case, such theories rely on the dancer being Biallowons, and on the latter's homosexuality. Gordon also misreads the photograph of the naked dancer as, 'a man in women's shoes', when he is obviously barefoot!

8 See Kirchner's description of the two women in 'Die Arbeit Ernst Ludwig Kirchners', quoted in Grisebach, *Kirchners Davoser Tagebuch*, p. 248.

9 For other interpretations of the two relief carvings see Gabler, 'E. L. Kirchners Doppelrelief: Tanz zwischen den Frauen – Alpaufzug. Bemerkungen zu einem Hauptwerk expressionistischer Plastik', *Brücke-Archiv*, XI, 1979-80; M. Schwander, 'Der Tanz zwischen den Frauen (zu Ernst Ludwig Kirchners Skulptur der frühen schweizer Jahre)', *Pantheon*, XLIV, 1986.

10 Quoted in Bolliger, 'Biography and Bibliography', p. 240.

11 For an account of this see M. Kuxdorf, 'The New German Dance Movement', in Bronner and Kellner, *Passion and Rebellion*, pp. 350-60.

12 Wigman presented her first solo programmes in 1919 in Davos, Winterthur and Zürich (see E. Scheyer, 'The Shapes of Space: the Art of Mary Wigman and Oskar Schlemmer', *Dance Perspectives*, XLI, 1970, p. 11.

13 For Kirchner's photographs of Nina Hard see Gabler, *E. L. Kirchner: Dokumente*, pp. 229, 231-2, 235-6.

14 Letter to Grisebach, December 1966 (in Grisebach, *Kirchners Davoser Tagebuch*, p. 296).

15 Grisebach, *Kirchners Davoser Tagebuch*, p. 115.

16 *Ibid.*

17 M. Wigman, 'The Extraordinary Thing Laban gave to the Dance', *The New Era*, May 1959, p. 102.

18 Kandinsky, 'Abstract Synthesis on the Stage' (1923), in *Complete Writings on Art*, p. 506.

19 Kandinsky, 'Dance Curves of Gret Palucca' (1926), in *Complete Writings on Art*, p. 520.

20 II. Redfern, 'Rudolf Laban and the Aesthetics of Dance', *British Journal of Aesthetics*, XVI, 1976, pp. 62-3.

21 D. Carr, 'Thought and Action in the Art of Dance', *British Journal of Aesthetics*, XXVII, 1987, p. 347.

22 See M. Wigman ('Extraordinary Thing' p. 103): 'Movement is the one and only material of the dance. In developing and mastering its spiritual and emotional values as well as its organic functions, the dancer is enabled to build up his body, so that it becomes what it should be: the ideal instrument of the dance.'

23 Carr, 'Thought and Action in the Art of Dance', pp. 346, 350.

24 Wigman, 'Extraordinary Thing', pp. 102-3

25 Carr, 'Thought and Action in the Art of Dance', p. 352.

26 Matisse, 'Notes of a Painter', in J. Flam, *Matisse on Art*, Oxford, 1984, pp. 35-6, 37.

27 L. de Marsalle (Kirchner), 'Drawings by E. L. Kirchner', in V. Miesel, *Voices of German Expressionism*, New York, 1970, p. 23.

28 *Ibid.*, p. 22.

29 These photographs are reproduced in Gabler, *E. L. Kirchner: Dokumente*, pp. 297-303.

Expressionism and dance: a literary perspective

Manfred Kuxdorf

Dance and literature in the early decades of the twentieth century show parallel trends and are linked much more closely than has been noticed in either discipline. It might come as a surprise that a systematic investigation into their relationship, such as exists with regard to French literature, or at least an analysis of how dance is reflected in literature, is still lacking in German.[1]

In the opening statements of Goethe's *Faust*, the poet claims that it is his assigned function to divide and pattern the changeless order of creation into 'rhythmic dance'. In the same era, Gottfried Herder recognised that for the ancients the art of dance had constituted an amalgam of all the arts, uniting them in one form.[2] Nietzsche's *Also sprach Zarathustra* laid the groundwork for the realisation that dance was the symbol of wisdom, for it means lightness, and lightness means joy. Zarathustra, widely read by many Expressionists, issued a caveat to the higher beings: 'Go out of the way of such absolute ones! They have heavy feet and sultry hearts: – they do not know how to dance'.[3]

At around the turn of the century and in the early decades of the twentieth century the art of dance became loaded with a great deal of ideological encumbrances and gained acceptance during the era of German Expressionism as an important vehicle for achieving the desired and most coveted common goal - the regeneration of mankind.

Gesture versus the word, movement versus still-life, rhythm versus pamphleteering, these seem to have been placed in opposition, and were at times a bone of contention. 'Why make the Dance significant, when there is already at hand such a completely expressive medium as literature?' asked Jean Morrison Brown in *The Vision of Modern Dance*.[4] The answer is that people on the whole are 'slaves to the Word' and know no other means of expression than through the Word. The dancer deplores this restrictiveness of expression and believes that dance as an art form has something to say which cannot be expressed by words. Rudolf von Laban, who became the mentor of the young Mary Wigman

and the creator of a form of dance notation which bears his name, emphasised, much in agreement with the pronouncements of Herder, that dance represents the union of all the muses: 'Dance expresses things which cannot, or cannot as fully, be expressed by word, drama, or even music'.[5] In her book *The Language of Dance*,[6] Mary Wigman offers an explanation as to why she, at a late stage in her life, attempted to 'retrace and re-create', with 'verbal images', some of the most important stages of her work. She summarised as follows:

> The medium of creativity granted me was the dance, always and ever the dance. Therein I could invent and create. Therein I have found my poetry, have given shape and profile to my visions, have moulded and built, toiled and worked on the human being, and for the human being. It might very well be that I love the dance so immensely because I love life, because of its metamorphosis and elusiveness.[7]

We should pause here and consider what kind of dance the majority of its protagonists in its idealised form had in mind. The new focus on dance not only awakened great enthusiasm in women, it also seized men and entire groups as well. The critic Hans Brandenburg claimed in 1919 that through dance women had not only achieved their greatest degree of emancipation and their entry into the world of politics, but: 'With dance the woman has given mankind her third and last gift of redemption: the female dancer steps up next to the woman as lover and as mother.'[8]

Dance from now on infiltrated many other forms of physical activity. The Norwegian Sonja Henie (1913-69) is credited with having introduced dance to figure skating. Among other related group activities is the so-called *Körperkulturbewegung* (Body-culture Movement), with its general awareness of the aesthetic as well as physical benefits of dance. Subsequently, so-called Choreutics societies, such as the *Hamburger Bewegungschöre* (Hamburg Movement Groups) sprang up all over Germany.

A newly gained consciousness of the interrelationship of body and soul also manifested itself in the founding of schools of gymnastics, as well as the *Turn-* and *Wandervereine* (Gym and Walking Clubs), a trend that had originated with the famous Friedrich Ludwig Jahn, a member of the German National Assembly, the often maligned *Turnvater Jahn* (1778-1857). Like Wedekind, he served his time as a 'demagogue' in a fortress for six years (1819-25), which goes to show how dangerous such novel ideas were in pre- and post-Wilhelminian Germany. The trend to natural nudity, which has never let up, had begun around the turn of the century as a means of improvement of one's general well-being. This too is part and parcel of the general trend toward bodily

awareness. Dance as a means of overcoming psychosomatic disorders, or simply of recognising the relationship that exists between an ailing soul and a sick body, gained acceptance around that time. Dancing and rhythmic movement in natural settings were, however, not only viewed as a therapeutic tool, but also as ends in themselves, for enjoyment, or for their inherent aesthetic value.

In contrast to and perhaps as a reaction against both the traditional ballet and the prevalent expressive style of the new dance, another dance form emerged, that of the *Girlkultur*, which refers to the exacting review style of dancing produced by such well-known groups as the Tiller-, the Ziegfeld-, and the Hoffmann-Girls troupes. Even more than in the ballet they stringently adhered to mechanical, almost military precision in their presentations of chorus-type leg kicking, embellished by angular and circular movements in group formation. The Tiller-Troupes, who were in great demand not only in London, Amsterdam, Turin, and New York, had originated in schools established by Mr and Mrs Tiller in London and in Manchester, where youngsters at the age of nine were trained in dancing and often performed in Christmas pantomimes. Their regular academic studies were not neglected either. When they grew up they were given jobs in various Tiller troupes. The first Tiller Girls came to New York in 1899 and the last appeared in 1925 for the Ziegfeld Follies.[9]

Beginning with the turn of the century it was Isadora Duncan who promoted the idea of dance, that is to say, expressionist dance, in Germany and elsewhere. Her dance must have had an overwhelming effect on audiences for it is said that when she danced in her tunic, when she turned her innermost being out, she made bearded men cry like babies.[10] Duncan saw in the dance the conscious expression of a naturalness which became the mediator between body and soul. She refused to wear traditional women's garments such as corsets, shoes, and even stockings, thereby abandoning what she considered the artificial and synthetic. She danced barefoot without ballet shoes.

The actual breakthrough in German dance occurred between 1918 and 1932 with the emergence of Mary Wigman, perhaps the most towering figure of the New German Dance Movement. Originally a discovery of Laban, she became first a student and later a teacher of rhythm movements (a cousin of today's aerobics without the huffing and puffing) at the school of Jaques-Dalcroze. Her technique was taught at the Wigman Central Institute in Dresden, founded in 1920. In contrast to ballet, she favoured angular symmetrics, rhythm over clear-cut movements, stark costumes, and music that consisted mainly of

percussion. Soulful expression took precedence over technical perfection. This explains why her dance was called *Ausdruckstanz* (Expressive Dance), linking it both in chronology and spirit to the general movement known as German Expressionism. Famous for her sombre, almost demonic dances, often presented while wearing a mask, Wigman appealed to the instinctive side of human nature and claimed to be in contact with primordial forces. Laban and Wigman together codified the laws of physical expression, which they called Eukinctic. Mary Wigman soon outstripped her teachers both in fame and influence, and her choreographic dance creations, which she herself called 'absolute dance', were soon idolised by the younger generation in Germany, especially by such notables as Harald Kreutzberg, Yvonne Georgi, and Gret Palucca, who became her foremost pupils.

They carried the Expressive Dance well into the 1930s, until they succumbed to the temptation of combining their style with that of the traditional ballet, thus creating a new dance form which enriched the hitherto precisional, clockwork type of ballet with more creative impulses by providing the opportunity for greater individualistic expression. The result is much along the lines of what we can observe today in modern ballet (Cranko's Stuttgart Ballet, for example).

Wigman first toured London in 1928 and then the United States in 1930, making a profound impact, especially in the United States, where one of her assistants, Hanya Holm, opened a branch of the Wigman school in New York. Holm subsequently deviated from the strict Wigman style and developed dances for such famous musical productions as *Kiss me Kate* and *My Fair Lady*.

Dance by its very nature is understood to be a performing art form that has to be seen to be appreciated. This adds, quite often, a voyeuristic quality to dance observation, linking it to the pantomime and the theatre. Already Werther, in Goethe's epistolary novel *The Sorrows of Young Werther* (1774), writes to his fictitious friend Wilhelm, of the lasting impression the dancing of Charlotte had made upon him:

> You should see Charlotte dance. She dances with her whole heart and soul: her body is all harmony, elegance, and grace, as if nothing else mattered, as if she had no other thought or feeling; doubtless, for the moment, everything else has ceased to exist for her.'[11]

Frank Wedekind might be credited as being the forerunner and representative of the dance idea in modern literature, not only in his well-known work *Erdgeist*, the *Lulu-Tragedy*, but in his lesser known work, *Mine Haha or on the physical education of young girls*. Being a

sensuous theoretician on the subject of beauty, composure, and expression, Wedekind had become disenchanted with the current educational methods of implanting such qualities in the school system. After having attended the gymnastics examination administered at a girl's high school,[12] his reflections about educational objectives concerning gracefulness and movement became a decisive impetus for his writing of the novel fragment, *Mine Haha*. While incarcerated at the fortress Königstein in 1900 for his uncomplimentary comments about the Kaiser, he created this gender-specific educational work, where in a utopian setting, by means of a rigorous regimen of dance, administered in isolation from society, young girls are turned into beautiful beings. The development of bodily qualities takes precedence over intellectual ones, and competence in dance, even enforced through punishment with the use of a willow switch, and not without a hint of sadistic, and even masochistic undertones, serves as a surrogate for character development.[13] It can be critically observed that on the one hand dance serves as erotic stimulation for the precocious girls in the isolated boarding school, focused on the idolised female dance instructor Simba, yet, on the other hand, dance in this work is seen more as a tool in the achievement of a societal function, that of fulfilling the voyeuristic demands of society, for whom these girls are destined to perform. Wedekind seems to have oscillated between presenting a description of these beautiful young dancers and simultaneously providing a critical distance from societal exploitation. The teaching of dance is carried out without providing the young girls with any instruction in areas of life mastery or allowing even the slightest spontaneity in their performance. Wedekind's *Mine Haha* is still a controversial work so far as its reception and interpretation is concerned. It is known, however, that after having read this work, Jaques-Dalcroze began to expand the famous Hellerau dance school near Dresden, which Wedekind visited on the occasion of a performance in 1912. Dalcroze personally guided Wedekind, a Professor Salzmann and the brothers Dohrn who were in the party, through the school.[14]

Wedekind had become acquainted with the ballet, circus and variété scene during his stay in Paris in 1891. He frequented the Moulin Rouge, the Folies-Bergères and other night-clubs where he became enthralled by the dancing of, amongst others, Jeanne la Fole, Emillienne d'Alençon, and Mlle Campana. Campana's subhuman gracefulness supposedly moved him to tears. His biographer, Artur Kutscher, reports that Wedekind liked to dance the Can-Can himself and was fascinated by the French National dance as he later became with the English

National dance.[15] The creation of pantomimes falls into this time, as do a number of dance songs and sketches of dance costumes. From now on Wedekind's literary production becomes increasingly linked with dance. In 1905 he wrote *Totentanz*, but more importantly, *Die Zensur* in 1907. In this one-act play Wedekind rails against the oppressive forces of censorship but also poses the question of how the two opposing poles of body and spirit can be united. Central to the story is a dance, an excessive dance, performed by the protagonist Kadidja, through which she wishes to achieve the sensual enticement of her lover and her own freedom of expression. Dance here, as is often the case elsewhere for Wedekind, represents a form of self-abnegation. When it is performed for the sole purpose of satisfying voyeuristic desires, he attaches a distinctly negative value to it. Should this be censored? One is reminded of the defiant refusal of Lulu in *Erdgeist*, when her beloved Dr Schön requests her to dance before him and for his bride. Lulu sees in this demand a degradation of her own self.[16] Similarly, in his essay 'Zirkusgedanken' (1887) Wedekind attempted to establish what might be considered a dubious distinction between the art of a trapeze artist and that of a tight-rope walker, the former ostensibly exposing her body for the base purpose of enticement, the latter more in a pose of artistic creativity. This view is also introduced in *Die Zensur* where the dancer is censured for presenting herself in a way which she considers to be a legitimate reflection of herself, her totality, though not quite free of exhibitionistic, sensually appealing qualities. Since her lover cannot accept this as her very being, their relationship is doomed. One is reminded here in passing of Alfred Döblin's *Die Tänzerin und ihr Leib* (1913), where the intellectually conscious ego and the physical manifestations of the body engage in a struggle for supremacy.

Georg Kaiser has often been hailed as the foremost dramatist of Expressionism. He viewed the contemporary dance scene with scepticism and undisguised contempt, in referring to Isadora Duncan as 'Miss Isadora Buttersemmel' (roll and butter).[17] In his early *Schellenkönig* (1895-96), Kaiser parodied the stilted dancing fashion of the time of Louis XIX as an example of an artificial life-style. Although Kaiser befriended many dancers and actors, he seems to have held a dim view of the objectives of the dance movement. If there was to be a regeneration of mankind, it had to come through the efforts of the writer, more precisely, the dramatist: 'When leaving the theatre one knows more about man's possibilities – about energy.'[18]

In a drama entitled *Europa, Spiel und Tanz in 5 Aufzügen* (1914/15), Kaiser presents men who have lost their robustness and even walk in an

effeminate, dance-like fashion. They represent a society that has man-
aged to repress all coarseness and has found a way to sublimate and
restrain their impulses.[19] In satirical exaggeration Kaiser makes his
protagonists parrot the phrases heard expressed by the then current
dancers: 'Dance as soul and soul as dance – dance as language of the
soul'.[20] In the final analysis Kaiser renders the application of the
dancer's idealism as impractical, even ludicrous. By transposing the
play into Greek mythology he has the opportunity to present an example
on a removed level, though with tangible implications. Zeus at first appears
in human disguise as a wooer of Europa. He imitates the mannerisms of
the effeminate males, and, as can be anticipated, fails. Only when he
reverts to the traditional figure of the steer does he succeed in
snatching the voluptuous Europa away from her compatriots. The
message learned is clear: 'Genuine life is strong life' (p. 651).

Kaiser's drama, although it may appear flippant on the surface, is
intended as a critical commentary on the renewal of mankind. In his
essay 'Europa', not always identified as a commentary on his play of
the same title, he stresses: 'The only demand on poetry is that of the
renewal of man – this has been emphasised as a reversal in *Europa*. The
comedy points towards the seriousness of the problem. Its capacity has
to be proven by means of the counter-play.'[21]

Significant insights into the concerns of the young generation of
Expressionist writers can be gleaned from their publications in the two
major journals, *Der Sturm* and *Die Aktion*.[22] Their use of the dance
motif can be grouped into two areas: Dance as Death, and Dance as Life
(the latter predominantly presented as a symbol of enticement, of
decadence), or occasionally also in a combination of the two.

The connection between dance and death has long been established.
Medieval European literature and woodcut depictions show Death
groping for victims of all stations and leading them in a dance-like
fashion to the beyond. A well-known example of death and dance is
also found in folklore, namely the tale of Snow White, where the evil
stepmother is punished by having to dance to death in red glowing
shoes of iron .[23]

The expressionist writers of the *Sturm* and *Aktion* circles viewed
society as a whole as existentially dancing on a volcano (fig. 23). The
demise was programmed; the cultural pessimist Oswald Spengler (1880-
1936), in his swan song to Western civilisation *Der Untergang des
Abendlandes* (The Decline of the West), I and II (1917 and 1922) had
provided the script. For Spengler the crisis of the modern age was seen
as a phenomenon inherent in every culture and civilisation. He only

23 Otto Dix, *To Beauty* (An die Schönheit), 1922

described the symptoms of exhaustion, the last phase of Western culture in which the cultural and creative energies are replaced by the rationalisation and mechanising tendencies of science and technology. No remedy, no mitigating solutions to overcome this crisis were offered.

In numerous poems (no fewer than seventeen) that appeared between 1910 and 1927 in the two journals, a pessimism of decline associated with Dance-of-Death imagery can be discerned. A few representative examples serve to illustrate this.

Salomo Friedlaender's 'Danse funèbre',[24] while still less political and more adhering to the Jugendstil-fashion, links the erotic act with dance as a lullaby of dying.[25]

Life is symbolically linked to dance in Kurt Heinar's 'Blondes Mädchen': *Tanzen/ Tanzen über weisse Wege/ Weite Wege/ Weiter* (Dancing/ Dancing over white paths/ Broad paths/ Onward).[26]

In René Schickele's 'Worte zu einem Tanz', clearly macabre accents of the Dance of Death become evident: *Takt der Kastagnetten,/ Cake walk vermummter Grisetten,/ Totengerippe, Totengerippe,/ schüttle die Betten ...* (Beat of the castanets,/ Cake walk of mummified grisettes,/ Corpses, corpses,/ rattle the beds ...).[27]

Orgiastic and intoxicating effects of dance predominate in the 'Dionysosorgie' by August Hermann Zeiz,[28] and in 'Der Spielmann und die Tänzerin' by Heinrich Horvát,[29] both lesser-known writers. The crass motif of death and dance is similarly depicted in 'Totentanz 1830-1913', by Ludwig Bäumer,[30] and yet another poem on the theme of death, 'Totentanz' by Hans Flesch von Brunningen.[31]

The description of the chaotic world appears in Paul Zech's 'Totentanz (Nordperu)',[32] and is still more pronounced in A. Schürer's long poem 'Ein Totentanz' filled with condemning imagery of the war front.[33]

Perhaps the most forceful of these poems is 'Totentanz' from the pen of Lothar Schreyer, who uses the technique of repetition with no punctuation: *Du Du Du Du/ Alle Kinder sterben/ Alle Kinder sterben/ Alle Kinder sterben/ Müssen Müssen/ Müssen Müssen/ Alle Kinder sterben/ Alle Kinder sterben/ Du Du Du Du* (You/ All children die/// Must// All children die// You).[34] The catch-words of the expressionist movement were *Ahnung und Aufbruch, Aufschrei und Bekenntnis* (anticipation and bursting forward, outcry and confession), to which the critic writer Kurt Pinthus added the ambiguous term 'Menschheitsdämmerung'.[35] Clearly, the twilight of humanity is depicted as a demise, as the presentation of doom and gloom, and the outcry comes strongly to the fore.

The preoccupation with the Dance of Death compels us to reflect on

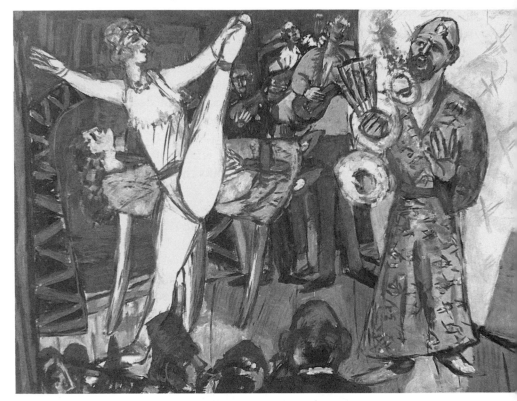

24 Max Beckmann, *Variety Show with Magician and Dancer*, 1942

the importance of this image for the young generation of writers, members of a war generation that had seen the flower of their compatriots, including many fellow writers and artists, mown down in the trenches of the Western Front.

There is hardly any reflection on or admiration of the then-current modern dance movement.[36] Yet a host of poems was composed in admiration of individual, mostly anonymous female dancers, in the form of declarations of love, such as Jakob 'von Hoddis's 'Die Tänzerin',[37] or Willy Knobloch's presentation of the dancer as a temptress, as in 'Tänzerin',[38] Reinhard Goering's 'Tanzetanz',[39] and Paul Hiller's poem to Rosha Nora, 'Die indische Tänzerin'.[40] Alfred Richard Meyer adds a humorous note to this phalanx when he describes his desire for a dancer, 'Die Barfußtänzerin Käte Fischer', in terms of a mountain climber who wishes to explore the alluring mountain from the toes upward, hoping to reach the top and be rewarded with the gift of the elusive Edelweiss.[41] More often, though, the accolades to the

dancer are contrasted with a castigation of the lewd onlookers, as in Paul Mayer's 'Der blonden Tänzerin': 'Von blöden Augen angestiert' (gawked at by silly eyes),[42] or as in the following example, taken from a cycle of ten poems by Jakob von Hoddis under the heading, 'Varieté', which shows the dancer in a milieu that is not only inappropriate but degrading: 'Drei Weiber läßt man auf der Bühne spielen,/ Die süßlich mit gemeinen Gesten protzen'. (Three women on stage are seen/ displaying gestures both sweet and mean) (fig. 24).[43]

Finally, Paul Zech, known as the poet of the proletariat, depicted the sultry atmosphere of the sailor's tavern in 'Tanz in der Matrosenschenke' (Dance in the Sailors' Pub),[44] which appears in stark contrast to the elegant, upper-class, but mask-like depiction of the dancers in Baden-Baden, portrayed by Max Beckmann.

In summary, from the dancers' and their protagonists' point of view dance as an art form was seen in idealistic terms, as a means of self-fulfilment, and as a means of achieving the desired reform of society. Literature, however, presented a multi-faceted view of dance. On the one hand there is the guarded admiration of dance, especially in Wedekind who finds it useful for possible experimentation as an educational tool or who presented it at times with critical distance. When one turns to the *Sturm* and *Aktion* circles, there is a great deal of veneration for the individual dancer and the art as such, not without an alluring element for the writer. The predominantly critical stance which we have observed is linked to the fact that the dance motif is utilised by individual writers to castigate and criticise contemporary society. Thus Dance appears most frequently as fulfilling a voyeuristic demand, especially in the variety show and ballroom settings, and is closely associated with death, decline, and decadence, thereby reinforcing the young writers' critical perception of their own doomed world.

Notes

1 D. Priddin, *The Art of the Dance in French Literature*, London, 1952. A seminal study linking dance and literature was made by Wolfdietrich Rasch in his essay, 'Tanz als Lebenssymbol im Drama um 1900', in his *Zur deutschen Literatur seit der Jahrhundertwende*, Stuttgart, 1967, pp. 58-77. The relationship of painting and dance has been examined in an article by Mary Kaprelian, 'Parallel trends in the development of German Expressionist painting and modern dance', in *New Directions in Dance*, T. Taplin (ed.), Toronto, 1979, pp. 51-9. At the time of presentation of this paper at Manchester in March 1992, I became aware of the recent analysis by Carol Diethe, 'The dance theme in German Modernism', *German Life and Letters*, XLIV, 1991, pp. 330-52.
2 Cf. W. Nufer, 'Herders Ideen zur Verbindung von Poesie, Musik und Tanz', *Germanische Studien*, LXXIV, 1929, p. 94.

3 F. Nietzsche, *Thus Spake Zarathustra*, tr. T. Common, New York, 1936, p. 111.

4 Princeton, 1979, p. 57.

5 R. von Laban, 'Vom neuen Tanz', *Hellweg*, 1925, p. 315.

6 M. Wigman, *The Language of Dance*, tr. W. Sorell, Middletown, CT., 1966, p. 118.

7 *Ibid.*, pp. 8-9.

8 'Das Ende der Tanzkunst', *Der Bücherwurm*, 1919, p. 81.

9 W. Terry and J. Rennert, *100 Years of Dance Posters*, New York, 1975, pp. 7 and 30.

10 H. Moscovici (ed.), *Vor Freude tanzen, vor Jammer halb in Stücke gehen*, Frankfurt, 1989, p. 7.

11 J. von Goethe, *The Sorrows of Young Werther*, New York, 1949, p. 19.

12 F. Wedekind, *Die Tagebücher: Ein erotisches Leben*, Frankfurt/Main, 1986, p. 57.

13 O. Best, 'Zwei Mal Schule der Körperbeherrschung und drei Schriftsteller', *Modern Language Notes*, 1970, pp. 724-41, identifies the educational methods of discipline as, 'Dressur zur Harmonie' (training for harmony).

14 A. Vomend, 'Das Motiv des Tanzes im Werke Frank Wedekinds: dargestellt an Hand dreier exemplarischer Analysen', unpublished MA thesis, University of Waterloo, 1990, p. 64.

15 A. Kutscher, *Frank Wedekind: sein Leben und seine Werke*, I, Munich, 1927, p. 264.

16 Wedekind, *Erdgeist*, Munich, 1980, p. 62.

17 G. Kaiser, *Nebeneinander*, in *Werke*, II, Berlin, 1971, p. 306.

18 Kaiser, 'Formung von Drama', in *Werke*, IV, Berlin, 1971, p. 574.

19 Kaiser, *Europa*, in *Werke*, I, Berlin, 1971, p. 306.

20 *Ibid.*, pp. 619-20.

21 Kaiser, 'Europa', in *Werke*, IV, p. 556.

22 A valuable study of the theme of Love in these two journals has recently been completed by Jürgen Froehlich: *Liebe im Expressionismus: eine Untersuchung der Lyrik in den Zeitschriften Die Aktion und Der Sturm von 1910-1914*, New York, Bern, Frankfurt and Paris, 1990.

23 See Ralph Manheim's translation of *Grimm's Tales for Young and Old*, Garden City, New York, 1977, p. 191.

24 See M. Kuxdorf (ed.), *Die Lyrik Salomo Friedlaender/Mynonas: Traum, Parodie und Weltverbesserung*, Frankfurt, 1990, p. 138.

25 *Die Aktion*, II, 1912, p. 209. Anselm Ruest, a cousin of Friedlaender, composed a poem in a similar vein: 'Herbstmorgen', in *Die Aktion*, III, 1913, p. 53.

26 *Der Sturm*, XV, 1924, p. 36.

27 *Die Aktion*, II, 1912, pp. 1348-9.

28 *Die Aktion*, II, 1912, p. 47.

29 *Der Sturm*, I, 1910, p. 381.

30 *Die Aktion*, III, 1913, p. 670.

31 *Die Aktion*, IV, 1914, pp. 656-7.

32 P. Zech, *Vom schwarzen Revier zur neuen Welt: Gesammelte Gedichte*, Frankfurt, 1990, pp. 127-8.

33 *Die Aktion*, VIII, 1918, pp. 195-8.

34 *Der Sturm*, XI, 1920, p. 19.

35 It should be noted that the German term 'Dämmerung' stands for both dawn and twilight. In the expressionist context it was used predominantly in the sense of 'dawning of humanity', indicating a breakthrough of a new era rather than a demise of the old.

36 August Stramm's 'Tanz', *Der Sturm*, XVII, 1926/27, pp. 49-50, and Jomar Fürste's poem to the Austrian dancer, 'Grete Wiesenthal', *Die Aktion*, V, 1915, p. 110, are to be counted as noteworthy exceptions.

37 *Der Sturm*, XXI, 1911, p. 374.

38 *Der Sturm*, X, 1919-20, p. 56. In a follow-up poem on the same page, 'Südlicher Tanz', Knobloch depicts a dancer in terms of a predatory cat-like animal.
39 *Der Sturm*, XVIII, 1927-28, pp. 140-1.
40 *Der Sturm*, III, 1912, p. 86.
41 *Der Sturm*, V, 1914-15, p. 7.
42 *Die Aktion*, XXXI, 1913, pp. 50-1.
43 *Der Sturm*, 21 January 1911, pp. 373-4.
44 *Der Sturm*, I, 1912, p. 140

Theatre

The religious element in expressionist theatre

Raymond Furness

In Reinhard Sorge's *The Beggar*, a play written in 1910 and performed some five years later, a discussion between various *literati* in the obligatory coffee-house turns upon a recent dramatic work which is regarded as trivial, typical of an age whose writers lack, 'the intense confirmation from the Beyond' and 'the Spiritual'; the third critic puts forward the following categorical statement: 'We are waiting for someone to interpret our destiny anew – this is a dramatist whom I would call truly great. Our Haupt-Mann, you see, is impressive as an artist, but limited as a prophet.'[1] What is needed, the critic believes, is one to interpret the symbols, a seer and prophet, instrument of mantological divination. And the protagonist of this play, 'the Poet' himself, as incarnation of pure feeling, will stride through various stations and experiences in his attempt to speak through symbols of eternity: imperious visions will alternate with fervent humiliation in this quest. We have in this exemplary play the rejection of art as mimesis or as entertainment and a fusion of art and theology, a heady synthesis indeed, made even more perfervid when millennial utopias are added.

It will be my intention to look at certain expressionist plays in an attempt to understand the predilection of authors commonly accepted as having been Expressionists at some time in their lives for topoi, symbols, figures and situations which have a religious dimension: whatever else Expressionism was, it was not such a radical break with the past as has hitherto been suggested, and it frequently betrays symbolist, neo-romantic or indeed romantic elements. With hindsight it may appear that it was naturalism which was a jejune *impasse*: with its insistence upon verisimilitude, plausibility and tactile impressionism it could not for long satisfy those who sought to portray transcendental realities, the inner life, the visionary and the ecstatic. Heirs to the Romantics the Expressionists may be, not necessarily neurotic and terminally violent as a recent study has argued,[2] but certainly intense, subjective and fervent. We remember that John Willett's book on

Expressionism had as its cover a detail from Matthias Grünewald's *Crucifixion*:³ the twisted agony of distortion and the intensity of religious expressiveness are here an appropriate emblem.

A good starting point for discussion would be the revival of mysticism in the late nineteenth century, the rejection of materialism and of a one-sided, mechanistic portrayal of the universe. Wagner's *Parsifal* is paradigmatic here, a work whose sultry religiosity appealed greatly to the decadents but which prepared the way for the consecration plays of Stefan George (*The Acceptance into the Order*, for example), the mystery of plays of Rudolf Steiner (*The Portals of Consecration*, 1907; *The Testing of the Soul*, 1911; *The Guardian of the Door*, 1912; and *The Soul's Awakening*, all performed in Munich) and the soul-dramas of a writer like Alfred Mombert (*Aeon*). Wagner's essay 'Religion und Kunst', published in the *Bayreuther Blätter* in October 1880 argued that it was the duty of art to come to the rescue of religion when the latter had ceased to have meaning for the populace, since art was able, through the manipulation of redolent symbols, to communicate an aura of mystery and wonder. Hermann Bahr's acute analysis of modernism in the *Studies towards a Critique of Modernism*, 1894, stressed above all the 'powerful movement away from superficial, crude naturalism' and the 'febrile search for the mystical', the need to 'exprimer l'inexprimable' and 'saisir l'insaisissable': the new writers were 'not by chance Wagnerians'.⁴ The movement towards what may be called neo-romanticism is transparent here, but our concern is with Expressionism: the links, however, are close, and writers not normally associated with the latter movement may well have prepared the way (we think of Hofmannsthal's *Everyman*) for the more strident eructations to follow. The theatre as temple – this *Bayreuth-Idee* was adumbrated in *The Beggar* – or as podium for the proclamation of some kind of 'world-redemptive vision' (political? ideological?) would increasingly usurp the theatre as mere representation or recreation. This will become manifestly apparent.

We have mentioned Wagner; Nietzsche is of equal importance here. Sorge's fusion of visionary fervour and ruthless idealism is reminiscent of the work of Ludwig Derleth. Like Derleth he was overwhelmed by Nietzsche's ecstatic dithyrambs and composed his own *Zarathustra* in 1911, a dramatic 'impression' in which the writer arrogates to himself the right to create and destroy at will. (*Odysseus*, a 'dramatische Phantasie' of the same year, is dedicated to 'the prophet of the Eternal Recurrence, Friedrich Nietzsche'.) Another 'dramatische Dichtung', *Antichrist*, quotes Nietzsche's last utterance as a motto: 'Do you

understand me? Dionysus against the crucified'. *Guntwar, a Becoming*, also of 1911, continues the portrayal of mystical *Entselbstung* (voiding of self) combined with a Nietzschean arrogance – this fusion of Zarathustra and Christ is a concept which fascinated many German writers at this time and is even attempted by the eponymous hero of Joseph Goebbels's novel *Michael*. It may be argued that any cosmogony or mythopoeic vision composed after Nietzsche's masterpiece must needs have felt the centripetal pull of that powerful creation; such was the force of Nietzsche's language that his imagery was indelibly imprinted upon the poetry of the following three decades. The declamatory and pseudo-biblical style of *Also sprach Zarathustra* will reverberate through literature and music before the First World War – the god-destroyer is also the god-seeker, and German expressionist theatre will provide many examples of vatic afflatus, frequently febrile. Sorge believed there was something Christ-like about Nietzsche's agony despite the latter's furious tirades against orthodox Christianity; to those starved of symbols and lacking the sustaining power of religious faith Nietzsche's own fusion of poetry, myth and cosmic vision offered a stimulating and awe-inspiring substitute. Dionysus-Christ-Zarathustra uplifted and challenged the imagination of many who found no fulfilment in the contemplation of drab social issues. After *The Beggar* Sorge's Catholicism became paramount: *The Birth of the Soul* and *Metanoeite* (the latter term being taken from Matthew, Chapter Three, verses 1-2 and meaning 'repent ye') are works of Christian apologetics couched in the form of Christian dialogues. Sorge prepared himself for the priesthood, but was killed at the battle of the Somme in 1916.

Important for Sorge and for many other expressionist playwrights was the influence of Strindberg. Strindberg had undergone a crisis when living alone in Paris and occupied himself with alchemical and occult studies: this crisis is described in *Inferno*, 1897. The period of reorientation which ensued, and the study of Swedenborg (the metaphysical play *Beyond* by Hasenclever, written in 1919, also owes much to the Swedish mystic) found expression in the plays *Advent*, 1899, *Easter*, 1900, and above all *To Damascus*, 1898-1901; subsequent plays which portray a mystical process of self-discovery include *Ghost Sonata*, 1907, and *The Great Highway*, 1909. I have written elsewhere of Strindberg's great importance in any enquiry into the roots of the anti-naturalistic tendency in the theatre;[5] between 1913 and 1915 there were one thousand and thirty-five performances of twenty-four different plays by Strindberg in Germany alone, and it was in Germany that Strindberg's expressionistic direction was to be developed and modi-

fied. *To Damascus* portrays the soul's struggle to find and transcend itself, the 'characters' being mere emanations from that soul, symbolising powers with whom the Unknown One is in combat. The canons of naturalism − the demand for plausibility and inner logic − are totally ignored, and an intense subjectivity prevails. The beggar, the woman, the doctor and the madman all represent aspects of the Unknown One's psyche, and they move before him on his journey of self-exploration. They can be called symbols − the beggar is that degradation which the protagonist fears and yet which is necessary for his rebirth; he is the embodiment of the Unknown One's repressed thoughts, the reminder of the possibility of an existence towards which the hero must move (we find a similar process in the scene with the penitents at the end of Georg Kaiser's *From Morning till Midnight*). The woman would be the link with life, a fusion of the sexual and the sublime which torments and inspires; the doctor represents the Unknown One's arrogance and pride (he is, incidentally, based upon Nietzsche, with whom Strindberg had briefly corresponded at the time of the former's mental collapse).

The concept of life as a great highway (Strindberg's *Stora Landsvagen*), along which a wanderer passes through various stages of martyrdom, represents frequently a secularised mystery-play, and Georg Kaiser comes forcibly to mind, a playwright whose work dominated the German theatre between the years 1917 and 1923. In Kaiser the idea of social reform is only of secondary importance − a Nietzschean self-overcoming, a spiritual regeneration must come first before society can be changed. *The Citizens of Calais* was first performed at the Neues Theater, Frankfurt am Main, in January 1917. This closely-argued condemnation of war culminates in a final tableau which, assisted by the lighting, emphasises the Christ-like sublimity of the moral victor and points at resurrection and ascension. Kaiser's most famous play, *From Morning till Midnight*, received its première three months later in Munich. It is a *Stationendrama* à la Strindberg, and with each 'station' the grotesque element becomes increasingly apparent. Symbols of death accompany the bank-clerk's frenzied course; betrayed by the Salvation Army girl he shoots himself before a crucifix, and his dying words sound like 'Ecce Homo'. The blasts on the trumpet which intersperse his final peroration seem to herald a last judgement. In *Hell Way Earth*, which was put on simultaneously in Berlin and Munich on 5 December 1919, we find a *Spazierer* (Wanderer) who passes through the various stages of capitalist society to found a new utopia; a bridge is crossed and the people, bathed in 'a radiant light', are transfigured in a luminous effulgence. At this point in Kaiser's work there is much talk of 'Trans-

formation', 'Breakthrough', 'Renewal', 'Conversion', 'Awakening': the New Man, whatever else he may be, is a vision of some sort of spiritual regeneration, diffuse but intense. Kaiser is not alone here — the work of Pär Lagerkvist (*The Difficult Hour*, 1918, and *The Secret of Heaven*, 1919) shares a kindred preoccupation. And Paul Kornfeld's *Heaven and Hell*, 1919 — the title is derived from Strindberg's *Legender*, where the latter speaks of Swedenborg's *De coelo et inferno* — has as its epilogue the Count's wanderings through the wilderness in search of Redemption. Kornfeld's essay 'The soul-inspired and the psychological man', a manifesto published in *Das junge Deutschland* in 1918, insists on an abstraction from reality and an emphasis on essential, that is, spiritual essences. A great gulf emerges between 'Here' and 'the Beyond'; and the belief that, to quote Georg Kaiser, 'Ultimate value lies beyond human affairs'[6] becomes part of the stock-in-trade of many dramatists of this time.

Strindberg died in 1912. In that same year the German sculptor and dramatist Ernst Barlach wrote his first play, the ghostly *The Dead Day*. Barlach had settled in the small town of Güstrow in Mecklenburg in 1910. He was not an avid theatre-goer but had read his Strindberg and greatly admired Hauptmann's 'Traumdichtung', *Little Hannah's Ascension* (he had come across a performance, quite by chance, in the Residenz Theater in Dresden in 1894). Goethe's *Faust* had always overwhelmed him, particularly Part Two: Max Reinhardt had staged the complete work in the Deutsches Theater, Berlin, in 1905 and had, incidentally, been most effective in the realisation of the plays of Strindberg, successfully touring Sweden in 1911 and again in 1917. The fusion of the real and the visionary in Hauptmann's play impressed Barlach deeply; a letter refers to the sense of intoxication he experienced after seeing it, and the sensation of feeling like a spirit that has stripped off its earthly raiment, flying now on free wings above the earth. *The Dead Day* has six characters — three humans, and three gnome-like figures, one of whom is invisible. The action takes place in darkness or semi-darkness. The dramatic exploration of the interaction of supernatural forces, some grotesque and menacing, others benign, culminates in the knowledge of The Son that his longing for the Father-principle is a longing for transcendence. Although he perishes, the gnome Steissbart proclaims that God is the Father of Man. The next play, *The Poor Cousin* of 1918 (originally called *The Easter-People*) gives a very plausible picture of an Easter outing on the banks of the Lower Elbe, but also exemplifies Barlach's concept of 'the growing excarnation of essential Man'. Fräulein Isenbarn becomes transfigured as the 'handmaiden of a

higher Master', realism having given way to mystery and ultimate redemption. *The Dead Day* equates the Mother with earth and the Father with spirit; *The Poor Cousin* talks of Easter and resurrection, a tension between 'Here' and 'Beyond' in an overtly Christian manner. The sculptures of Barlach are similar in their portrayal of heavy, earthbound figures who nevertheless aspire towards visionary awareness: *Der Ekstatiker* is a good example here. *The Dead Day*, with the clash of the generations (here mother/son) is very much of its time, but in this play the conflict is sublimated into a religious dichotomy. And although Barlach is convinced of man's higher derivation there is a unity of the physical and the spiritual in his work which saves it from whimsy and bizarre eccentricity. Reality, even if it is only 'a fart of the Lord', is 'still a part of Him'.[7]

It is not only in times of crisis that religious awareness is quickened: we have seen this tendency emerge long before the First World War. But the years of conflict, suffering and collapse necessarily meant an intensification. Wolfgang Rothe, in an excellent article entitled 'Man before God: Expressionism and Theology',[8] discusses what he calls 'Weltfrömmigkeit' (world-piety) and the debasement of such words as 'Heart', 'Soul', 'Sun', 'Light', in both the poets and the dramatists in the years during and immediately after the First World War. Old Testament themes and figures are found in Friedrich Wolf, Arno Nadel and Stefan Zweig – the year 1917 saw Wolf's *The Lion of God*, Nadel's *Adam* and Stefan Zweig's *Jeremias: A Dramatic Poem in Nine Scenes*.

Another element, one which might be called the 'existentialist-ecstatic', with an emphasis on the I/Thou relationship, not merely with sexual but also religious overtones, is seen in Kokoschka's *The Burning Bush*, performed in 1917, and also in August Stramm's *Happened*, with its 'He', a blind wanderer who comes from somewhere beyond the stars and who dies in the arms of 'She': the final tableau (where 'She' stammers 'I Thou You Me ... We!') is meant to represent a *pietà*, as is the ending of Kokoschka's play. Hasenclever's *Beyond*, performed in Leipzig in 1920, is little more than a staccato, passionate interchange between two symbolic characters surrounded by hallucinatory effects (dissolving walls, trees growing into windows and looming shadows) and involved in a mystical, nebulous presentation of life and death. An interest in Jewish themes was awakened after the war by the writings of Martin Buber; Karl Barth's rigorous theology similarly brought Christian themes to the fore. But the collapse of Germany in November 1918, the establishment of the Weimar Republic, the turmoil of violence unleashed upon the streets during the fighting between extremist

factions, the fervent and hectic optimism and the strident cry for brotherhood, created an atmosphere in which utopias, dystopias and chiliastic visions met in zymogenous confusion. It is a convention that earlier Expressionism gave way at this time to a more active, political attitude, but it would be unsubtle to claim that politics ousted everything – if the new republic was meant to introduce a Heaven on Earth, then priests, prophets and god-seekers were not so easily exorcised.

Ernst Toller's *The Transformation,* 1918, is an exemplary *Stationendrama*, which reverberates with Nietzschean imagery and culminates, Zarathustra-like, in the market place where a vision is preached of universal love; religious ecstasy triumphs, for it is the God in Man that must be redeemed for a new millennium to dawn. Most remarkable is Johannes R. Becher's play *Workers Peasants Soldiers*, 1921. The title leads the audience or readers to expect 'Agitprop' theatre, but the subtitle 'A People's Breakthrough to God', and the fact that the play (or *Festspiel*) was meant to belong to a trilogy *Um Gott* gives the work an extra dimension, 'Wandlung', 'Licht', 'Ekstase' – these familiar topoi provide yet further examples of 'O Gott' (rather than 'O Mensch') drama – or, better, an uncomfortable fusion of humanity and divinity prevails at this time. Werfel's *Mirror Man* trilogy of 1920 implies that expressionistic idealism could merely be a monstrous self-delusion or self-obsession; the second part very skilfully portrays the chaos of beliefs associated with the expressionist years – religious longing, according to Werfel, was fused with political activism, primitivism, quietism, Buddhism and theosophy.

Ludwig Rubiner's *The Powerless Ones*, 1919, is again shot through with light symbolism, as is Fritz von Unruh's *Platz*, 1920. The Manichean division of the world into Light and Darkness will undeniably assume a political flavour; it is the fervour with which the new age was greeted which, almost of necessity, took on a religious atmosphere of hope and transcendental expectation. But the subjectivity, mysticism, and what may be called a religious concern for the soul of man struggling to free itself not only from the bonds of capitalism but even from life itself, could not be maintained at white heat and fever pitch for long – the collapse into bathos was perhaps inevitable, and the cosmic element receded as the years of crisis gave way to a more stable form of government. *Aktuelles Theater* – Toller's *Such is Life!* of 1927 is a good example – offered a satirical and flippant view of society in the Weimar Republic, an equivalent of the *Neue Sachlichkeit* of G. F. Hartlaub; Hasenclever's lively comedy *Marriages are made in Heaven* is eight years and as many light years away from *Beyond*. Where are the

Gottsucher now, the visionaries, the prophets of the imminent excarnation of essential man? Would they survive the trauma of 1933 to greet the '1000-year Reich' as the new Millennium?

Sorge had, as has been stated, been killed at the battle of the Somme in 1916; Georg Kaiser fled Nazi Germany and died in Switzerland in 1945; Barlach died in isolation and obscurity in 1938 (his sculptures were exhibited in the *Entartete Kunst* [Degenerate Art] exhibition of 1937); Hasenclever fled to France where he committed suicide in 1940; Kornfeld was transported from Prague to Lodz were he died in 1942; Toller went into exile and committed suicide in 1939; Arno Nadel was murdered in Auschwitz in 1943; Stefan Zweig committed suicide in 1942. Rubiner had died in 1920; Friedrich Wolf survived the Third Reich and returned to East Germany to work in the theatre before his death in 1953. It appears that the rise of Nazism was the death knell of Expressionism, but we must be more subtle here. The Jewish element was of course, reviled, as was the left-wing utopianism, but Expressionism is a complex phenomenon and the links between it and Nazism should not be overlooked. The hero of Joseph Goebbels's *Michael* had argued that 'We men of today are all expressionists, men who wish to mould the outer world from within. The expressionist builds a new world within himself. It is fervour which is his secret and his power.'[9] The rejection of stultifying intellectualism, the praise of Van Gogh and Dostoevsky, the worship of energy and the use of images derived from *Also sprach Zarathustra* display obvious expressionist features. Goebbels had also written a drama *Heinrich Kampfert* and left parts of a religious play *Judas Iscariot*.

A dramatist who acted as a bridge between Expressionism and National Socialism is Hanns Johst. Johst had been very much of his time with his expressionist plays *The Youthful One: An ecstatic Scenario* of 1916 and the Grabbe play *The Lonely One: The fall of a Man* of the following year. Johst's *Schlageter*, performed on Hitler's birthday in 1933 and dedicated to him in 'loving veneration and unswerving loyalty' is blatantly propagandistic in the idealisation of the title-figure; expressionist elements are still present in the final scene of the tableau-like setting, the hyperbole and the emotional intensity; *Thomas Paine*, 1927, had also betrayed exaggerated and visionary elements. But of greater importance for our argument is the role of mystery plays in the theatre of Nazi Germany, *Thingspiele* whose cultic, festive quality owes much to earlier models (Gottfried Keller's remarkable essay 'Am Mythenstein', written after a visit to the *Schillerfest am Mythenstein*, called for a new, national, festive theatre, the resuscitation of ancient

myths and legends). Some may feel it inappropriate, indeed blasphemous, to imply that any aspect of Nazism could be called 'religious', but totalitarian regimes have a pseudo-devotional aura about them, some cosmic reference which prefers mythology to history. The following statement is attributed to Adolf Hitler: 'I create my religion out of *Parsifal*. Worship in a solemn form. One can only serve God in the robes of a hero.'[10]

Richard Euringer's *German Passion*, 1933, originally a *Hörspiel* (or *Hörwerk*), combines the tradition of the open-air stage with choric recitation, fanfares, circus-effects and mystical 'Devotion'. Euringer conceived of the theatre as a 'Theatre of Nature', embracing fire, earth, water and air, the constellations and spirits of tribal deities: the people were to see presented before them an enactment of their chthonic origins. If the theatre of Weimar had concerned itself merely with ladies' underwear, sex, drunkenness, mental illness, decadence and materialism (I am grateful to J. M. Ritchie for Johst's comments here),[11] then the new Reich was to project cosmic, cultic verities. The characters of Euringer's play include 'the Unknown Soldier', 'Worker', 'Hag', 'War Invalid', 'Girl', 'Children' and 'Mother'. The German people, undermined by bolshevism and international Jewry, will nevertheless be saved: the unknown Soldier rises from his grave, a crown of barbed wire upon his head. He ascends into heaven, and the Evil Spirit is overthrown.

Kurt Eggers's *Play of Job the German* is a similar work, where 'the Lord of Hosts' promises 'the Evil Spirit' domination over the earth if he could succeed in tempting Job the German to renounce his belief in Him: war, plague, poverty, sickness and despair test the faithful Teuton who nevertheless triumphs and is chosen by 'the Lord of Lords' to rule over the earth.

One further example of a quasi-religious experience is E. W. Möller's *The Dice Game of Frankenburg* of 1936 which, although it is based on an incident from the seventeenth century, portrays trial and atonement in the manner of Georg Kaiser (*The Citizens of Calais*). J. M. Ritchie has well described the première at the time of the Berlin Olympic Games.[12] To return to Euringer: his *Totentanz*, 1934, harks back to the 'Walpurgisnacht' scene of Goethe's *Faust* in the rhythmical, dynamic alternation of pithy stichomythia: it describes the cleansing of 'Nihilists', 'Pacifists', 'Pimps', 'Bank robbers' from the temple of life, and the triumph of Nordic man.

Let us pause here. To what extent may these choric mystery-plays-cum-oratorios be called 'expressionist'? If Expressionism is a movement

towards abstraction, towards the typical and the essential rather than the personal and the individual; if it exemplifies a predilection for ecstasy and despair, and hence a tendency towards the inflated and the grotesque; if it turns towards a mystic element with apocalyptic overtones; if the urgent sense of the here and now is seen not from any naturalistic standpoint, but *sub specie aeternitatis*; if there is a revolutionary fervour in it, an aspect of the atavistic, the passionate and the radical – then *Thingtheater* must surely lay claim to inclusion in the history of expressionist theatre.

Echoing Richard Wagner, Alfred Rosenberg claimed that 'it is only in Europe that art becomes a true medium of transcendence, a religion in itself'.[13] When art and religion interlock, then there indeed are some very strange hybrids. The use of massed choruses, marching, music and declamation produced a form of *Gesamtkunstwerk* which aimed at an all-embracing experience, a sense of communion and ritual. What was new, of course, was the nationalistic element, the fatherland elevated to mythological status, and the belief in the mysterious supremacy of Nordic man. The international, left-wing aspects of Expressionism belong, it seems, in a different category altogether. If Expressionism is the eruption of the most general emotions, passions and virtues, with love of humanity, brotherliness and willingness for self-sacrifice to the fore, then the *Thingspiele*, in their mystical nationalism, stand at one remove – no 'O Mensch' pathos, but 'O deutscher Mensch'.

Expressionism may be defined as the revolt of the spirit against reality. The soul under stress, racked and burning in some fearful incandescence, or longing for some nebulous excarnation, are its most striking hallmarks. Sorge's young hero longed for an ultimate vision beyond reality; Hasenclever strove to portray a 'Beyond'; Kaiser described the quest for some transcendental awareness, his heroes moving through stages of martyrdom; Kornfeld insisted on *der beseelte Mensch* (the soul-endowed man); Barlach sought Easter and Resurrection; Becher and others conceived of a new age with its deification of man; the Third Reich was portrayed by some in terms more appropriate to a medieval mystery play. And Bayreuth and Dornach, *Thingspiel* and ritual *Festspiel*, and *Faust II* provide a fascinating counterpoint. It is very much removed from our own time which is attracted above all by the (frequently aberrant) sexual daring of much expressionist writing, also by the cult of violence in many of the plays. But the god-seekers should not be forgotten, however singular the epiphanies they sought, for it is they who give to modern German literature its most distinctive voice.

Notes

1 R. Sorge, *Werke in 3 Bänden*, Nuremberg, 1964, II, p. 23.
2 C. Walker, *Expressionist Poetry and its Critics*, London, 1986, p. 167.
3 Willett, *Expressionism*.
4 H. Bahr, in *Literarische Manifeste der Jahrhundertwende*, E. Ruprecht and D. Bänsch (eds), Stuttgart 1970, p. 191.
5 R. Furness, *Expressionism*, London, 1973, pp. 5-7.
6 Quoted in B. Kenworthy, *Georg Kaiser*, Oxford, 1957, p. 101.
7 J. H. Reid, 'The Halves and the Whole: Another look at Ernst Barlach's *Der arme Vetter*, *The Modern Language Review*, LXXII, 1977, p. 626.
8 In W. Rothe (ed.), *Expressionismus als Literatur*, Berne and Munich, 1969, pp. 37-66.
9 J. Goebbels, *Michael: Ein deutsches Schicksal in Tagebuchblättern*, Munich 1933, p. 42.
10 Quoted in J. Fest, *Hitler*, Frankfurt am Main, 1973, p. 683.
11 J. Ritchie, *German Literature under National Socialism*, London, 1983, p. 101.
12 *Ibid.*, p. 106.
13 Quoted in U. Ketelsen, *Von heroischem Sein und völkischem Tod*, Bonn, 1970, p. 43.

Deciphering Wassily Kandinsky's *Violet*: activist Expressionism and the Russian Slavonic milieu

Shulamith Behr

In his correspondence with Kandinsky, Arnold Schoenberg seized on the rejection of discursive continuity in *The Yellow Sound* (1912) as posing a 'puzzle' for the contemporary viewer:

> It [*Der gelbe Klang*] is exactly the same as what I have striven for in my *glückliche Hand*, only you go still further than I in the renunciation of conscious thought, any conventional plot. That is naturally a great advantage ... It is important that our creation of such puzzles mirror the puzzles with which we are surrounded, so that our soul may endeavour – not to solve them – but to decipher them. What we gain thereby should not be the solution, but a new method of coding or decoding. The material, worthless in itself, serves in the creation of new puzzles.[1]

Schoenberg's reception of *The Yellow Sound* acknowledges the necessity to develop 'new' strategies of 'deciphering' the theatrical event as inner experience, a notion central both to Kandinsky's theories in the treatise *On the Spiritual in Art* (1912) and to the aesthetics of the expressionist movement as a whole. According to Schoenberg, the onus is placed on the spectator, as 'physiological subject and autonomous viewer' to 'code' and 'decode' the spectacle without involving 'finalisation' or 'ultimate closure' of interpretation. The extract bears unwitting testimony to the immense changes brought about by the effects of modernity on aspects of perception, observations which are even more pertinent when it comes to an investigation of *Violet* (1914), since the stage-composition appears to make a virtue of disharmony and lacks ultimate resolution.[2]

On first reading, it seems rambling, capricious and even incoherent. Interludes of abstract, coloured light fluctuate with numerous *mises-en-scène* varying from an austere interior to an ornate Russian setting, from a pastoral idyll to an urban city-scape. Nevertheless, the apparent formlessness belies a 'richly interwoven texture', closely corresponding

to symphonic composition, a metaphor Walter Sokel has employed to characterise the theme-centred as opposed to the plot-centred arrangements of expressionist drama.[3] Deciphering the various levels at work in *Violet* requires acknowledgement of a complex network of factors stemming from Kandinsky's involvement in a wide circle of ideological debates pertinent not only to expressionist avant-garde culture in Germany but also to the Russian Slavonic milieu and heritage. This essay explores the referents of *Violet* to Futurism and activist Expressionism and interprets the stage-composition in the light of Kandinsky's editorial activities with the Bosnian Serb, Dimitrije Mitrinovic, during 1914. Both investigations serve to illuminate the expressionist overtones of the stage-composition but from distinct vantage points. Before proceeding with further observations regarding the characteristics and thematic sequences of *Violet*, it is relevant to establish the context in which the theatrical piece was written.

Part of the circumstances arose from Kandinsky's association with Hugo Ball who, after attending the Max Reinhardt School in Berlin (September 1910) and directing a short season at the Plauen Stadttheater, was appointed to the post of *Dramaturg* (critic/playwright) at the Kammerspiele in Munich (September 1912).[4] While he met Kandinsky around this time, it was not until May 1914 that Ball expressed his fascination for the Russian's genial personality, 'most revolutionary' ideas and 'spiritual influence'.[5] In proposing a programme for the summer season of the Münchener Künstlertheater (Munich Artists' Theatre), Ball cited Kandinsky's *The Yellow Sound* as one of the appropriate examples of the 'new theatrical expression'.[6] Such efforts to rejuvenate the Künstlertheater failed to materialise, however, as did Ball's attempts to publish a book on 'Das Neue Theater' or 'Expressionistisches Theater' in collaboration with Kandinsky, Franz Marc, Thomas von Hartmann, Fokine and von Bechtejeff.[7]

Nonetheless, it is possible to reconstruct Ball's conception of the 'new theatre' which, interestingly, also involved the drawing up of architectural plans aimed at creating a form of 'Festspielhaus', a theatre of ritual performance.[8] Furthermore, the list of theoretical texts drawn up in Ball's diaries is instructive in elucidating the primacy of the *Gesamtkunstwerk* which, in uniting the latest tendencies in the arts (music, dance, word and stage-design), performed the function of 'discharging' constrained psychic energies of the inner dramatic life.[9] As long as these aesthetic considerations were radical, they satisfied the expressionist ardour for revolutionary social reconstruction.

In June 1914, the *Neue Verein*, an established Munich literary club

with which Hugo Ball had previously been in conflict, agreed to allow him to direct six matinées at the Kammerspiele.[10] In addition, Ball arranged with Herwarth Walden to display loan exhibitions from the Berlin *Sturm* gallery in the foyer of the theatre starting in September.[11] One of these exhibitions was to be devoted to Kandinsky's works accompanied by a matinée, an Act ('Bild') of his new stage-composition *Der violette Vorhang* (Violet Curtain), a copy of which had been placed 'at Ball's disposal'.[12] Ultimately, the events of the First World War prevented fulfilment of these schemes.

Among the papers in the Kandinsky Legacy in Paris, a summary of the composition still bears evidence of the first title *Violetter Vorhang* that was subsequently reduced in German and Russian manuscripts.[13] The significance of the initial title can be gauged from the fact that, at junctures of the work, the curtains become part of the props, hindering the actors and invading the setting.[14] This leads one to conclude that the function of the curtains, as history or destiny, is greater than that of the characters. Further evidence of this interpretation is provided in the final Act: a stretcher containing a body covered by a violet draping is carried in by two 'lackeys'. In the treatise *On the Spiritual in Art*, moreover, Kandinsky codified the physical and psychological effects of colour, proclaiming, in particular, that violet had a 'morbid, extinct quality like slag', and was used in China as the garb of mourning.[15]

Having outlined the context and gauged the significance of the initial title of *Violet* as implying a conflict between the forces of immortality and destiny, attention can be directed towards a closer examination of the play's structure. It is arranged in seven acts or scenes which, as in *The Yellow Sound*, are termed 'Bilder' or 'Pictures'. Within another outline of *Violet* in the Kandinsky Legacy in Paris, the short stage-composition *Apotheosis* was listed after the seven acts and the strong possibility exists that it was intended to conclude the work.[16] The semantic modifications that occur as a consequence of this addition will be considered below.

Further divisions arise in the compositional structure; pauses, indicated by calculated seconds in brackets, are used for emphasis between different actions or lighting directives. The precision of this technique differs substantially from that employed in *The Yellow Sound*, in which visionary, temporal abstractions, such as 'immediately', 'later', 'after some time', were relied upon.[17] In *Violet*, we are given an accelerated pace of the dramatic effects, signifying a considerable change of style. This observation is particularly applicable to the sound effects which include the use of musical instruments and *bruitist* noises (urban,

military and domestic). These alternate with speech or correlate with movement and lighting effects. The musical score, therefore, is not an orchestrated development of theme and variation, as initiated by Thomas von Hartmann for *The Yellow Sound*, but corresponds to the alliteration of the individual instrument's timbre (e.g. 'Boum' of drum or 'Trou-ou' of trumpet).

Significantly, Kandinsky had every intention of satisfying Edward Gordon Craig's ideas regarding the crucial nature of the stage-director for restoring the art of the theatre to its 'own creative genius'; a single sheet of music, 'Eventuelle Melodien für Bild I und II', in Kandinsky's script remains in the Legacy in Paris.[18] Another extant plan (fig. 25) detailing the co-ordination of colour, movement, music and voices for Act 2, demonstrates Kandinsky's methods of ascertaining the continuity of these performance elements at a glance. Ultimately, the adoption of such radical sound effects (bruitist, vocal and instrumental) represents an acknowledgement of the debates in Italian and Russian Futurism. Kandinsky's exploitation of the components of speech in *Violet* is considerably more phonetic than his poetry in *Klänge* (1913) and merits comparison with experiments in language conducted in these circles.[19]

The verbal content eludes discursive analysis; incomplete, vague sentences and phrases, with changes in tone and rhythm precisely textualised, are conveyed by isolated voices or choruses. At times, segmentation of key words is effected by the lengthening and repetition of syllables and/or consonants (e.g. 'co-lap-se-d-d-d'). As in *On the Spiritual in Art*, which conveyed Kandinsky's theories regarding the 'inner sound' ('*innerer Klang*') of words and colours, the programmatic statements in *Beyond the Wall*, written in 1914, attest to his continued interest in the autonomy of word/sound and colour and to the necessity of promoting an 'enstrangement' of the word in order to trigger an aesthetic response.[20]

Nonetheless, having suggested the mutual interests of Kandinsky and the Futurists, it is necessary to qualify these observations. Kandinsky still deplored the public spectacle of Futurist propaganda and his more relaxed attitude towards experimentation in *Violet* belies the tone of his invective regarding the Italian Futurist exhibitions in Herwarth Walden's *Der Sturm* gallery in Berlin during 1912.[21] At the same time, one has to consider the impact of his interaction with Hugo Ball and activist literary Expressionism which itself embraced Futurist notions of the dynamism of modern life. Confirmation that the artist was aware of the intellectual discourses presented in the pages of *Die Aktion* is provided in the observation that he signed a petition organ-

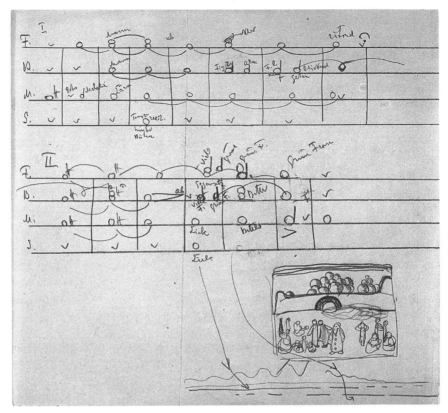

25 Wassily Kandinsky, *Diagram and sketch for Second Act of 'Violet'*,
1914, pencil and ink

ised by Heinz Eckenroth, a Munich publisher, in solidarity with the
magazine after it was seized by the state censors on three occasions in
1914. The petition, entitled 'Drei Jahre Aktions-Arbeit; Für die
"Aktion"', was published in Eckenroth's magazine *Phöbus* in 1914 and
included the names of Hugo Ball, Heinrich and Thomas Mann in the list
of twenty-nine Munich writers and artists.[22]

When it comes to an analysis of the thematic material of *Violet*, it is
useful to refer to categorisations of the two faces of expressionist drama:
one which harked back to Romanticism in emphasising the positive
content of 'mission' and the other which parodied that sense of 'mission'
and looked forward to future theatrical experimentation.[23] While *The
Yellow Sound*, in its visionary concerns for the spiritual regeneration of
man, can be anchored within the first category of expressionist
idealism, *Violet* resists firm classification by juxtaposing elements of
'mission' with a nihilistic presentation of the materialistic world.

The parodying of social classes constitutes a new departure for

Kandinsky's theatrical material. In three out of the seven acts in *Violet*, attention is focused on an elegantly dressed couple who do not acknowledge each other's presence. The fluctuations between curtailed speech, contrived self-consciousness, the inept attempts of the man to perform a conjuring act with a lemon and a blue handkerchief, all point to a scenario of farce and cabaret.[24] In addition to ruthlessly unmasking the obsessive materialism of the merchant middle-classes, Kandinsky's portrayal of other levels of society is similarly unflattering. In Act 6 the workers, who wheel in a cart surmounted by a green parrot in a golden cage, stop, blow their noses and spit, their drawling voices being interrupted by the screeching of the parrot. The servants in the final act repeat a meaningless set of actions, carrying a luxuriously-set table from one side of the stage to another, in response to the orders of a chimney-sweep. Apocalypse as revelation, the *leitmotiv* of the text and performance of *The Yellow Sound*, is transformed into a forceful programmatic statement of imminent destruction, as palm trees fall and refrains vocalise the collapse of the ramparts.[25]

While Kandinsky's influence on Ball has been the exclusive focus of attention in most investigations of this period, it is apparent that Ball was instrumental in redirecting Kandinsky's notion of the *Bühnengesamtkunstwerk* towards breaking through the 'sterile crust of society'.[26] The fine balancing act that Kandinsky strove to preserve in *The Yellow Sound* between the principles of 'construction' (order) and 'nothingness' (chaos), the Apollonian and the Dionysian, was dispensed with in *Violet*. No longer was the objective spirit of the work of art safe from invasions of the empirical and the contemporaneous world in attempting to achieve a sense of 'Rausch' (frenzy), a condition central to Nietzsche's metaphoric images of the creative process. This predilection towards eliciting the 'irrational' is in line with Kandinsky's theoretical statements in his treatise *Beyond the Wall* where he quoted from Balzac:

> The rational mind, compared to emotion, is always poor. The first is always and naturally limited, the second is unlimited. To serve reason instead of emotion is a characteristic of a soul incapable of arousing.[27]

Yet Ball, like Nietzsche before him, sought utopian solutions in order to channel the instinctual Dionysian elements into an aesthetic reformation of society:

> My thesis went like this, that the purpose of the Expressionist theatre is the festival play; it contains a new conception of the total work of art. The form of the present-day theatre [does not touch] the subconscious at all. The new theatre will use masks and stilts again. It will recall archetypes and use

megaphones. Sun and moon will run across the stage and proclaim their sublime wisdom.[28]

Ball's internalisation of the Nietzschean cycle of destruction and re-creation in his writing on the 'Festspielhaus' embraces both the total work of art and the recuperation of ritualistic and folk genres, formats that we know were close to Kandinsky's aspirations. Though it is not clear whether the above entry was retrospectively altered in Ball's diary after 1924, it uncannily provides a manifesto for the divergent themes of *Violet* which allude to the devastation of contemporary society and to those 'archetypal' origins as a way of formulating a particular comment on modern man. Hence, it seems to be no coincidence that men, with yellow, multi-coloured spotted faces, clatter around on stilts in the fifth act and, indeed, the moon does follow the direction of the sun across the stage in Act 6.

For Kandinsky, utopian sentiments embodied a synthesis of the archetypal male/female opposites as metaphors for creative spirituality and nature, a conclusion that can be endorsed through an examination

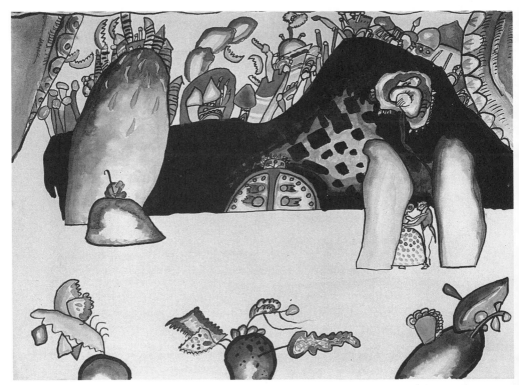

26 Wassily Kandinsky, *Study for Second Act of 'Violet'*, 1914, pencil, ink and watercolour

27 Wassily Kandinsky, *Sketch for Second Act of 'Violet'*, 1914, pencil

of the images of Paradise that emerge episodically during the stage-composition. A knowledge of Kandinsky's oeuvre facilitates the linkage of the lovers in Act 2 with the theme of Paradise as a Garden of Love.[29] An examination of the preparatory studies for this setting enables one to substantiate this deduction. Set between narrow high stones on the right, the couple are placed at an arm-length's embrace in a Russian *mise-en-scène* (fig. 26), against the background of a walled town surmounted by a multitude of domes. A flower hovers above the lovers, like an orbital planet, a symbolic reference to the sun/moon relationship of divine or seraphic love. In another scenic sketch (fig. 27), a reclining odalisque-type nude replaces the three large, schematic plants situated by the footlights and represents earthly love.[30]

For the moment, it is sufficient to observe that Kandinsky conceived of the Garden of Love beyond the confines of the medieval walled town. Furthermore, the symbolic representatives of divine love are set amidst the turbulence of characters in national dress performing a popular dance with bells, clogs and whistles, which, in Bakhtinian theoretical terms, evokes the atmosphere of universal and world carnival.[31] A Dionysian release of ecstatic, unconscious forces may be inferred from the movement of the compact group of figures driven by a red ray of light from one side of the stage to another. Spiritual renewal of society, in the guise of Seraphic love, is dependent on emergence from procreative chaos.

The 'Urbilder' that Ball spoke of as being evoked via the village and festive rituals are further amplified by the primordial referents of the following act. The combination of rocky hills, silverish stream, a huge, gilded sun, fountain and rainbow (plate V) alerts one to a similar scenario within Kandinsky's oeuvre. It is interesting that, in 1914, he would return to the crucial period of 1908 in recalling *The Ariel Scene* from *Goethe's Faust II*, a painting which the artist presented to Maria Strakosch-Giesler after attending a lecture by Rudolf Steiner entitled 'Sonne, Mond und Sterne'.[32] As Sixten Ringbom has commented, while the characters of the *Ariel Scene* are difficult to identify, the *mise-en-scène* is more explicit and alludes to the words of Faust in the Prologue to the second part of Goethe's drama.[33]

The commingling of the senses of sight and sound materialises in Kandinsky's directions. The idyllic setting admittedly is populated by a bloated, deliberately awkward, red cow and a chorus of wooden-like figures, colourfully dressed in Russian costumes, Kandinsky's alternative parody of Faust's mythic 'Paradise'. A violin playing scales off-stage, rather than an Aeolian harp, presages the choir which sings the

words 'the ramparts have collapsed' to a dance theme and stamp their feet. Violet light wanders over both stage and audience, accompanied by sounds of a primitive pipe alternating with a bassoon. This ritualistic union with nature, encompassed by Kandinsky's ideas of utopia, is reinforced by the appearance of a gilded sun, a fountain (purification) and rainbow (hope for the future) that remains illuminated while the rest of the stage is plunged into darkness.

That the primitivist statement outlined above is well anchored in contemporary evaluations of modernity can be gauged from the substance of Act 6. Severely contrasting with the rural evocations cited previously, the setting comprises a backdrop containing a large apartment on a street. Faces occasionally appear at the small windows. Yet it would be simplistic to overstate Kandinsky's manifestation of cultural pessimism. The artist aligned himself with expressionist sentiments which addressed the dilemmas of modernity via a recourse to the eternal values of the primitive.[34] Paradisiacal notions of instinctual divine love would bridge the gap between the individual and the communal, town and country, urban and rural. However, the complex relationship of nature to culture was not the exclusive preserve of sections of the avant-garde, cultural critics and social theorists in Germany. An organic synthesis of country, village and town, in accordance with less secular, transcendental ideals was an explicit aim of pan-Slavists in accommodating the pressing demands of modern society. As a consequence, it is necessary to anchor Kandinsky's engagement with modernity in the context of his Russian cultural heritage and ideas on national identity.

I have demonstrated elsewhere that the evidence at hand regarding Kandinsky's editorial activities with Dimitrije Mitrinovic is crucial for the light it sheds on the artist's allusions to the Russian Slavonic milieu in his paintings, writings and in the stage-composition *Violet*.[35] Contrary to the belief that the First World War interrupted the completion of a second issue of the *Blaue Reiter Almanac*, the idea itself had already been replaced by proposals for a 'Yearbook which prepared to unite all the spiritual disciplines'.[36] By March 1914, Mitrinovic's name was firmly associated with this venture, Franz Marc's position having been usurped by this twenty-six-year-old student of art history. Yet Mitrinovic was not uninitiated and his publications were dedicated to the awakening national consciousness of the Southern Slav states and to the necessity for heroic minorities to gain freedom in the modern age.[37]

By the end of February 1914, he was on sufficiently familiar terms with Kandinsky to deliver a lecture, entitled 'Kandinsky and the New

Art: Taking Tomorrow by Storm', accompanied by lantern slides and an exhibition of the artist's works, in the Great Hall of the Deutsches Museum in Munich. In his lecture notes, Mitrinovic maintained that the history of the revolution in painting reached its climax in Kandinsky:

> Kandinsky as the typical representation of the revolution not only in the art of painting. Race-impulse. Russia the most recently cultured goes furthest into revolution and deepens the new movement through the Slavonic Weltanschauung. Kandinsky's mysticism [is] to some extent a synthesis and perfecting of the most recent currents in art.[38]

Mitrinovic's equation of modern art and political revolution, cultural modernity and the Slavonic national milieu, synthesised by mysticism, are interesting indicators of Kandinsky's preoccupations during late 1913-14.

In his *Reminiscences* (1913), Kandinsky declared his allegiances with the principles of Slavic intuitive freedom and appeared to disassociate his concept of the coming spiritual epoch from that of Rudolf Steiner.[39] He increasingly alluded to that tradition of Russian mystical writing that anticipated religious revelation via a powerful synthesis of the achievements of early Christian and Eastern thought, the names of Dmitrii Merezhkovsky and Vladimir Solovyov being frequently invoked in Mitrinovic's correspondence with Kandinsky.[40] The vague references to the imminence of a new spiritual epoch in the *Blaue Reiter Almanac* had become politically anchored in a form of Pan-Christian Universalism by 1914. Entitled 'Towards the Mankind of the Future through Aryan Europe', the new Yearbook was envisaged as an annual, comprising contributions from political, sociological, philosophical, religious and cultural commentators, the term 'Aryan' implying an initiative to unite the Baltic States and Russia within European cultural modernism.[41] As these activities coincided with the writing of *Violet*, it is instructive to examine whether one can observe any principles of convergence in the stage-composition of the utopian concepts of pan-humanity, universalism, cultural modernism and the national milieu as synthesised by the spiritual.

That *Violet* was intended to provide representatives of pan-humanity can be ascertained from Kandinsky's directions for Act 2, 'A Crowd comes running out; all periods, all ages, all colours, all types are represented'. In general, the cast includes various social classes – from the tongue-tied members of the merchant bourgeoisie to workmen, lackeys and peasants (moujiks) – and identifiable favourite types (e.g. a beggar, lovers, a chimney-sweep and a street-organist). The adaptability of the text, moreover, to portray different national characteristics is

testimony to its universal intentions. Whereas the Russian version specifies the 'Komarinski' and 'Volga boat song' as popular songs or melodies for incorporation in Act 6, the German manuscript cites: '"Kommt ein Vogel geflogen" (every child knows this song in Germany)' and 'O du lieber Augustin', in addition to providing indications of rhythmic dance themes in other contexts.[42]

The function of such cultural signifiers to promote the accessibility of the medium is extended by the prominent role given to popular theatre and variety – Morris dancing with clogs and bells; men on stilts; children dressed for the fair; music from the barrel organ; a squawking parrot. The contemporaneity of the *mise-en-scène* and the noises of the city vie with constructivist techniques of the multi-media experience. Furthermore, war-like metaphors, contained in the recurring refrain 'The ramparts have collapsed', are endorsed by the marching footsteps of soldiers, the striking of a clock, shrill military orders. Such manifestations of cultural modernism were the result of a combination of factors stemming from Kandinsky's interaction with activist Expressionism and Mitrinovic's enthusiasm for the Futurist movement.

In postulating a future state of harmony, the stage-composition contrives to suggest a common ground between extremes, viz. recurring myths of Russia and demands of the modern age. The orientalised depictions of the walled city in Act 2 (fig. 26) and the richly ornamented arrangement of the multitude of domes and cupolas, contribute to the myth of the exportable Russia, the images of 'the other' so cherished by the West.[43] Movement and sound confirm this interpretation, the crowds performing folkish-type dances with clogs, bells and whistles. By contrast, Act 6 portrays a 'boring' urban street, the inhabitants of which refute the idea of community. A pastiche of popular melody anticipates the setting while, during the performance, the musical accompaniment resounds intermittently from the street-organ. The appearance of workmen pushing a cart coincides with the climax of the act, the transformation of this miserable setting by the cosmic manifestation of an impending eclipse, shooting stars and multi-coloured rays of light uniting the participants fleetingly, the implication being an ephemeral synthesis of the social classes by transforming light.

The mediating forces in *Violet* are supplied by the elemental and scenic features of Act 3, the idyllic mountain stream and fountain being dominated by the bucolic, the red cow (plate V). The chorus is interspersed by the lowing of the cow, the sounds of a bassoon and primitive pipe, obviously a plea for a consideration of the underlying mythic origins of Russia as opposed to the external trappings furnished

in the previous act. Evidently, it is the inspiration of the former which provides the stimulus for spiritual synthesis of the past and present. The choice of the image of the cow surrounded by aural light possibly alludes to the mythical interpretation of the image as both sign ('Mother nature') and symbol ('celestial'). The explanatory potential of the motif can be exploited to reveal its function.[44] The large cow is raised on a white, bloated stone like a deity above the figures on the right. After the huge gilded sun appears on the left, a pink halo surrounds the cow and falls on to the chorus. As darkness descends, the cow lows plaintively '(as if its calf has been taken away)'. Yet the rainbow, as a symbol of reconciliation in Genesis and the apocalyptic setting of the Throne of God in Revelations, remains illuminated as the rest of the scene is plunged into darkness. The capacity for the Resurrection of the lost Paradise is invested with its full significance.

If, indeed, *Violet* is meant to be concluded with *Apotheosis*, then the message of the stage-composition becomes somewhat more ambivalent. In *Apotheosis*, the major events consist of the interplay of coloured abstract shapes with a minimal role being accorded to the men in white who are eventually ousted by the increased activity of the violet spot.[45] Symptomatic of mortality, the violet shape causes havoc and conflict, the accelerated pace of the visual rhythms being accompanied by repeated cracks of a whip. That such ominous forces are incompatible with concepts of Nietzschean procreative chaos is substantiated by women's voices which proclaim that the ramparts 'never collapsed', the apocalypse was still-born.

As Richard Sheppard maintained in his interpretation of *Violet*, 'apocalyptic hope and cultural pessimism exist next to one another'. The 'darker sense of history which haunts so much of early Expressionist art and literature' remained unassimilated 'into a religious pattern of resurrection out of cosmic *krisis*'.[46] Even in the final sequences of Act 7, hope still reigns in the form of a child's voice screaming, 'the ramparts of the future, the newest of all'. It is only with the addition of *Apotheosis*, however, that the chiliastic overtones of *Violet* remain unattainable and it is this sense of negativism which evokes the conflicting themes of German Expressionism.

Notes

1 Kandinsky and Schoenberg, *Letters, Pictures and Documents*, p. 54. Letter dated 19 August 1912.
2 J. Crary, 'Techniques of the Observer', *October*, 1989, pp. 3-35 *passim*, attributes this phenomenon to the invention of photography in the nineteenth century and

to the proliferation of optical devices which negated the *camera obscura* as a sovereign metaphor for describing the status of the observer.

3 W. Sokel (ed.), *Anthology of German Expressionist Drama*, New York, 1963, p. xv.

4 P. Mann, *Hugo Ball: An Intellectual Biography*, London, 1987, pp. 29-30.

5 H.Ball, *Briefe 1911-1927*, A. Schütt-Hennings (ed.), Cologne, 1957, p. 30.

6 H. Ball, 'Das Münchener Künstlertheater. Eine prinzipielle Beleuchtung', *Phöbus*, I/2, May 1914, pp. 68-74 (p. 73).

7 Ball, *Briefe*, pp. 28-32. Letter to Maria Hildebrand-Ball 27 May 1914.

8 *Ibid.*, p. 29.

9 H. Ball, *Flight out of Time: A Dada Diary*, New York, 1974, p. 10. Ball, 'Das Münchener Künstlertheater', p. 73.

10 Mann, *Hugo Ball*, pp. 30-1.

11 Ball, *Briefe*, p. 33 (29 June 1914).

12 *Ibid.*, p. 34.

13 The bulk of Kandinsky's unpublished theatrical material is located in the Kandinsky Legacy, Musée National d'Art Moderne, Pompidou Centre, Paris. A French translation of *Violet* by Andrei B. Nakov, based on incomplete German and Russian manuscripts, is published in: Kandinsky, *Écrits Complets*, pp. 83-112. An English translation can be found in my PhD thesis: S. Behr, 'Wassily Kandinsky as Playwright: The Stage-Compositions 1909-14', University of Essex, 1991, II, Appendix 4, pp. 20-51 (hereafter Behr WKP).

14 Behr WKP, II, Act 1, p. 20; Act 4, p. 39.

15 Kandinsky, *Complete Writings on Art*, p. 189.

16 Behr WKP, II, Appendix 5, pp. 52-3.

17 See S. Stein, *The Ultimate Synthesis: An Interpretation of the Meaning and Significance of Wassily Kandinsky's 'The Yellow Sound'*, MA dissertation, State University of New York at Binghampton, 1980, p. 70, for discussion of the apocalyptic features of Kandinsky's style of writing.

18 Copy of manuscript kindly provided by Jessica Boissel, Musée National d'Art Moderne, Paris. See Behr WKP, I, pp. 110-12, for impact of Edward Gordon Craig.

19 Behr WKP, I, pp. 149-52, for commentary on Kandinsky's interaction with Russian Futurism.

20 Kandinsky, *Écrits Complets*, pp. 117-18.

21 W. Kandinsky and F. Marc, *Briefwechsel*, K. Lankheit (ed.), Munich, 1983, p. 171, Kandinsky to Marc, 11 May 1912.

22 *Phöbus*, no. 2, 1914, pp. 85-7, quoted in Y. Heibel, '"They Danced on Volcanoes": Kandinsky's Break-through to Abstraction, the German Avant-Garde and the Eve of the First World War', *Art History*, XII/3, 1989, p. 361, note 43.

23 Sokel, *Anthology*, pp. xiiff.

24 Behr WKP, I, pp. 74-6; pp. 91-6, focuses attention on the inspiration of German and Russian cabaret and on the phenomenon of intimate theatre's appropriation of the genres of popular theatre.

25 E. Roters, 'The Painter's Night', *The Apocalyptic Landscapes of Ludwig Meidner*, Munich, 1989, p. 87, points to the etymological meaning of the word *Apocalypse* as standing for a revelation, not a catastrophe, disclosing the hidden side of a cosmic crisis and the nature of its causes.

26 Cf. P. Mann, *Hugo Ball*, p. 37.

27 Translation from copy of Russian manuscript in Gabriele Münter- und Johannes Eichner-Stiftung, Städtische Galerie im Lenbachhaus, Munich. I appreciate Nina Bailey's assistance with the translation.

28 Ball, *Flight out of Time*, p. 9.

29 See R. Washton Long, 'Kandinsky's Vision of Utopia as a Garden of Love', *Art Journal*, XLIII/1, 1983, pp. 50-60. Washton Long points to Kandinsky's acquaint-

ance with both the Wagnerian and Russian mystical traditions that used the couple as a symbol for transcendent love.

30 *Ibid.* and Behr WKP, I, pp. 158-60. A book by Erich Gutkind (Volker), *Siderische Geburt* (1910 *Sidereal Birth*), also notably impressed Kandinsky and Gabriele Münter from 1912 onwards. In utopian tones, Gutkind postulates the physical union of two lovers as a metaphor for divine love ('Seraphic'). This is contrasted with 'erotic love', characterised by the need to embrace any number of individuals.

31 M. Bakhtin, *Rabelais and His World*, Cambridge, Mass., 1968, p. 7.

32 S. Ringbom, *Sounding Cosmos: A Study in the Spiritualism of Kandinsky and the Genesis of Abstract Painting*, Abo, 1970, pp. 68 71.

33 See J. Goethe, *Faust* II, London, 1959, p. 26.

34 See Lloyd, *German Expressionism*, for a study of the Dresden and Berlin contexts of the primitivism/modernity debate.

35 S. Behr, 'Wassily Kandinsky and Dimitrije Mitrinovic; Pan-Christian Universalism and the Yearbook "Towards the Mankind of the Future through Aryan Europe"', *Oxford Art Journal*, XV/1, 1992, pp. 81-8.

36 Kandinsky and. Marc, *Briefwechsel*, Kandinsky to Marc, 10 March 1914, p. 252.

37 A. Rigby, *Initiation and Initiative: An Exploration of the Life and Ideas of Dimitrije Mitrinovic*, Boulder, 1984, p. 27.

38 Behr, 'Wassily Kandinsky and Dimitrije Mitrinovic', p. 82.

39 Kandinsky, 'Reminiscences' (1913), in *Complete Writings on Art*, p. 377.

40 Behr, 'Wassily Kandinsky and Dimitrije Mitrinovic', p. 83.

41 *Ibid.*, pp. 84-6, for details of the proposed Yearbook and for critical discussion of the racist origins of this terminology.

42 Information confirmed by Jessica Boissel, Musée National d'Art Moderne, Paris.

43 In E. Said's *Orientalism*, London, 1978, the Western discourse and image of the Orient is critically challenged.

44 Behr WKP, I, pp. 193-5, for a more detailed annotation of this motif in comparison with the Russian artist Marc Chagall.

45 *Ibid.*, II, Appendix 5, pp. 52-3.

46 R. Sheppard, 'Kandinsky's *oeuvre* 1900-14: The *avant-garde* as rear-guard', *Word and Image*, VI/1, 1990, pp. 53-5.

Lothar Schreyer's theatre works and the use of masks

Brian Keith-Smith

None of the research published on Lothar Schreyer so far has really highlighted one important feature of his work as dramatist and theatre director: the use of masks. This developed from his earliest works through his theories on expressionist theatre and on to a hitherto unknown development near the end of his life. His texts for the stage, mainly published in *Der Sturm*, seem at first sight to be experiments in language reduced to a bare minimum. These express inner urges and visionary flights of imagination, sometimes primitive sexual instincts, at others attempts to escape individuality in order to achieve a more cosmic level of awareness. The extremes of these works suggest a writer either aiming to shock – thus his production of August Stramm's *Sancta Susanna* – or to convert – as can be seen in his own *Mondspiel* production at the Bauhaus, an event that incurred Walter Gropius's displeasure and led to Schreyer's early departure from Weimar. However, already in his pre-expressionist phase, material from two of his thirteen early, as yet unpublished, dramas reveals the importance of the use of masks either as a theme or as a technique on the stage: *Narzissus* (1908) his first completed drama, and a different version of the same material *Masken* (1916).[1]

The Narcissus theme, used four times in the first play, is full of potential, but Schreyer was unable to create more than inchoate characters, and his overall structure is not entirely convincing. Whereas in *Narzissus* the search for self-identity is treated as a formula, in *Masken* the search for a fuller meaning in life is worked out as a metaphor. When Hartwig, the ageing sculptor, says to his son in *Narzissus* 'wir müssen uns in Masken sehen, um uns ganz zu finden' ('we must see ourselves in masks in order to find ourselves completely'), he is seeking a replacement for his lost ability to create beauty, an extra dimension to his everyday-self no longer attainable through art, or – as we realise later – through the memory of a previous affair with his model, Lisa. Schreyer wanted to move beyond this

drama of psychological analysis to one of fate so, in *Masken*, we see Hartwig struggling from the start against his awareness of stasis in his psychic development. Only by playing the lost part of Gabriele's dream (Gabriele is later revealed as Hartwig's and Lisa's long-lost daughter), can he approach not just her but, through her, life itself. Gabriele, significantly, appears as a masked figure – hence Hartwig does not recognise her as his daughter but as an allegory of the life force.

Sexuality, a dominant force in some of Schreyer's published dramas, here plays a destructive role. When Hartwig is alone with her he plays a 'Maskenfest' (fancy-dress ball) and claims, 'Denn du bist mein. Du gabst mir, daß mein Innerstes sich befreien konnte' ('For you are mine. You made it possible for my most inner-being to free itself'). Yet, once the identities of the mask-bearers are revealed, and with this the incestuous relationship between father and daughter, life demands revenge and both have to die. The mask-bearer Gabriele has a double role of goddess of fate and eventual victim, her tragic necessity residing in the force of her beauty. Here, Schreyer uses the device of the mask to ask if beauty can be reconciled with life for, while masks are used, the restrictions implied by both forms of existence can be avoided. The mask already becomes a means of freeing the self from a narcissistic inward gaze not into art but *through* beauty into a total surrender to life.

Release from restrictions is emphasised in the title of Schreyer's main unpublished theoretical work on the theatre 'Die Befreiung der Bühnenkunst' (The Liberation of Stage-art), 1912, developing some of his earlier essays and examining man on the stage as a theatrical metaphor for existence in general.[2] Among theories on components needed for a *Bühnenkunstwerk*, we find an equation made between the sacrificial priest and the stage-director, who both alter the everyday-event and person to produce a level of revelation and symbol. As far as masks are concerned, Schreyer proceeds from the need for stylisation of the human form and its movements on the stage, emphasising the symbolic potential of environment and of the central figures themselves in a basic rhythmic movement. Such movement, he found at first, was best represented by marionettes in groups with accompanying intensities of sound, the individual words or phrases expressing personal inner feelings but flowing as a joint idea into the melody of a chain of sound. Such devices ensure change by unfolding the actors' individuality into an artistic 'Gestalt'.

Schreyer, as *Bühnenkünstler* (artist of the stage), directs the actors whose costumes and masks are the first necessary categories enabling change to take place. He soon distinguishes between a 'harmonious'

style of stage-art that has fixed bounds and a 'rhythmic' one that is superior, because boundless. The more intense the performance becomes, the more 'rhythmic' the result and the further the actors move away from single identifiable contours, almost disappearing in some 'cosmic' totality. The typification needed to overcome the individual self-consciousness of each actor is firstly encouraged by the concept of the marionette and then, secondly, in practice, apparently achieved by the wearing of masks. Without masks performance can go no further than formula, with them it can become metaphor.

Schreyer's drawing *Skizze für ein Marionettentheater* (1920), an attempt to synthesise in artistic form his productions from the *Sturm-Bühne* (Berlin) and the *Kampf-Bühne* (Hamburg) between 1918 and 1921, is supposed to represent by its inner structure a glimpse of the world of feelings, interrelationships and emphases, flattened out or obscured by purely physical definitions of each marionette. The drawing shows movement and rhythm within overall harmony – the basic pattern but not the metaphor of Schreyer's theatrical art.[3]

The detailed techniques considered in 'Die Befreiung der Bühnenkunst' can be summed up in the phrase 'Entäußerung des Menschlichen' ('yielding up of the human') achieved in a form of controlled ecstasy that, as Mary Shields explains, 'is not a matter of boundless self-expression but its opposite, the release from personal individuation'.[4] In his early experiments Schreyer designed marionettes, such as 'Das weibliche Ich' from *Geburt* (Birth). He soon moved on to 'Ganzmasken' (full masks) or 'Übermarionetten' (supermarionettes). 'Frau' from *Buß-Schrei* (Cry of Repentance), for instance, is still at normal human scale. A parallel development was taking place with Oskar Schlemmer's plans for the *Triadic Ballet* in Stuttgart before he and Schreyer met in the Weimar Bauhaus.[5] In Schlemmer's design, *Plan of Figures for the Triadic Ballet* (1920), numbers and colours are applied consciously to produce one form of synthetic theatre.[6]

To understand the link between Schlemmer and Schreyer it is useful to consider a fragment published by Heinrich von Kleist in Berlin in 1810 two days before his essay 'Über das Marionettentheater' in his *Berliner Abendblätter*:

> One could divide men into two classes: those who understand themselves 1) by means of a metaphor and 2) by means of a formula. Of those who can understand themselves in both there are not enough to make up a class.[7]

Schreyer and Schlemmer discussed Kleist's 'Uber das Marionettentheater' at the Weimar Bauhaus and Schreyer claims, in his book on expressionist theatre, that they were the first to work out Kleist's

problem to a preliminary solution by producing 'Übermarionetten'.[8]
The actors, by wearing masks and playing out the parts of marionettes,
incorporated both metaphor and formula, the metaphysical and the
mechanical, in order to produce a 'Gestalteinheit' (unity of form). Inside
the mask, the actor danced in and with the mask, became its focal point
and could only move according to the mechanical laws of the mask
itself. A change in the mode of movement thereby results, especially
when the dance is directed solely towards an expression of the mask's
potential. Thus, as Volker Pirsich has pointed out, in *Mann* the figure
'Mann' can move whereas the figure 'Erde', in the encounter between
them that forms the content of the piece, is a fixed mask only able to
turn and shake.[9] In *Kindsterben* (Child death), the mother-figure has to
pass various abstract designs or stations of suffering towards the peace-
giving encounter with death, who stands motionless waiting to offer
her solace and peace. Expressionism, taken here to one of its extremes,
becomes the discovery of an archetype achieved by the combined use
of masks and of 'Grundbewegungen' (essential movements). The me-
chanical laws of these were worked out by Schlemmer in a series of
drawings that emphasise the potential lines of force extended into the
space around a human figure, for instance in his *Eccentric Space Lines* of
1924.

With Schreyer, a new spiritual, almost superhuman, reality is por-
trayed in rhythmic movement assisted by a third artistic category:
rhythmic sounds. For Schreyer, none of these categories relate directly
to everyday appearances, movements or speech. Whereas daily routine
makes selective demands on the individual – how to communicate with
someone else, how to get efficiently from one place to another, how to
recognise friend or foe – Schreyer's (and to a lesser extent Schlemmer's)
aim was to produce on stage the extensibility of the individual into a
new spiritual man. A typical mechanical experiment by Schlemmer is
seen in his *Stave Dance* (1927) that emphasises his individuality as
opposed to Schreyer's, for both men were intrigued by the possibilities
of new forms on the stage.

In a long section in his work on expressionist theatre, Schreyer
explains how, by studying Kandinsky among others, he learnt to build
up a pattern of inter-relationships between man and his environment.[10]
The designs which he produced for the text *Kindsterben* (1920) were
described as the, 'crystallised power centre of the play ... each one of
them a constructive, sculptural, colourful work of art' (p. 200). This
play was particularly noteworthy at the Kampf-Bühne for the develop-
ment of 'Klangsprechen' (sound-speech) and special sound effects

28 Lothar Schreyer, *Kreuzigung*
(Crucifixion), 1920, hand-coloured
woodcut on paper

ERSTER DRUCK DER KAMPFBÜHNE

DIE KAMPFBÜHNE ÜBERGIBT IHREN FREUNDEN UND GLEICHGESINNTEN DEN
ERSTEN SPIELGANG EINES BÜHNENWERKES / DIE SCHÖPFUNG DES
SPIELGANGS IST FÜR DIE BÜHNENKUNST VON GLEICHER BEDEUTUNG WIE
DIE SCHÖPFUNG DES NOTENSYSTEMS UND DER NOTEN FÜR DIE TONKUNST
ALLE SPIELE DER KAMPFBÜHNE SIND NACH SPIELGÄNGEN GESPIELT
● SPIELGANG KREUZIGUNG/BÜHNENWERK VII IST EIN HOLZSCHNITTWERK
UND ENTHÄLT SIEBENUNDSIEBZIG HOLZSCHNITTE / GRÖSSE 25×36 cm.

● DIE ERSTE AUSGABE VON DER WIR 25 WERKE DRUCKEN IST AUF ECHTES
JAPANPAPIER MIT DER HAND GEDRUCKT BEMALT / NUMERIERT UND
SIGNIERT / ALS MAPPE ODER LEDERBAND / WERKSTATTPREIS 5000MARK
● DIE ZWEITE AUSGABE VON DER WIR 500 WERKE DRUCKEN IST AUF
GUTES DEUTSCHES PAPIER MIT DER PRESSE VOM STOCK GEDRUCKT
JEDES BLATT IST HANDBEMALT / DAS WERK IST ALS PAPPBAND GEBUNDEN
WERKSTATTPREIS BEI BESTELLUNG BIS ERSTEN MAI 150 MARK
BEIDE AUSGABEN ERSCHEINEN IM MAI 1921.

WIR WISSEN / DASS DIESE ERSTE VERÖFFENTLICHUNG EINES
SPIELGANGS EINE KOSTBARKEIT FÜR BIBLIOPHILE SAMMLER
IST / WIR WÜNSCHEN / DASS UNSER WERK ZU DEN MENSCHEN
KOMMT / DIE DEN SINN FÜR UNSERE ARBEITSGEMEINSCHAFT
UND FÜR UNSERE ARBEIT HABEN / WER NOCH NICHTS VON
UNSERER ARBEIT KENNT / KANN DURCH DIESES WERK
UNMITTELBAREN EINBLICK IN UNSERE ARBEIT EMPFANGEN /
WER UNS FERN STEHT / KANN AUS DEM SPIELGANG DEN SINN
DER GEMEINSCHAFT BEGREIFEN / DIE ZU ALLEN ZEITEN
VORAUSSETZUNG DER BÜHNENKUNST IST /

WERKSTATT DER KAMPFBÜHNE
HAMBURG LOOGESTIEG 17

29 Lothar Schreyer, *Mother-figure*,
1920, ink and watercolour on paper

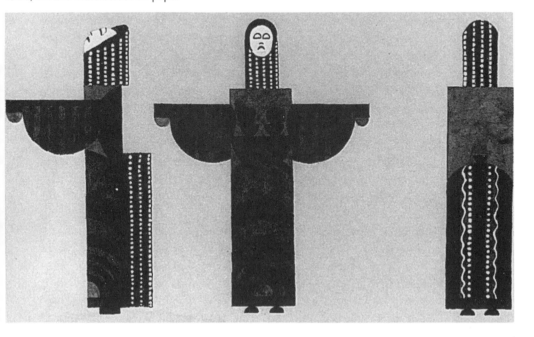

produced mainly by using a glass harmonica (p. 168). Indeed, Schreyer demonstrates how he considered the individual (already masked) could escape by becoming a mouthpiece of something greater than himself, thus extending Kleist's ideas about movement on to an acoustic level. Thus by use of mask, rhythmic movement and sound effects, man should be able to develop from the corporeal, through soulfulness, to spirituality.

In the so-called *Spielgänge*, or director's scores, held as manuscripts in the Deutsches Literaturarchiv in Marbach, Schreyer focuses on the forces that the central figures have to suffer. Each performance he describes as a form of passion through which the actors in human-sized masks become more aware of a spiritual, often religious dimension. This is seen at its clearest in *Kreuzigung* (Crucifixion), 1920, the only text for which Schreyer published a full *Spielgang* (fig. 28).[11] The opening pages show the use of non-figurative elements – signs, structures, number combinations and directions for sounds. Alongside these went words and (in performance) the physical appearance of supermarionettes that point to the interplay between resemblance and abstraction. The mother-figure here is a fine example (fig. 29). By such means the 'inner face' as Schreyer called it, of the artist, actor or person, is projected. This process is further defined in the unpublished manuscript *Die Bildverkündigung* (The Prophetic Image), 1940-46, where he defines the 'Sinnbild' (meaningful image) as a lens in which the power of light is collected and, 'allows inner glances through the externally perceptible appearance to penetrate into the inner realms of life, to give body to the actual inner image and to gaze on the meaning of life in the mirror of the original image.' Man, in undergoing such a process Schreyer would have us believe, finds his rightful place in a cosmic system, becomes a co-creator of the universe and completes the development of nature. At the centre of *Kreuzigung* are the words 'God is dead', a challenge to the central figures to awaken to the potentials of their situation. That is a form of dreamlike wandering through the world, to which they are bound, but also aware of a dimension of inner light deposited by the 'Heilandlicht' (light of the Saviour). The performance becomes an intensely concentrated quest for the rhythmic expression of that inner light. The mask thus becomes, 'the mirroring of a divine force which man should recognise in order to raise himself towards it ... the mask is the changed state of man, whose countenance shines in ecstasy'(p. 133).

In his *Mondspiel*, 1923, Schreyer used masks up to three metres high to explore the way towards a form of *unio mystica* in which the longing and lust of earlier texts were purified and raised to another level.

Whereas his male and female figures undergo a crucifixion by the world in *Kreuzigung*, leaving their animal and human characteristics behind them and being supposedly redeemed into a world of the spirit, in *Mondspiel* they have reached a stage where 'she' speaks the part of Mary, 'he' the part of the dancer. Having undergone a spiritual change before the play, the performers' individual personalities have already been extinguished and they have become part of a stable world governed by geometric forms only discernible because of the masks they manipulate. This essentially lyrical work replaces conflict and development of the central figure by an internal swaying movement.

Maria im Mond (fig. 30), resembling a painting on glass, is like a screen through which words are chanted as if from a void. The 'Tanzschild' is a still further abstracted form. Neither is a human mask but, each, a monumental symbolic figure with stylised minimal movements and gestures, manipulated from behind rather than worn. Both represent a stage of already purified awareness in which content, visual and even metaphoric signs are supposed to have been erased. The calculated application of tonal patterning to the words and phrases, as Ingo Wasserka has pointed out, defies rational analysis in performance but bears out experimentally the logic of Schreyer's theories.[12] All character, individuality of expression, or even human reference, has been removed. What remains are symbols in colour and form-combinations, as signs of 'cosmic' forces. Indeed, there is a general chronological development in Schreyer's earlier use of marionettes through to the huge total masks of *Kindsterben* and *Mondspiel* whereby there is less movement and more emphasis on sound.

In Schreyer's published essay 'Mensch und Maske' (1924), he insists that masks are a means firstly for the actors to purify their inner world and, secondly, by extension, for the audience as well.[13] He believed that, by total surrender to the mask and identification with it, actors and audience could reach a stage where they become the representations of the essence of their being. The masks are therefore the first and essential device by which a transformation takes place for them; furthermore, 'the mask is the form in which the inner world appears in the outer world' ('Mensch und Maske', p. 189).

Schreyer claims that as audience we tend to mistake the mask as a disguise for the person. In other words we wrongly identify the mask as the hidden person. Schreyer wants the actor to release himself from the world through the mask, but also from any attempt to incorrectly identify the mask itself as the hidden person. The function of the mask in his theatre is to release the actor from his own personality and from

any identifiable role. It therefore becomes a means of 'purifying' the actor's inner world and, in so doing, its effects of harmony, order and independence may be transferred to the audience, who may be led to form a selfless community. As Schreyer puts it, 'Drama is the inner action of the human being who recognises himself and through his action changes himself into higher humanity' ('Mensch und Maske', p. 190).

Two essential experiences are claimed here: 'knowing oneself' and 'purification'. They are well-known stages on the *via mystica* which Schreyer described elsewhere in great detail.[14] Only the use of masks, whether in fact on the stage, or understood as a metaphor for human life, Schreyer emphasises, can 'illuminate' the actor, the individual, and by extension others around him. As he put it: 'Out of this light then grows the new world, the little world of the stage works as a

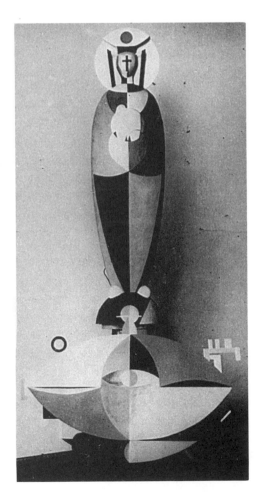

30 Lothar Schreyer, *Maria im Mond*, 1922, tempera on paper

recognition of meeting and of union'.[15] In other essays, in his art, poetry, lectures and his play for children *Die Vogelpredigt* (Sermon of the Bird), 1951, Schreyer hoped to incite a younger generation to undergo such spiritual exercises. As is generally known, this led him to active involvement with Roman Catholic liturgy, art and meditation.[16]

However, alongside his interest in Christian mysticism as one logical extension of his hopes for a new form of theatre, he studied not only oriental and other religions – he incidentally spent several years working on harmonical problems with the latter-day Pythagorean Hans Kayser – but he also planned a major study on the history of masks in the twentieth century, and he was to sum up one of their functions as the 'Durchsichtigkeit des Stofflichen' (making material transparent) (Schreyer 1948, p. 35).

After the Second World War Schreyer brought together many of his earlier theories and an account of his experiments in the book *Expressionistisches Theater* (1948). Here he emphasises that his interest always lay in man rather than in art, while recognising that the mask could become a magical sign, either raising man in a sacrificial dance of transformation to salvation, or enslaving him by demonic powers. Schreyer then distinguishes between mask in ˙cultic theatre as the 'mirror of a divine power that man should recognise in order to raise himself towards it' and the mask in profane theatre as a 'mirror of a human condition that man should recognise in order to experience and overcome that condition' (*ibid.*, p. 133). Whereas in India, Burma and Siam he finds masks in cultic theatre that show man already transformed in the ecstasy of a vision of the divine, in Japan he finds masks in profane theatre that are the consolidation or the exorcising of the human soul. In the Roman Catholic mass, he no longer finds a world of masks, but one of vestments and corporeal change.

In expressionist theatre he hoped to reproduce man as a figure of sound, of movement and of colour-form. This would then extend and synthesise the concept of man in his original state as a 'gebrochenes Lichtwesen' (being of fractured light), a process found by him in Kandinsky's *Der gelbe Klang* (*ibid.*, p. 158). The synthesis begins in the so-called 'Wortkunstwerk' (verbal art work), the basis of his Spielgänge, which, to become effective needs 'Masken des Werdens' (masks of becoming) (*ibid.*, p. 193). The concept of mask is then taken a stage further to represent specifically the 'Farbformkomposition' (colour-form composition) out of which emerges the new 'Menschengestalt' (form of man). The mask enables the actor not to move naturally, but to change into a 'künstlerisch zweckhafte Bewegung' (artistically signifi-

cant way of movement). The mask thus becomes the outer veil of the inner man for, as the person is the mask of the natural figure of the man, the mask is the person of the artificial figure of the man. Both mask and person become the means of making visible the invisible essence of man's being: 'Thus the mask of the stagework is a poetised streaming forth of the idea of the essential being, a streaming forth, which proclaims the idea in form and colour, just as the idea is proclaimed in the sound of words and in movement' (*ibid.*, p. 219). Once man has himself become such a mask, once he is the body of the colour-form enfiguration of his spiritual existence, then he portrays its true essence and the task of the stagework is complete – his very existence becomes a form of 'synthetic theatre'.

Schreyer developed his ideas on masks in two further directions. The first, published in 1950, entitled 'Vom abstrakten Theater der Zukunft' (On Abstract Theatre of the Future), an imaginary dialogue between Josef Knecht and Peter Jakobus, is an extension of Hermann Hesse's novel *Das Glasperlenspiel* (The Glass-bead Game).[17] Here he defines the abstract theatre of the bead-game as the highest utterance of this life open to us. In this the laws of growth and decay are enfigured, and the art of creating a community is seen as a process of abstraction, divorced from innate characteristics, into the expression of a new, artificial form. Magical transformation leads either to a godless society with no meditation, or to a genuine religious community. The theatre hoped for is not one that presents a 'Gottmenschen' (already committed religious man), but man on the way towards purification and enlightenment. It is not, then, a form of devotion, but, again, a form of release.

In 1961 Schreyer offered to write a book on the mask as a spiritual and artistic phenomenon and referred to some twenty basic themes, expanding on his practical involvement with the stage for the *Sturm* and at the Bauhaus.[18] He lists some thirty-seven problems to be discussed, reading like a list of essays that he feared he would not be able to write towards the end of his life. One of these – 'Totenmaske bleibt – noch einige Zeit' – refers to his experience of great actors and actresses, who he claims were all special, not for the roles they played, but because they revealed the creative ability of the human being. In his words: 'I met in their actor's craft the proclamation of the inner image of man'. In his opinion, Max Reinhardt's multi-faceted production of mood and ensemble caused audiences to relax, thus preventing ascension to a spiritual realm. Only the really great figures could overcome this. Far more effective, he claims elsewhere, were the masked figures on the variety stage and the ice-rink, anonymously

playing out their cosmic dance patterns and rousing 5000 spectators to admiration and frenzied applause. The mask is thus understood as a means towards audience ecstasy.

In another essay 'Der Tanz mit der Maske' he emphasises the artistic as opposed to the social potentials of masked dance, whose origins lie in cultic expression. In cultic theatre the masks should appease God and frighten off enemies of potential change in man. The mask and God bring man in rhythms of dance to ecstasy. So-called primitive peoples, he finds, can still perform such expression and achieve change, and he cites Tibetan monks and Javanese dancers as the purest remaining examples. In the grotesque masks of carnival he sees a 'demasking' in the use of masks whereby the personality of the wearer is overcome firstly in the wearing of such a mask and, secondly, by the awareness of that mask's demands and potential.

Lothar Schreyer's theories towards a redemption of man in 'synthetic theatre' were only realisable through the development of marionettes into masks. These were prerequisites in a release of the individual from narcissistic self-awareness, aesthetic perusal of beauty and individual self-expression in art. Thanks to masks, a state of ecstasy can be achieved with controlled rhythmic use of all theatrical categories to produce the longed-for refocusing of the fractured light in man. The mask thus emerges neither as a means of hiding nor as an alternative static psychological screen, but as an essential metaphoric means to man resuming his status as a complete human being. For Schreyer, that meant an ideal one, within an enlightened community. It is thus fitting that Schreyer's coloured drawing *Der Dom* (The Cathedral), 1925, represents this ideal of man not as a passive sufferer of life, but as the artistic creator of a work of art – and that becomes his cathedral.

Notes

1 These are to be published by Edwin Mellen Press, Lampeter, in 1993 in my twenty-four volume edition of Schreyer's works.
2 Early essays include: 'Vom Verfall der Bühnenkunst', *Xenien*, V, 1912; 'Die jüngste Dichtkunst und die Bühne', *Die Scene*, V, 1915 and 'Das Bühnenkunstwerk', *Der Sturm*, VII, 1916-17.
3 First published in *New German Studies*, XII/3, 1984, p. 180, and now in my monograph *Lothar Schreyer. Ein vergessener Expressionist*, Stuttgart, 1990, p. 28.
4 M. Shields, 'A Study of the Periodical *Der Sturm*' (unpublished doctoral thesis, University of East Anglia, 1978), p. 229.
5 Schreyer describes their meeting in his *Erinnerungen an Sturm und Bauhaus*, Munich, 1966, pp. 174-84.
6 See K. v. Maur, *Oskar Schlemmer*, Munich, 1982, pp. 198-204.
7 H. von Kleist, *Sämtliche Werke und Briefe. Band II*, Munich, 1970, p. 338.

8 L. Schreyer, *Expressionistisches Theater*, Hamburg, 1948, pp. 50-2, 55. Also see my article on this in *New German Studies*, XII/3, 1984, pp. 175-99.

9 V. Pirsich, *Der Sturm. Eine Monographie*, Göttingen, 1981, pp. 533-4.

10 Schreyer, *Expressionistisches Theater*, pp. 69-82, including the text of Kandinsky's *Der gelbe Klang*. Further references are given after quotations in the text.

11 L. Schreyer, *Kreuzigung. Spielgang. Werk VI*, Hamburg, 1920. See also: M. Gordon, 'Lothar Schreyer and the Sturmbühne', *The Drama Review*, XXIV/1, 1980, pp. 85-102, including a translation into English of the text with full reproduction of the *Spielgang*; M. Steinhorst, 'Lothar Schreyers *Kreuzigung*. Analyse des Spielgangs' (unpublished Master's thesis, University of Munich, 1986) with a new transcription of the work using different notation symbols.

12 I. Wasserka, 'Die Sturm- und Kampfbühne, Kunsttheorie und szenische Wirklichkeit im expressionistischen Theater Lothar Schreyers' (unpublished doctoral thesis, University of Vienna, 1965), p. 120.

13 L. Schreyer, 'Mensch und Maske', *Jugend und Bühne*, L. Pallat and H. Lebede (eds), Breslau, 1924, pp. 189-94. Further references are given after quotations in the text.

14 See especially L. Schreyer, 'Das Theater und der Geist', *Das Nationaltheater*, I/1, 1928-29, pp. 30-7.

15 Schreyer, 'Mensch und Maske', p. 194. See also 'Das Geheimnis des irdischen Spiegels' in B. Keith-Smith, *Lothar Schreyer*, pp. 380-8 and commentary pp. 383-4.

16 L. Schreyer, *Die Vogelpredigt*, Kassel and Basle, 1951.

17 L. Schreyer, 'Hermann Hesse *Das Glasperlenspiel* und das abstrakte Theater der Zukunft', *Die neue Schau*, XI/4, 1950, pp. 94-6.

18 Published in *Der Sturm*, XVIII, 1927-28, p. 19. This drawing, and other references to unpublished material, are located in the Deutsches Literaturarchiv, Marbach, Schreyer Archive 1990 Box XIII.

Culture and anarchy in expressionist drama

Rhys Williams

The politics of the expressionist writers has long intrigued and frustrated critics. Wolfgang Paulsen, in one of the first academic assessments of the period, undertaken in 1935, opted to divide expressionists into two groups: Expressionists proper (who placed all the emphasis on spiritual values and who traced their antecedents back to Early German art) and Activists (whose lineage went back, via Karl Marx, to Enlightenment rationalism).[1] Paulsen's thesis, stimulating as it was, forced him into some intellectual contortions in assigning writers to one group or another, contortions which have reappeared in many subsequent critical approaches to the movement. Only in the last decade or so, has due regard been shown to the importance for the expressionist generation of other varieties of socialism than Marxism, and only now is it possible to join together what Paulsen put asunder.

Paulsen's work was very much a product of the 1930s; by 1935, the political landscape in Germany was a much simplified one. The polarisation of politics at the end of the Weimar Republic tended to foreground Marxism as the opposition to National Socialism, and the minor varieties of anarcho-socialism, so influential before and during the First World War, were forgotten, or marginalised. The Cold War, of course, reinforced this tendency: socialism became associated exclusively with Marxist-Leninism, or Stalinism. Now that the Cold War has been declared officially over, it has also become possible to reappraise the contribution made by socio-anarchism to Expressionism. There is more than one socialism, and not all socialist ideas run counter to the notion of 'spiritual revolution'. In this article I propose to present briefly the socialism of Gustav Landauer[2] and to trace the powerful impact which these ideas had on three representative, but quite disparate, writers: Georg Kaiser, Ernst Toller and Carl Sternheim.[3] It will emerge, I suspect, that the failure of the Munich 'Räterepublik' and the brutal murder of Landauer in 1919 also contributed to the eclipse of this strand of socialism.

Paulsen derived his term 'Aktivismus' from the group of Expression-
ist writers who contributed to the periodical *Die Aktion*. In the pages of
that journal attitudes and tastes are exhibited which bear witness to
Landauer's influence on that generation. Landauer's opposition to the
Social Democratic Party; his rejection of bureaucratic centralism; his
championing of the organic community; his pacifism; his admiration for
Tolstoy and Walt Whitman – all these are reflected in the periodical.
Nor were Landauer's ideas without important antecedents: he saw
himself as a successor to Proudhon and extolled British traditions of
anarcho-socialism. William Morris's Socialist League in the 1880s em-
bodies a number of features, particularly a romantic medievalism,
which Landauer adopted. As early as 1904, together with his wife,
Hedwig Lachmann, Landauer translated and edited Oscar Wilde's *The
Soul of Man under Socialism*, a work which combines socialist and
individualistic ideas in a manner calculated to appeal to both Landauer
and the expressionist generation. In that essay Wilde argues that
socialism, in freeing man from competitive and acquisitive drives,
permits the individual to fulfil his artistic and spiritual aspirations.
Wilde, too, rejects authoritarian socialism in favour of a free and
voluntary association of individuals. Landauer's own most influential
political essays belong to the first decade of the century: his long essay
Die Revolution appeared in 1907 and his *Aufruf zum Sozialismus*, which
was given as a lecture in 1908, was published as a book in 1911. These
two works contain the essence of that theory of spiritual revolution
which Landauer sought to bring about, a spiritual revolution which
shaped the Expressionist movement more profoundly than has hitherto
been appreciated.

Die Revolution[4] (1907), which was published as the thirteenth volume
of the series *Die Gesellschaft*, edited by Martin Buber, is concerned,
above all, to define 'Geist' as the necessary basis of culture in a nation.
This definition is arrived at by first clearing the ground: history, for
Landauer, is non-scientific and non-rational. The past is not fixed, as
the subject of scientific study, but a process, in which we are involved.
The corollary is that we interpret the past in different ways, according
to the needs and insights of the present and in preparation for the
future. While history influences mankind, the existential interests of
mankind influence history. Landauer's most vivid illustration of a
'Volk' or 'Nation' under the influence of active 'Geist' is Christianity,
the Christianity of the Middle Ages. Christianity becomes a 'Geist'
which permeates all the social organisations of the medieval period and
welds the diverse human functions into a cultural unity. 'Geist' itself

does not bring about the social organisation, but, given the appropriate circumstances, 'Geist' can become a cohesive force within a society, but only if certain conditions prevail, namely, a set of freely determined mutual relationships, such as were found in the medieval city-state, or the medieval guild.

Landauer is a profound enthusiast of the Middle Ages. Like many influential figures in the early years of the century he sees the medieval world as the high point of Western Culture, from which there has been a steady decline. The importance of 'Geist', he suggests, diminished with the Renaissance and the new sense of individualism. Variations on Landauer's arguments were to reappear, incidentally, in the work of Hugo Ball, whose *Zur Kritik der deutschen Intelligenz* (1919) similarly indicts the whole of the Western tradition since the Renaissance. Landauer argues that Western history since the Middle Ages has been a long struggle to regain the stability offered by 'verbindender Geist'. All subsequent revolutions, the 'Bauernkriege' (Peasant Wars), the English Revolution, The Thirty Years' War, the American Revolution, the French Revolution, even the Franco-Prussian war, are seen as attempts to bring about the reign of 'Geist', even the November Revolution in Germany, one imagines, would have been included in his catalogue. The struggle of 'Geist' against dogmatism is the long march of history.

The modern political state, Landauer argues in *Die Revolution*, arises only when the medieval 'Geist' diminishes: it has various forms, despotic absolutism, absolutism of the law, and finally, the absolute power of nationalism. With the onset of capitalism, it is apparent that, in addition to state wealth, there is national wealth, dealings that involve individuals, binding them into a unity which is separate from the state. He sees socialism as born out of capitalism, but rejects vehemently the attempt to unify national wealth and the state. The socialist party, he argues, in accepting any notion of state government, is preventing the realisation of 'Geist' as a living, socially cohesive force. If the revolution is to succeed, a method must be found to circumvent state power and control. Landauer's anarchistic version of socialism rests on the assumption that the individual can simply refuse to lend his support to the state and its rule will crumble.

If this is Landauer's view of anarchism, and, it should be noted, this is an anarchistic variant of socialism with a peculiarly mystical flavour, then where does culture fit in? The answer is that if 'Geist' displayed any life at all during the period following the Middle Ages, then it was in the life of inspired individuals, artists and intellectuals. While the masses were permeated only briefly with 'Geist' in sudden, but

temporary moments of upheaval, the gifted individual could perceive through his vision the possibility of a community permeated by 'Geist'. Political changes cannot, in themselves, re-establish 'Geist' as a guiding principle of human life; the only hope lies in a social revolution based on the willingness of free individuals to submit themselves to 'Geist'.

With his *Aufruf zum Sozialismus*, Landauer attempted to develop a more precise set of articles of faith for the *Sozialistischer Bund*, which his treatise would directly create.[5] The *Bund* intended a non-violent social revolution, based on individual commitment to a new notion of social community. Landauer's vision of socialism is vehemently anti-Marxist, anti-materialist; he concedes that 'Geist' can swiftly degenerate into institutionalised rigidity and dogmatism, and that in periods which are uncongenial it retreats into the individual, who becomes a representative of 'Geist' in dark times. After reiterating the historical scheme of *Die Revolution*, Landauer turns to a condemnation of contemporary society. What society in the present lacks is 'verbindender Geist'; production has become an end in itself, irrespective of whether goods are needed. Landauer's diagnosis of what one might call alienation, involves man's spiritual and emotional impoverishment. The bold robber-knight, the larger-than-life criminal of the idealised Middle Ages, has given way to its modern counterpart, the petty thief and embezzler; prostitution is rife, with pleasure becoming a commodity to be bought and sold. And the whole system is maintained by the state through its police. Nationalism has become a surrogate unifying force in this alienated society, but the state can never provide genuine 'verbindender Geist', since the latter can be located only within the individual.

At this point in his treatise Landauer turns his attack on Marxism: Marx can see socialism only as the ultimate development of capitalism, since for him the collapse of capitalism will bring socialism, while for Landauer, the despised petit-bourgeois factory-owner is praised for his attempts to keep dehumanising working-practices at bay. Not only does Landauer attack the principles of Marxism, but also socialism as practised in Germany. The trade unions fight for wage rises but, since prices inevitably rise, the worker is no better off. Turning his attention to the distractions offered by capitalism for the worker, Landauer attacks sport in particular. The new professional sportsman, the cyclists of the six-day cycle races in Kaiser's *Von morgens bis mitternachts*, turn physical activity into a kind of surrogate, unproductive work.

In his analysis of economic factors, Landauer isolates three forms of modern slavery: landowning, the circulation of goods which do not

satisfy consumption, and surplus value. The danger of money lies not only in its capital growth, but also in its permanence, its refusal to be consumed. He advocates the adoption of the theory of Silvio Gesell (later to become, for a brief period, economics minister in the ill-fated *Räterrepublik*) that a form of money should be invented which loses its value and which must therefore be exchanged for goods as soon as possible thus maximising its circulation. As regards surplus value, Landauer uses the term value in the sense 'richtiger Wert, wahrer Wert' (genuine value). This value is not the same as the price. As Oscar Wilde put it: 'a cynic is a man who knows the price of everything, and the value of nothing'. The demand which Landauer makes is that the price of things should correspond to their value. Marxists are mistaken, he argues, when they place all the emphasis on work and working conditions to explain the disparity between the value of goods and their price. If they looked further, they would discover that the root of the problem lies in the nature of money itself, in its permanence. Surplus value does not arise at a specific point in the production of goods, but through the circulation of money itself. The solution – and this might strike the modern reader as somewhat idealistic – can come only when workers realise that they can cease to give their assent to capitalism; what is needed is a new sense of community.

The unit envisaged as the ideal is larger than the family, for the latter is concerned only with private interests. The aim of Landauer's variant of socialism is so to organise society that everyone works only for themselves, with a system of exchange to regulate needs and supplies. What is needed is a radical reappraisal of values inspired by 'Geist', for 'Geist' is dynamic, constantly challenging rigid forms. The treatise ends with a series of rallying cries, slogans appealing for a return to the land, and extolling the individual as the sole means to change. The new society will not spring from a general strike, or from proletarian action, but from the rejection of money. There are hints here of the idealisation of the medieval village community, self-sufficient and operating by barter, producing only what the community needs. Landauer's programme involves creating within capitalist society socialist communities which operate according to this pattern, and he ends his treatise with a call to his readers individually to join such communities, withdraw their support in practical terms from capitalist society, and put into practice the idea of a socialism free from the state.

It will by now be apparent just how significant Landauer's ideas were for the expressionist generation. In Landauer's work, political

activism and spirituality are not antithetical (as in Paulsen's model) but go hand in hand; indeed, 'Geist' is the very instrument of political revolution. Space does not permit me to elaborate on the broad influence of Landauer on the Expressionist movement, but it is clear that his ideas inspired many middle-class writers for whom the growing power of the industrial proletariat offered little hope of fundamental change. For Georg Kaiser, Landauer became a guiding figure. It was thanks to a favourable essay by Landauer that Kaiser's *Die Bürger von Calais* was first performed, and from 1916 to Landauer's death, three years later, Kaiser and Landauer corresponded regularly.

Kaiser's *Von morgens bis mitternachts* may be read as a dramatisation of Landauer's indictment of capitalism in his *Aufruf zum Sozialismus*, not only in broad terms but in specifics. Kaiser does not follow Landauer in outlining a positive possibility for change, but of the necessity for change Kaiser is convinced, and such an alternative is present, if not for the benighted Kassierer (bank-clerk), then, at least by implication, for the audience. Kaiser's play offers, above all, a set of variations on the theme of value, on the contrast between what Landauer calls 'true value' and the value placed on things in a capitalist economy. The opening scene in the bank presents the Kassierer as an automaton, wholly submerged in his function. He accepts the conventional relationship between money and what it can buy without question, even unthinkingly, confining himself to the purely mechanistic role as a minor functionary in the capitalist economy. But the arrival of the exotic Italian lady and the sexual innuendo of the bank manager jolt him out of this conventional relationship to money. By the end of the first scene his relationship to money has become problematic. Even before he dips his fingers into the till, he has lost his capitalist sense of values; he has fallen from his naive state of capitalist grace. The remainder of his journey is a quest to find a new value-scheme to replace the one which he has lost, but since his unit of exchange remains money, he will be doomed to failure. His stolen money fails to buy the Italian lady, nor can it indeed fulfil his veritably Faustian thirst for intense experience: 'Ich habe das Geld bar!! – Wo ist Ware, die man mit dem vollen Einsatz kauft?'[6]

Throughout the remainder of the play the Kassierer will explore what can be bought by money; he will expect for his 'genuine' currency 'genuine' values in exchange. The six-day cycle race supplies a rather obvious model of the capitalist state. As Landauer had insisted, sport has become a form of alienated work; here, the race, with its arbitrary injection of cash, prompting sudden spurts and temporary

winners and losers, symbolises the role of incentives and wage in-
creases under capitalism. The Kassierer is not particularly concerned
with the effect of his money on the cyclists, but with the effect on the
public, for in the intensity of response he gains an inkling of 'Geist', of
a mass society willing to act and respond as one. For a few moments it
seems that capitalism is yet capable of producing that community of
values which the Kassierer desires. He provides a further massive sum,
but the arrival of His Majesty, the Kaiser, to take his seat in the royal
box interrupts proceedings. The fact that nationalism has conditioned
the spectators' response, that the most intense outcry followed the
victory of the German rider, indicates that the longed-for community of
values is far from being achieved. The class society, signalled by the
three levels from which the spectators watch, has developed national-
ism as a surrogate value, which, although it succeeds in submerging the
tensions in society, is not the revolution which Landauer desired; it is
not the 'verbindender Geist' which he advocated. With the playing of
the national anthem, the Kassierer leaves the stadium in disgust.

His next attempt is to explore the conventional image of the
capitalist life of luxury, what Landauer dismissed as 'Alkohol, Hurerei
und Luxus' (p. 72). Once again the blandishments offered prove
illusory, the image fails to correspond to reality, 'the value' and 'the
price' are at odds. The first of the masked girls over-indulges in the
champagne and is incapable of supplying the sexual thrill which the
Kassierer desires; the second is sober, but drops her mask to reveal a
true face far less appetising to him than the tinsel image; the third, who
drives him to a pitch of excitement by her refusal to dance, turns out to
have a wooden leg. The comic misunderstandings of this scene serve to
underline the disparity between image and reality; the Kassierer, too, is
a bogus dandy, a 'Kleinbürger' disguised as a toff, the implication being
that the attractions dangled before the 'Kleinbürger' in a capitalist
society reveal themselves as illusory.

The final scene at the Salvation Army hall again seems to offer a
spiritual alternative to the materialist values which dominate society.
Kaiser, like Brecht (and no doubt influenced by George Bernard Shaw's
Major Barbara) tended to view the Salvation Army as offering merely a
palliative to capitalist exploitation. For him, capitalism would be kept
in place if the proletariat could be kept on the straight and narrow and
the worst social evils of alcohol contained. The confessions of the
various sinners, each of whom represents an aspect of the Kassierer's
own experience, initially suggest that religious salvation may at least
atone for the greed and materialism of society. But even in this setting,

material values intrude. In a parody of the betrayal of Christ – the sufferings of the Kassierer are presented throughout as 'Stationen' on a journey to crucifixion – the Salvation Army girl who has operated throughout the second part of the play as the voice of conscience for the Kassierer, betrays him for money. The Kassierer's final insight into Landauer's thesis that the problem of modern society lies in the existence of money itself prompts his passionate denunciation:

> Mit keinem Geld aus allen Bankkassen der Welt kann man sich irgendwas von Wert kaufen. Man kauft immer weniger, als man bezahlt. Und je mehr man bezahlt, um so geringer wird die Ware. Das Geld verschlechtert den Wert. Das Geld verhüllt das Echte – das Geld ist der armseligste Schwindel unter allem Betrug! (I, p. 515)

The whole scene of religious transcendence is dismantled by the Kassierer's subsequent gesture of throwing away his remaining money: the assembled sinners forget their new-found spiritual values and fight for the money. Betrayed to the police for money, the Kassierer shoots himself. Clearly, religion cannot offer the solution to contemporary society. Although space does not permit detailed analysis of the play, in *Gas* (1917-18) Kaiser was to develop his analysis of society, permitting the Milliardarsohn (multi-millionaire's son) to expound Landauer's theory of money and presenting the structures of industrialised society as fundamentally faulty, bearing within them the seeds of their own destruction.

Ernst Toller, too, confessed to having been profoundly influenced by Landauer, whose work he probably read in 1917. As Richard Dove[7] has convincingly shown, Toller's *Die Wandlung* presents an antithesis between the nation state and the true community of free individuals on the Landauer model. Friedrich's experience is a quest for community; he does not find it in the family, nor in submerging his individuality in nationalism. His ideal of patriotism is shattered by his war experience, and he logically destroys the statue of the goddess of victory which he was engaged in sculpting. Toller, through Friedrich, rejects the institutions of the capitalist state and offers, instead, a vision of a new community, which will be achieved only when men rediscover their common humanity. The revolutionary rallying-cry with which the play ends is pure Landauer; the creative 'Geist' has been submerged by capitalist industrialisation. Only when the inner humanity, the 'Geist' is released will social relationships be transformed. What Friedrich proclaims is not merely a spiritual revolution; it is political, but political in a socio-anarchist, rather than a Marxist sense.

Toller's experience of the Munich Revolution and the *Räterrepublik* appear to have been disillusioning; he swiftly realised that non-violence and revolutionary solidarity were incompatible values. In his play *Masse Mensch* (1921) he conducts a post-mortem on the revolution. Dove makes a convincing case for reading the play as a debate between Landauer and Marx, between individual and spiritual regeneration on the one hand and historical determinism on the other.[8] The Woman represents an ethical, non-violent socialism, while 'der Namenlose' (the anonymous one) supplies a deterministic Marxist counter-argument. For the Woman, the ideal is not the state, but a community of free individuals ('Gemeinschaft' or 'werkverbundene freie Menschheit'); she refuses to define the revolution as merely the seizure of power, seeking instead the spiritual liberation of the masses. The revolutionary change which the play presents in the final scene is again a transformation of values. The Woman goes to her death, yet her exemplary self-sacrifice transforms the consciousness of two prisoners who enter her cell to steal her belongings. Toller offers a final example here of the necessity for inner and individual change as a prerequisite of wider social revolution in Landauer's sense.

The impact of the First World War on the Expressionist generation is a crucial factor in the reception of Landauer's ideas. While it seemed axiomatic that the society which had unleashed the war was ripe for revolution, there was little consensus about the form which that revolution should take. Carl Sternheim, living the life of a *grandseigneur* in his mansion south of Brussels in 1916, began a study of socialist and anarchist texts in 1915 and 1916. His political comedy *Tabula rasa* offers further evidence of Landauer's importance. Sternheim even considered calling the play 'Der Aufbruch', throwing all the emphasis on the radical break which the hero, Ständer, makes with society at the end of the play.[9]

The final choice of title conveys both the clean break with society and the final reckoning with some of the political assumptions of German socialism. Ständer – his name suggests both his independence and his sexual potency – is no ordinary representative of the proletariat. He, and his friend Heinrich Flocke are the aristocrats of the workforce at the glass factory. But Ständer is afraid that their privileged position will come under scrutiny during the celebrations of the firm's centenary and seeks to distract both the workers and the management by agitating for a new workers' library, a device which permits Sternheim to insinuate that the acquisition of bourgeois culture will emasculate the proletariat. To ensure a dense enough smoke-

screen, Ständer summons Werner Sturm, a communist agitator, only to find that Sturm plans a workers' takeover. This danger is averted by the arrival of Arthur Flocke, a social democrat who envisages the gradual elevation of the workers to bourgeois status. If Sturm unleashes a revolution, Ständer's shares in the company will become worthless; if Flocke's views triumph, Ständer will lose credibility as the workers' spokesman.

In the event, the library scheme is accepted and, to complete the emasculation of the workers, Ständer is nominated as a worker-director, a post which he rejects on health grounds. Had the play ended at that point, it would have fitted well into the scheme of Sternheim's pre-war comedies, but a new ingredient is introduced. Ständer unveils a doctrine of anarchic individualism and vows to turn his back on Europe. Ständer does not believe that revolution will come simply by replacing private ownership with public ownership; a more radical break with capitalism is needed. In Sternheim's other writings, in essays, and short stories, the alternative is invariably located outside society, either in an asylum, or in a south-sea idyll of regression. In other words, although the genre is different and the tone more cynical, although the settings are sometimes exotic, Sternheim's anarchic vision is coloured by Landauer's notion of individual transformation as a prerequisite for a new community of free individuals.

While Landauer constantly extolled the 'verbindender Geist' of religion in the Middle Ages as the value which held individuals together in a community of values, he did not believe that the solutions of the past were relevant for the twentieth century. Although the revolutionary impetus of much expressionist writing exploits the intensity and anti-materialism of religion, it is seldom religious in itself. The 'Wandlung' (transformation) which Expressionism extols can look deceptively like both religious conversion and political revolution, but it is neither. Or, at least, it is both simultaneously. Critics have been perplexed by the co-presence in expressionist writings of reactionary and progressive ideas; was the movement to be condemned (as Lukács argued) for failing to deliver a Marxist analysis, or was it to be praised for offering a critique of capitalism? Was it backward-looking and agrarian, or was it guided by a vision of the future? These contradictions may be resolved if we see the ideal of socialism presented by Expressionists of quite different backgrounds, not as a Marxist and materialist theory, but as an expression of Landauer's vision.

Notes

1 W. Paulsen, *Expressionismus und Aktivismus: eine typologische Untersuchung*, Berne and Leipzig, 1935.

2 Useful recent studies of Landauer include W. Kalz, *Gustav Landauer: Kultursozialist und Anarchist*, Meisenheim am Glan, 1967; C. Maurer, *Call to Revolution: The Mystical Anarchism of Gustav Landauer*, Detroit, 1971; and E. Lunn, *Prophet of Community: The Romantic Socialism of Gustav Landauer*, Berkeley and Los Angeles, 1973.

3 This article is an adaptation and extension of my earlier article, 'Culture and Anarchy in Georg Kaiser's *Von morgens bis mitternachts*', *The Modern Language Review*, LXXXIII, 1988, pp. 364-74.

4 A second edition of Landauer's *Die Revolution* appeared in Frankfurt am Main in 1919.

5 For a useful introduction to Landauer's ideas, see G. Landauer, *Aufruf zum Sozialismus*, H. Heydorn (ed.), Frankfurt am Main, 1967. Subsequent quotations are from this edition; page references are given in parentheses in the text.

6 G. Kaiser, *Werke*, W. Huder (ed.), 6 vols, Frankfurt am Main, Berlin, and Vienna, 1971-72, I, p. 483. All subsequent references are to this edition.

7 R. Dove, *Revolutionary Socialism in the work of Ernst Toller*, New York, 1986 (Utah Studies in Literature and Linguistics, 26). See especially pp. 30-7, 60-2, 69-79, 124-6.

8 *Ibid.*, pp. 124-6.

9 For a more detailed analysis of *Tabula rasa*, see Rhys W. Williams, *Carl Sternheim: a critical study*, Berne and Frankfurt am Main, 1982 (Europäische Hochschulschriften: Deutsche Sprache und Literatur, 494), pp. 118-29. See also F. Mennemeier, 'Carl Sternheims Komödie der Politik', *Deutsche Vierteljahrsschrift*, XLIV, 1970, pp. 704-26.

SELECT BIBLIOGRAPHY

Documentary texts

T. Anz and M. Stark (eds), *Expressionismus: Manifeste und Dokumente zur deutschen Literatur 1910-1920*, Stuttgart, 1982.

H. Bahr, *Expressionismus*, Munich, 1920. *Expressionism*, tr. R. Gribble, London, 1925.

P. Bekker, 'Musikalische Neuzeit', *Frankfurter Zeitung*, 29/vii/1917, reprinted in *Kritische Zeitbilder*, Berlin, 1921, pp. 292-9.

S. Cheney, *Expressionism in Art*, New York, 1934.

Die Deutsche Werkbund-Ausstellung Köln, Cologne, 1914, reprinted in *Der westdeutsche Impuls 1900-1914. Kunst und Umweltgestaltung im Industriegebiet*, Cologne, 1984.

C. Einstein, *Negerplastik*, Leipzig, 1915.

P. Fechter, *Der Expressionismus*, Munich, 1914.

W. Hausenstein, *Die bildende Kunst der Gegenwart*, Berlin, 1914.

H. Hildebrandt, *Der Expressionismus in der Malerei: Ein Vortrag zur Einführung in das Schaffen der Gegenwart*, Stuttgart and Berlin, 1919.

A. Hüneke (ed.), *Der Blaue Reiter: Dokumente einer geistigen Bewegung*, Leipzig, 1986.

W. Kandinsky, *Über das Geistige in der Kunst*, Munich, 1912. *Concerning the Spiritual in Art*, tr. M. Sadler, London, 1914.

W. Kandinsky, *Écrits Complets*, Paris, 1975.

W. Kandinsky, *Complete Writings on Art*, K. Lindsay and P. Vergo (eds.), London, 1982.

W. Kandinsky and F. Marc (eds), *Der Blaue Reiter Almanach*, Munich, 1912.

W. Kandinsky and A. Schoenberg, *Letters, Pictures and Documents*, J. Hahl-Koch (ed.), London, 1984.

A. Kuhn, *Die neuere Plastik: von achtzehnhundert bis zur Gegenwart*, Munich, 1921.

G. Lukács, 'Größe und Verfall des Expressionismus', 1934, in *Probleme des Realismus*, Berlin, 1955, pp. 146-83.

W. Paulsen, *Expressionismus und Aktivismus: eine typologische Untersuchung*, Berne and Leipzig, 1935.

F. Roh, *Nach-Expressionismus*, Leipzig, 1925.

A. Schering. 'Die expressionistische Bewegung in der Musik', *Einführung in die Kunst der Gegenwart*, M. Deri (ed.), Leipzig, 1919.

A. Schoenberg, *Letters*, E. Stein (ed.), London, 1964.

A. Schoenberg, *Style and Idea: Selected Writings of Arnold Schoenberg*, L. Stein (ed.), tr. L. Black, London, 1975.

A. Schoenberg, 'Die glückliche Hand', *Gesammelte Schriften* I, I. Vojtech (ed.), Frankfurt am Main, 1976, pp. 237ff.

J. Simon, 'Musikalischer Expressionismus', *Musikblätter des Anbruch*, II, 1920, p. 411.

E. Steinhard, 'Bemerkungen zum Expressionismus', *Die Musik*, XV, 1922, pp. 50ff.

E. Steinhard, 'Nachexpressionismus', *Der Auftakt*, VI, 1926, pp. 147ff.

H. Stuckenschmidt, 'Musik und Expressionismus', *Die rote Erde*, I, 1920, p. 340.

E. von Sydow, *Die deutsche expressionistische Kultur und Malerei*, Berlin, 1919.

H. Tiessen, 'Der neue Strom, Expressionismus', *Melos*, I, 1920, p. 102.

W. Worringer, *Abstraktion und Einfühlung* Munich, 1910. *Abstraction and Empathy*, tr. M. Bullock, London, 1967.

W. Worringer, *Formprobleme der Gotik*, Munich, 1911, *Form in Gothic*, tr. H. Read, London , 1957.

Theory

T. Adorno, *Philosophie der neuen Musik*, Frankfurt am Main, 1958. *Philosophy of Modern Music*, tr. A. Mitchell and W. Bloomster, London, 1973.

T. Adorno, 'Musikalischer Expressionismus', *Gesammelte Schriften*, XVIII, Frankfurt am Main, 1984.

G. Bianca, *Espressionismo e formalismo nella storia dell' estetica musicale*, Padua, 1968.

R. Brinkmann, 'Schönberg und das expressionistische Ausdrucksprinzip', *Bericht über den 1. Kongress der Internationalen Schönberg-Gesellschaft*, R. Stephan (ed.), Vienna, 1978, pp. 13-19.

R. Brinkmann, *Expressionismus: Internationale Forschung zu einem internationalen Phänomen*, Stuttgart, 1980.

P. Bürger, *Theory of the Avant-Garde*, Manchester, 1984.

M. Bushart, *Der Geist der Gotik und die expressionistische Kunst: Kunstgeschichte und Kunsttheorie, 1911-1925*, Munich, 1990.

M. Cheetham, *The Rhetoric of Purity: Essentialist Theory and the Advent of Abstract Painting*, Cambridge, 1991.

H. Chipp (ed.), *Theories of Modern Art: A Source Book by Artists and Critics*, Berkeley, 1968.

E. Gombrich, 'Expression and Communication', *Meditations on a Hobby Horse and other Essays on the Theory of Art*, Oxford, 1971, pp. 56-69.

D. Gordon, 'On the Origin of the Word "Expressionism"', *Journal of the Warburg and Courtauld Institutes*, XXIX, 1966, pp. 368-85.

K. Möser, *Literatur und die 'Grösse Abstraktion', Kunsttheorien, Poetik und 'abstrakte Dichtung' im Sturm 1910-1930*, Erlangen, 1983.

G. Perkins, *Contemporary Theory of Expressionism*, Britische und Irische Studien zur deutschen Sprache und Literatur, 1, Bern, Frankfurt am Main, 1974.

R. Taylor (ed.), *Aesthetics and Politics*, London, 1977.

M. von Troschke, 'Expressionismus', *Handwörterbuch der musikalischen Terminologie*, Wiesbaden, 1972 (1987).

B. Wallis (ed.), *Art after Modernism: Rethinking Representation*, New York, 1984.

M. Werenskiold, *The Concept of Expressionism: Origin and Metamorphoses*, Oslo, 1984.

R. Wollheim, *On Art and the Mind*, London, 1973.

K. Wörner, 'Expressionismus', *Die Musik in Geschichte und Gegenwart*, III, F. Blume (ed.), Kassel, 1954, pp. 1655-73.

K. Wörner, 'Philosophie des musikalischen Expressionismus', *Die Musik in der Geistesgeschichte*, Bonn, 1970, pp. 1ff.

General titles including art, architecture, film, literature and music

T. Adorno, *Alban Berg: der Meister des kleinsten Übergangs*, Vienna, 1968. *Alban Berg: Master of the Smallest Link*, tr. J. Brand and C. Hailey, Cambridge, 1991.

A. Balfour, *Berlin: Politics of Order 1739-1989*, New York, 1990.

R. Barilli (ed.), *Espressionismo Italiano 1910-20*, Turin, 1990.

J. Barlow, *German Expressionist Film*, Boston, 1982.

S. Barron (ed.), *German Expressionist Sculpture*, Los Angeles, 1983.

S. Barron (ed.), *German Expressionism 1915-1925: The Second Generation*, Munich, 1989.

S. Behr, *Women Expressionists*, Oxford, 1988.

H. Boorman, 'Re-thinking the Expressionist Era; Wilhelmine Cultural Debates and Prussian Elements in German Expressionism', *Oxford Art Journal*, IX/2, 1986, pp. 3-15.

I. Boyd Whyte, *Bruno Taut and the Architecture of Activism*, Cambridge, 1982.

S. Bronner and D. Kellner (eds), *Passion and Rebellion: The Expressionist Heritage*, London, 1985.

Brücke Museum, *Gemälde, Glasfenster und Skulpturen des Brücke-Museums*, 1975.

L.-G. Buchheim, *The Graphic Art of German Expressionism*, New York, 1960.

L. Cammaroto, *L'espressionismo e Schoenberg*, Bologna, 1965.

R. Cardinal, *Expressionism*, London, 1984.

F. Carey and A. Griffiths, *The Print in Germany 1880-1933: The Age of Expressionism*, British Museum, London, 1984.

E. Carter, 'Expressionism and American Music', *Perspectives of New Music*, IV, 1965, pp. 1-13.

G. Chapple and H. Schulte (eds), *The Turn of the Century: German Literature and Art 1890-1914*, Bonn, 1981.

A. Comini, 'Gender or Genius? the Women Artists of German Expressionism', *Feminism and Art History: Questioning the Litany*, N. Broude and M. Garrard (eds), New York, 1982.

C. Dahlhaus, *Schoenberg and the New Music*, tr. D. Puffett and A. Clayton, Cambridge, 1987.

H. Dill, 'Schoenberg's *George-Lieder:* the Relationship between Text and Music in the Light of some Expressionist Tendencies', *Current Musicology*, XVII, 1974, pp. 91-5.

M. Eberle, *World War I and the Weimar Artists: Dix, Grosz, Beckmann, Schlemmer*, London and New Haven, 1985.

L. Eisner, *The Haunted Screen: Expressionism in the German Cinema and the Influence of Max Reinhardt*, London, 1969.

R. Evans (ed.), *Society and Politics in Wilhelmine Germany*, London, 1978.

R. Evans, *Rethinking German History: Nineteenth Century Germany and the Origins of the Third Reich*, London, 1987.

S. Everett, *Lost Berlin*, Bison, 1979.

U. Evers, *Deutsche Künstlerinnen des 20. Jahrhunderts*, Hamburg, 1983.

U. Finke, *German Painting: From Romanticism to Expressionism*, London, 1974.

P. Franklin, *The Idea of Music: Schoenberg and Others*, London, 1985.

R. Furness, *Expressionism*, London, 1973.

P. Gay, *Weimar Culture*, Penguin, 1968.

P. Gay, *Freud, Jews and other Germans: Masters and Victims in Modernist Culture*, Oxford, 1978.

German Expressionism: Bibliography (Catalogue of the Library of the Robert Gore Rifkind Centre for German Expressionist Studies at the Los Angeles County Museum of Art), Boston, 1990.

German Expressionist Prints and Drawings: The Robert Gore Rifkind Centre for German Expressionist Studies, 2 vols, Munich, 1990.

R. Gollek, *Der Blaue Reiter im Lenbachhaus München*, Munich, 1974.

D. Gordon, 'Expressionist Art by Antithesis', *Art in America*, LXIX, March 1981, pp. 98-111.

D. Gordon, *Expressionism: Art and Idea*, New Haven and London, 1987.

C. Haxthausen and H. Suhr (eds), *Berlin Culture and Metropolis*, Minneapolis and Oxford, 1990.

R. Heller, *Art in Germany 1909-1936: From Expressionism to Resistance (The Marvin and Janet Fishman Collection)*, Munich, 1990.

J. Hermand, 'Expressionismus beim jungen Hindemith?', *Hindemith-Jahrbuch*, XVI, 1987, pp. 18-31.

J. Hermand, 'Musikalischer Expressionismus', *Beredte Töne: Musik im historischen Prozess*, Frankfurt am Main, 1991, pp. 97-117.

J. Hert, *Reactionary Modernism: Technology, Culture and Politics in Weimar and the Third Reich*, Cambridge, 1984.

G. Heuberger (ed.), *Expressionismus und Exil: Die Sammlung Ludwig und Rosy Fischer*, Munich, 1990.

R. Hinton Thomas, *Nietzsche in German Politics and Society, 1890-1914*, Manchester, 1983.

Historisches Museum der Stadt Wien, *Traum und Wirklichkeit: Wien 1870-1930*, Vienna, 1985.

D. Howe, *Manifestations of the German Expressionist Aesthetic as presented in Drama and Art in the Dance and Writing of Mary Wigman*, Ann Arbor, 1985.

M. Jacobs, *The Good and Simple Life: Artist Colonies in Europe and America*, Oxford, 1985.

P. Jelavich, *Munich and Theatrical Modernism: Politics, Playwriting and Performance, 1890-1914*, Cambridge (Mass.) and London, 1985.

C. Joachimedes and N. Rosenthal, *Metropolis*, Martin Gropius Bau, 1991.

C. Joachimedes, N. Rosenthal and W. Schmied (eds), *German Art in the Twentieth Century: Painting and Sculpture 1905-1985*, Munich, 1985.

B. Keith-Smith (ed.), *German Expressionism in the United Kingdom and Ireland*, Bristol, 1986.

T. Kneif 'Ernst Bloch und der musikalische Expressionismus', *Ernst Bloch zu Ehren*, S. Unseld (ed.), Frankfurt am Main, 1965.

E. Kolinsky, *Engagierter Expressionismus: Politik und Literatur zwischen Weltkrieg und Weimarer Republik*, Stuttgart, 1970.

E. Krenek, *Über neue Musik*, Vienna, 1937; tr. *Music Here and Now*, New York, 1939.

T. Krens, M. Govan and J. Thompson (eds), *Refigured Painting: The German Image 1960-1988*, Munich, 1989.

L. Lang, *Expressionist Book Illustration in Germany 1907-1927*, New York Graphic Society, Greenwich, 1976.

Leicestershire Museums Publication No. 120, *Domesticity and Dissent: The Role of Women Artists in Germany 1918-1938*, 1992.

A. Lessem, 'Schoenberg and the Crisis of Expressionism', *Music and Letters*, LV, 1974, pp. 429ff.

A. Lessem, *Music and Text in the Works of Arnold Schoenberg: The Critical Years, 1908-1922*, Ann Arbor, 1979.

J. Lloyd, *German Expressionism: Primitivism and Modernity*, New Haven and London, 1991.

A. McCredie, 'The Munich School and Rudi Stephan (1887-1915); some Forgotten Sources and By-ways of Musical Jugendstil and Expressionism', *The Music Review*, XXXIX, 1968, pp. 197-222.

M. McNichols-Webb, *Art as Propaganda: A Comparison of the Imagery and Roles of Woman as depicted in German Expressionist, Italian Futurist and National Socialist Art*, Ann Arbor, 1988.

K. McShine, *Berlin Art 1961-1987*, Munich, 1987.

J. Maegaard, 'Some Formal Devices in Expressionistic Works', *Dansk aarbog for musikforskning*, VII, 1961, pp. 64ff.

M. Makela, *The Munich Secession (Art and Artists in Turn-of-the-Century Munich)*, New Jersey/Oxford, 1990.

G. Masur, *Imperial Berlin*, London, 1971.

S. Mauser, *Das expressionistische Musiktheater der Wiener Schule*, Salzburg, 1981.

V. Miesel (ed.), *Voices of German Expressionism*, New Jersey, 1970.

S. Miller (ed.), *The Myths of Primitivism*, Routledge, London, 1991.

K. Morris and A. Woods, *Art in Berlin 1815-1989*, High Museum of Art (Atlanta, Georgia), Seattle and London, 1990.

G. Mosse, *The Crisis of German Ideology*, London, 1966.

B. Myers, *The German Expressionists: A Generation in Revolt*, New York, 1957.

Nationalgalerie, Staatliche Preußischer Kulturbesitz, *Kunst in der Bundesrepublik Deutschland 1945-1985*, Berlin, 1985.

D. Olson, *The City as a Work of Art: London, Paris, Vienna*, 1986.

E. Padmore, 'German Expressionist Opera', *Proceedings of the Royal Musical Association*, XCV, 1968-9, pp. 41-53.

A. Papadakis, C. Farrow and N. Hodges (eds), *New Art*, London, 1991.

P. Paret, *The Berlin Secession: Modernism and its Enemies in Imperial Germany*, Harvard, 1980.

W. Pehnt, *Expressionist Architecture*, London, 1973.

G. Reinhardt, *Die frühe 'Brücke': Beiträge zur Geschichte und zum Werk der Dresdner Künstlergruppe 'Brücke' der Jahre 1905-1908*, Brücke Museum Veröffentlichungen, Heft 8, 1975-76.

L. Richard (ed), *Phaidon Encyclopaedia of Expressionism*, Oxford, 1978.

I. Rigby, *An alle Künstler! War-Revolution-Weimar*, San Diego State University Gallery, 1983.

R. Ringger, 'Orchesterstücke des Expressionismus', *Neue Zeitschrift für Musik*, XCIX, 1968, pp. 441-3.

L. Rognoni, *The Second Viennese School: Expressionism and Dodecaphony*, London, 1977.

I. Rogoff (ed.), *The Divided Heritage: Themes and Problems in German Modernism*, Cambridge, 1991.

C. Rosen, *Schoenberg*, London, 1976.

M. Roskill, *Klee, Kandinsky and the Thought of their Time: A Critical Perspective*, Illinois, 1992.

E. Roters, *Berlin 1910-1930*, New York, 1982.

W. Rubin and K. Varnedoe (eds), *Primitivism in Twentieth Century Art*, New York, 1984.

R. Rumold and O. Werckmeister, *The Ideological Crisis of Expressionism: The Literary and Artistic German War Colony in Belgium 1914-1918*, Columbia, 1990.

G. Salvetti, 'Espressionismo musicale del primo dopoguerra: seconda fase, o crisi?', *Chigiana*, XXXV, 1982, pp. 109-18.

E. Santomasso, *Origins and Aims of German Expressionist Architecture*, Ann Arbor, 1973.

C. Schorske, *Fin-de-Siècle Vienna: Politics and Culture*, New York, 1980.

W.-A. Schultz, *Die freien Formen in der Musik des Expressionismus und Impressionismus*, Hamburg, 1974.

H. Segal, *Turn of the Century Cabaret: Paris, Barcelona, Berlin, Munich, Vienna, Cracow, Moscow, St Petersburg, Zurich*, New York, 1987.

P. Selz, *German Expressionist Painting*, Berkeley, 1957.

R. Sheppard (ed.), *Papers of the UEA Conference on German Expressionism in the United Kingdom and Ireland*, University of East Anglia, 1986.

R. Sheppard (ed.), *Expressionism in Focus*, Dundee, 1987.

W. Sokel, *The Writer in Extremis: Expressionism in German Literature*, Stanford, 1959.

Solomon R. Guggenheim Museum, *Expressionism - A German Intuition 1905-1920*, New York, 1980.

H. Stuckenschmidt, 'Was ist musikalischer Expressionismus?', *Melos*, XXXVI, 1969, pp. 1-5.

B. Taylor and W. van der Will, *The Nazification of Art*, Winchester, 1990.

D. Taylor, *Left-Wing Nietzscheans: The Politics of German Expressionism 1910-1920*, Ann Arbor, 1989.

E. Timms, *Visions and Blueprints*, Manchester, 1988.

C. Tümpel (ed.), *Deutsche Bildhauer 1900-1945 Entartet*, Zwolle, 1992.

K. Varnedoe, *Vienna 1900: Art, Architecture and Design*, New York, 1986.

P. Vergo, *Art in Vienna 1898-1918*, Oxford, 1975.

M. Wagner, 'Zum Expressionismus des Komponisten Paul Hindemith', *Erprobungen und Erfahrungen*, D. Rexroth (ed.), Mainz, 1978, pp. 15-26.

J. von Waldegg and D. Stemmler, *Die Rheinische Expressionisten: August Macke und seine Malerfreunde*, Bonn, 1974.

V. Weber, *Expressionism and Atonality: the Aesthetic of Arnold Schoenberg*, Yale University PhD, 1971.

J. Weinstein, *The End of Expressionism (Art and the November Revolution in Germany, 1918-1919)*, Chicago and London, 1990.

F. Whitford, *Expressionism*, London, 1970.

F. Whitford, *Expressionist Portraits*, London, 1987.

J. Willett, *Expressionism*, London, 1970.

J. Willett, *Art and Politics in the Weimar Republic: The New Sobriety 1917-1933*, New York, 1978.

Worpswede 1889-1989, *Hundert Jahre Künstlerkolonie*, Worpswede, 1989.

NOTES ON CONTRIBUTORS

Shulamith Behr is Bosch Lecturer in German Twentieth-Century Art at the Courtauld Institute, London. Her doctorate focused on Wassily Kandinsky's Stage-Compositions 1909-14. Author of *Women Expressionists*, her current publications continue her research interests on the circle of women artists of the Neue Künstlervereinigung München and Blaue Reiter Group.

David Elliott is Director of the Museum of Modern Art in Oxford. Widely known for his work on radio and television and as a member of many international juries, he is the author of books on a wide range of artistic topics but is perhaps especially noted for his expertise on twentieth-century Russian art.

David Fanning is Lecturer in Music at Manchester University. An active critic and pianist, his scholarly publications are mainly in the field of Russian and Scandinavian music, but he is also author of an important study of Alban Berg's sketches for *Wozzeck*.

Peter Franklin is Lecturer in Music at Leeds University and author of *The Idea of Music: Schoenberg and Others* and a detailed study of Mahler's Third Symphony in the series *Cambridge Monographs on Music*.

Raymond Furness is Professor of German at the University of St Andrews and author of numerous books and articles, including *Expressionism*, *A Literary Guide to Germany: the 20th century, 1890-1945*, *Wagner and Literature*, and *A Companion to 20th Century German Literature*.

Christopher Hailey is Assistant Professor of Music at Occidental College, Los Angeles. Co-editor and translator of the Berg/Schoenberg correspondence, translator of Theodor Adorno's *Alban Berg: Master of the Smallest Link* and author of a life and works study of Franz Schreker, he is currently working on an edition of the correspondence between Kurt Weill and his publishers.

Stephen Hinton is Assistant Professor of Music at Yale University. His publications include *Kurt Weill: The Threepenny Opera* in the series *Cambridge Opera Handbooks*, *The Idea of Gebrauchsmusik*, and an edition of Weill's collected writings. He is currently working on a history of Anglo-American music theory in the twentieth century.

Douglas Jarman is Principal Lecturer in Academic Studies at the Royal Northern College of Music, Manchester, author of a number of books and articles on the music of Alban Berg and editor of the forthcoming Concerto volume of the Berg *Gesamtausgabe*.

Brian Keith-Smith is Senior Lecturer in the German Department, University of Bristol. He has published a book and five articles on Lothar Schreyer and a volume of his selected works. The first title of his twenty-four-volume Schreyer edition *Die Mystik im Elsass* will be followed by five volumes of Schreyer's dramas and essays on the theatre.

Manfred Kuxdorf is Professor of German at the University of Waterloo, Canada, editor of the series *German Studies in Canada*, and president of the *Canadian Council of Teachers of German*. He has published on such diverse writers as Georg Kaiser, Artur Schnitzler, and the German-Jewish writer Salomo Friedlaender/Mynona. His current research encompasses the work of the parodist and satirist Hans Reimann.

Gill Perry is Lecturer in Art History at the Open University and author of *Paula Modersohn-Becker: Her Life and Work* and a forthcoming study entitled *'She Sees like a Woman and Paints like a Man': Emilie Charmy, Women Artists and the Parisian Avant-Garde*. She is also editor of a forthcoming anthology: *'The Delicate Taste': The Construction of the Feminine in Eighteenth Century Art and Literature*.

Erich Ranfft is completing a doctorate on 'The Cultural and Ideological Significance of Expressionism in German Sculpture c.1910-1930'. His Masters dissertation at Queens University (Canada) dealt with Adolf von Hildebrand's 'Front' against Auguste Rodin. His publications include contributions to *Vanguard*, the catalogue *Active Process Artists' Books* and a review article in *Art History* on recent scholarship in twentieth-century German sculpture. He has recently been appointed Henry Moore Scholar at the University of Leeds.

Colin Rhodes is Lecturer in Critical and Historical Studies at Loughborough College of Art and Design. He has written a monograph on Ernst Ludwig Kirchner and published articles in *Art History*. He is currently writing a book on Primitivism.

J. R. (Hamish) Ritchie is Professor of German at the University of Aberdeen. Joint editor of the journal *German Life and Letters* and author of many articles and books, including the editions of expressionist plays published by Calder and Boyars, he has been made a Commander of the Order of Merit by the German government in recognition of his work.

Dennis Sharp is a chartered architect, writer and critic, executive editor of *World Architecture*, and vice-president of the Royal Institute of British Achitects. Formerly Lecturer in Architecture at Manchester University he commenced his own practice in 1982 and is the author of a number of books on architecture, including *Modern Architecture and Expressionism* (1966) and *Architecture; a Visual History* (1991).

Werner Sudendorf is Direktor of the Stiftung Deutsche Kinemathek, Berlin. His numerous publications include works on Eisenstein, Marlene Dietrich, Karl Grund, E. A. Dupont and Artur Robison.

Peter Vergo is Reader in Art History and Theory at the University of Essex and an authority on nineteenth and twentieth-century German art. He is at present working on a *catalogue raisonné* of twentieth-century German paintings in the Thyssen-Bornemisza collection in Lugano.

Marit Werenskiold is Professor of Art History at the University of Oslo. Sometime Visiting Member of the Institute for Advanced Studies at Princeton, she is the author of books on *The Concept of Expressionism* and *Matisse's Norwegian Pupils*.

Rhys Williams is Professor of German at the University of Swansea. He has published widely on twentieth-century German literature, particularly on Expressionism (Sternheim, Benn, Einstein, Kaiser) and on post-war literature (Andersch, Walser, S. Lenz). He is currently President of the Carl Einstein Society.

John Willett was for many years assistant editor and planning editor of the *The Times Literary Supplement*. An acknowledged authority on the period of Expressionism, he is well known for his many books and articles on the art of the Weimar Republic, and in particular for his books on and translations of Brecht.

INDEX

Numbers in bold refer to major entries

TE D